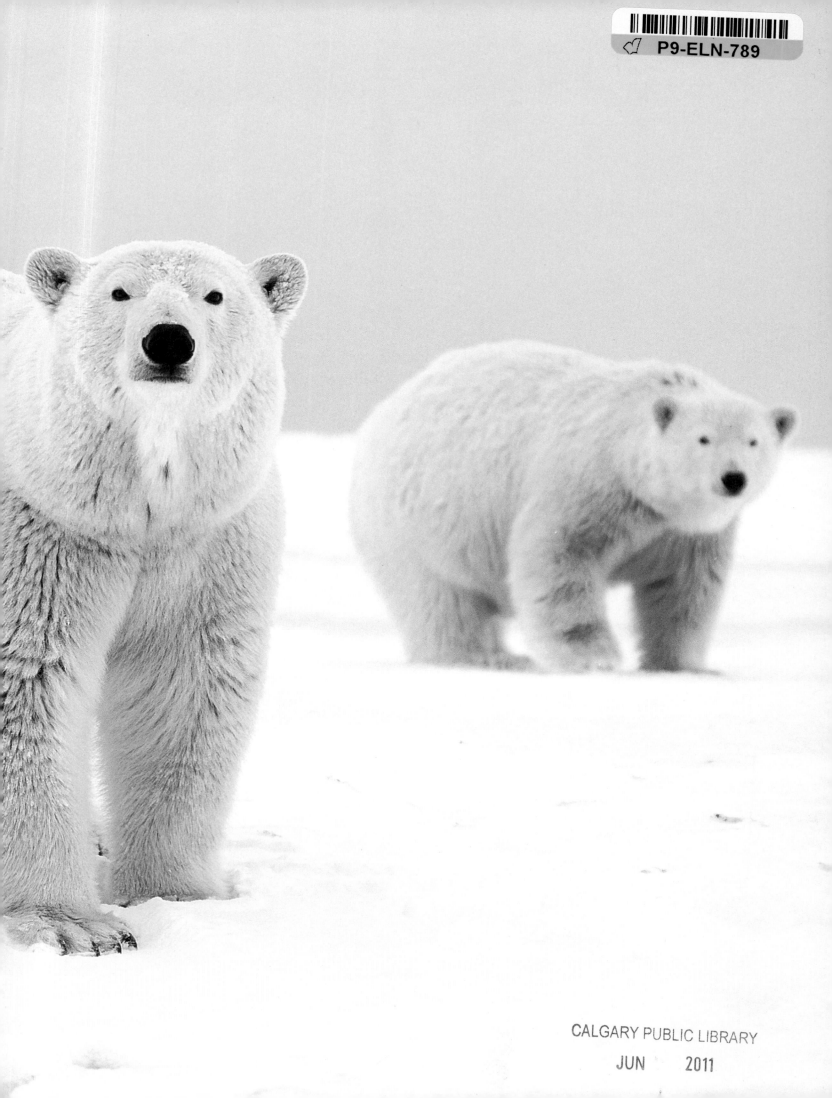

BEARS OF THE LAST FRONTIER

The adventure of a lifetime among Alaska's black, grizzly, and polar bears

CHRIS MORGAN

FOREWORD BY SUSAN AND JEFF BRIDGES

Stewart, Tabori & Chang
New York

We see land as much, much more than others see it. Land is life. Without our land, and the way of life it has always provided, we can no longer exist as people. If the relationship is destroyed, we too are destroyed.

—Richard Nerysoo, Native Elder

Published in 2011 by Stewart, Tabori & Chang
An imprint of ABRAMS

Text copyright (c) 2011 Chris Morgan
Map illustrations copyright (c) 2011 Kris Tobiassen

Bears of the Last Frontier is a production of Pontecorvo Productions and Thirteen in association with Wildlife Media, National Geographic Channel, PBS, and WNET.ORG.

Library of Congress Cataloging-in-Publication Data

Cataloging-in-Publication Data has been applied for and may be obtained from the Library of Congress. ISBN: 978-1-58479-931-3

Editor: Dervla Kelly
Designer: Kris Tobiassen
Production Manager: Anet Sirna-Bruder

The text of this book was composed in Sketch Block Light and Schmutz Cleaned.

Printed and bound in U.S.A.

10 9 8 7 6 5 4 3 2 1

Stewart, Tabori & Chang books are available at special discounts when purchased in quantity for premiums and promotions as well as fundraising or educational use. Special editions can also be created to specification. For details, contact specialsales@abramsbooks.com or the address below.

ABRAMS
THE ART OF BOOKS SINCE 1949

115 West 18th Street
New York, NY 10011
www.abramsbooks.com

FOR SOFIA AND SAM,
and the wild places of their future

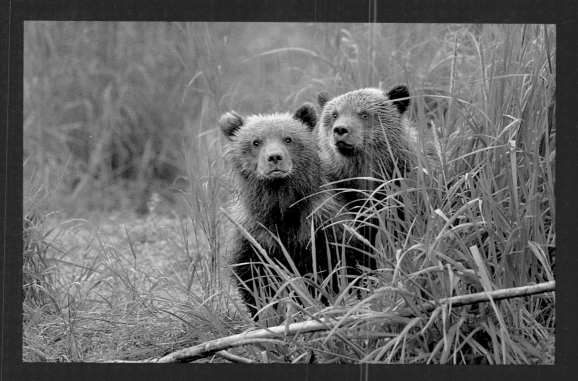

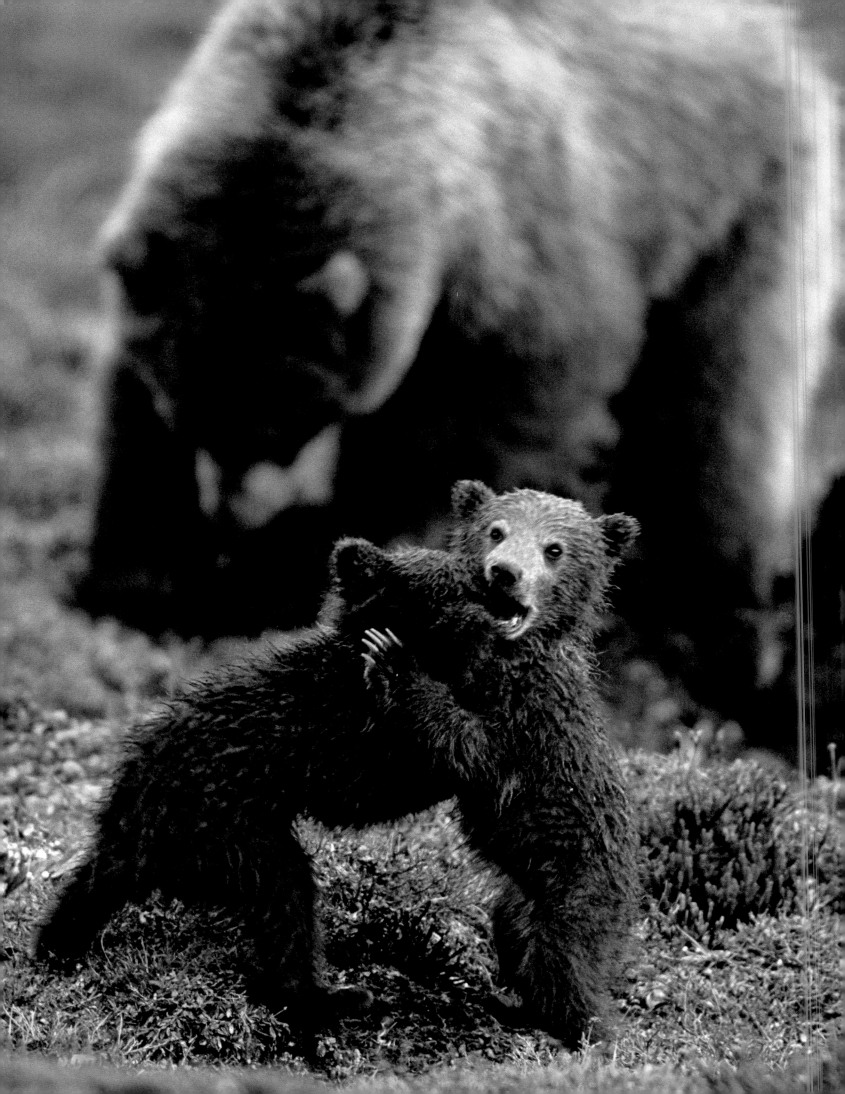

CONTENTS

FOREWORD

By Susan and Jeff Bridges

For a week last spring, I visited a remote estuary along the North Pacific Coast, where grizzlies wander the shorelines dining on seafood and sprouting plants. If I'd watched from any closer, I would have come back to camp each evening soaked from the splash of big paws. To me, bears stand as symbols of entire wildlife communities and of society's commitment to keep them healthy and whole. To my husband, Jeff, bears are about awe in the presence of raw power—fear wrapped in wonder, the kind of tensions that get an actor's fires dancing.

Among the strongest, fiercest carnivores on the planet, bears come with claws and teeth ready-made for horror flicks—no getting around that. Yet when they play-wrestle or rear up on two legs to check something out, both Jeff and I find them really easy to relate to. They can be clown-

ish, cute, even teddy-bear-on-the-pillow cuddly. At times it seems like there's a bear doing something to fit almost any opinion of what these animals are actually like.

Along with a three-part PBS *Nature* film special, Chris Morgan's wonderful book *Bears of the Last Frontier* celebrates the trio of species native to North America: black bears, grizzlies, and polar bears. By "the last frontier," he means Alaska, where the animals still roam awesome expanses scarcely nicked by the modern era. The great majority is public land. All that rugged acreage and the animals thriving on it belong to every U.S. citizen. This is a priceless inheritance—and a super-size responsibility.

While our main home sits in Southern California, we have as much hope for the future of nature invested in Alaska as other Americans do. And our interest in bears runs south from there. Black bears? They live all around our Montana ranch and wander through the yard by the main log cabin every so often. Grizzlies? Check. Some travel the national forest slopes sweeping upward between our property and the snowy peaks. We know from experience how a fresh pile of grizz droppings along a backcountry path sets all your senses on vibrate and makes the mountains loom larger than they did just an eyeblink before.

Polar bears? Okay, we'd have to call in the special effects department to conjure any

of those in the Lower 48. But the point is that bears play starring roles in the Rocky Mountain landscape that have long been part of our life as a family. Jeff and I are active supporters of the Vital Ground Foundation, a land trust focused on protecting grizzly bear habitat in Alaska and Canada as well as here in the West, and we've served as Honorary Board members for two decades.

As you turn the pages of *Bears of the Last Frontier*, you'll discover why Chris Morgan describes these animals as keystone species. You'll see how they shape ecosystems by choosing certain prey, competing with other natural hunters and scavengers, tilling tons of earth as they dig for roots or rodents and excavate winter dens, and spreading the seeds from meals of berries and wildflowers. You'll understand why bears need large wildland ranges and also movement corridors that will keep populations in different strongholds connected over time. Most of all, you'll come to recognize bears as smart, curious, fast-learning fellow mammals. With an amazing range of individual personalities and moods, they turn out to be more like us humans than you might ever have imagined before, even as they lead the way on a journey into nature's untamed heart.

page iv Cubs of the year, or spring cubs, play while Mom digs for roots to eat.

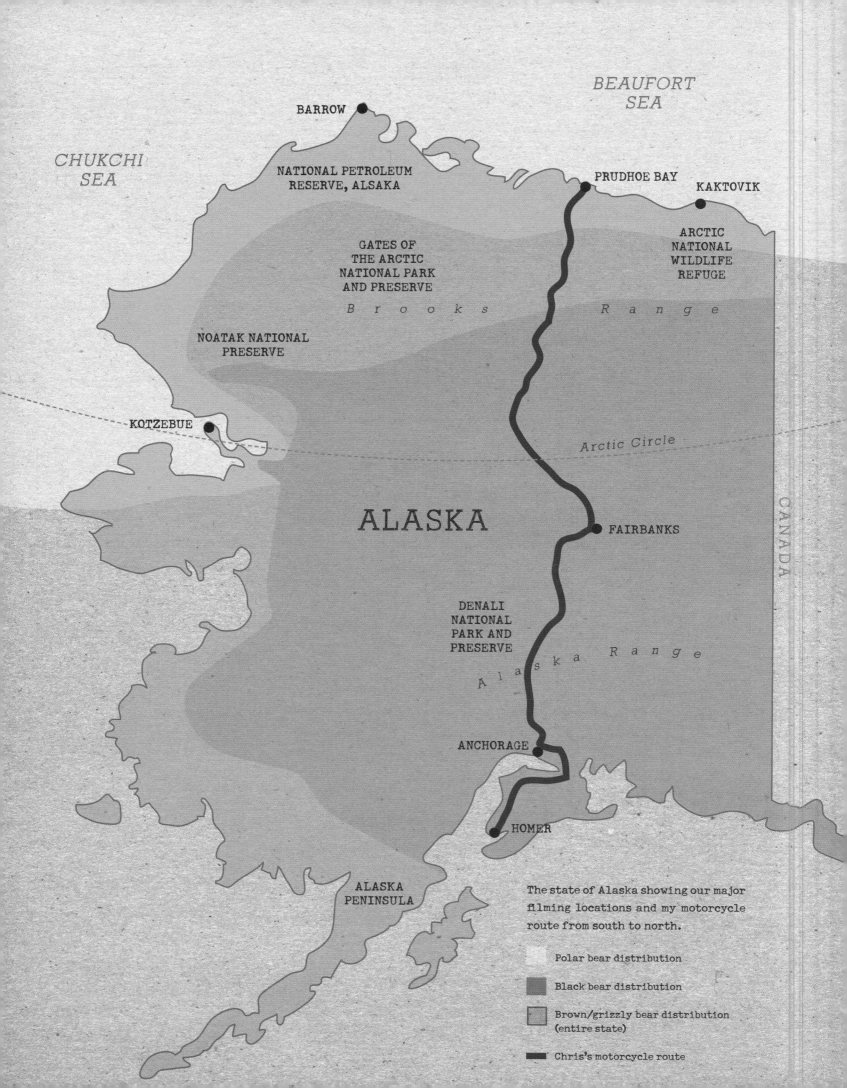

BEAUFORT
SEA

CHUKCHI
SEA

BARROW

NATIONAL PETROLEUM
RESERVE, ALSAKA

PRUDHOE BAY

KAKTOVIK

GATES OF
THE ARCTIC
NATIONAL PARK
AND PRESERVE

ARCTIC
NATIONAL
WILDLIFE
REFUGE

Brooks Range

NOATAK NATIONAL
PRESERVE

Arctic Circle

KOTZEBUE

ALASKA

FAIRBANKS

CANADA

DENALI
NATIONAL
PARK AND
PRESERVE

Alaska Range

ANCHORAGE

HOMER

ALASKA
PENINSULA

The state of Alaska showing our major
filming locations and my motorcycle
route from south to north.

Polar bear distribution

Black bear distribution

Brown/grizzly bear distribution
(entire state)

Chris's motorcycle route

PREFACE

Bears have been my life. So the fact that I am sitting down for the first time to write a book about them is incredibly daunting. Fortunately, I'm not short of material. Over the course of a year and a half, my colleague and award-winning filmmaker Joe Pontecorvo and I spent many, many months in bear country—piecing together the lives of these fascinating animals for the PBS *Nature* film special we created together, *Bears of the Last Frontier*.

Bears are among the most intelligent mammals on earth, but they are wildly misunderstood. We set out to immerse ourselves in their world and to further understand these majestic animals on their own ground. Our journey covered more than 3,000 miles by road and many thousands more by bush plane.

Everybody knows that Alaska is big. But for me, it wasn't until I rode across its endless length that I got a full appreciation of the scale involved. This northernmost state

is the same size as the next three largest states of California, Texas, and Montana combined. It is around nine times larger than my home state of Washington, and thirteen times the size of my native England.

Alaska harbors all three of North America's bear species, from 300-pound black bears to polar and brown bears weighing well over half a ton. It is home to the highest mountain on the continent, vast glaciers, immense forests, and a level of isolation to be found nowhere else in the United States.

This was one of the most rewarding experiences of my life—and a complete privilege. Every morning on location I would pinch myself at how lucky I was to be living this dream. Well, not every morning: Some days were no fun at all, but more of that later.

As I sit here writing the final words of this book, I am surrounded by books, articles, and memories. A map of Alaska is pinned to the wall in front of me, dappled with circles, dots, lines, and crosses—reminders of the incredible places I have been over the last year and a half. And as my eyes skip from one memory to another across the rivers, mountains, and coastline, I realize one thing: Despite the thousands of miles we traversed, we barely scratched the surface.

I'm hoping that, as you comb through the pages of this book, you will feel immersed in the world of the bear, and perhaps even enjoy a taste of life on the road with a film crew. I've tried to capture the whole experience in words and images, but it's a tough task. Like the great state of Alaska, our story covers a lot of ground. I hope you enjoy the ride!

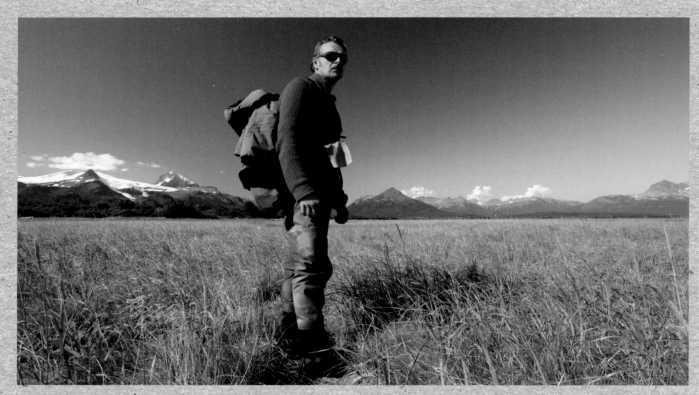

Hiking a bear trail in my favorite place on Earth: the Alaska Peninsula. The perfect location to launch *Bears of the Last Frontier*.

INTRODUCTION

You can study bears for a living?

When you're ten years old, your mind can take you any-
where. Almost. Even back then, with my imagination wide
open, I'm not sure that I believed any *real* adventure was in
store for me. I'm happy to say I was wrong.

As a boy growing up in England, I would dream about
wild places far from home, places where magnificent crea-
tures still roamed the landscape as they had done thousands
of years ago. But back then, the magnificent creatures of my
backyard had to suffice for the time being. I'd spend hours
and days exploring ten square feet and "capturing" ants,
potato bugs, and worms. On a lucky day, an unsuspecting
lizard would walk by—but never a bear.

I had to wait for a chance happening when I was eigh-
teen before a light went on in my head, revealing my mis-
sion in life. Working as a counselor at a summer camp in
New Hampshire, I bumped into Doug Kane, a black bear

biologist who was visiting to talk to the children about the animals he was studying in the local White Mountain National Forest. To this day, I'm not sure if he knows that he changed everything for me. In fact it was the biggest crossroads of my life. I sat transfixed by every word of his presentation, mouth agape, in awe of the fact that someone could study bears for a living. It was almost unfathomable for a young man from England. After all, I had every intention of becoming a graphic designer, and my U.S. trip was just a mad fling before settling into art college. But my experience in New Hampshire changed everything. Kane had barely delivered the last sentence of his presentation before I was gasping to him about helping with some of the fieldwork.

Happily, he obliged, and so began my lifelong commitment to bear conservation. My first evening of fieldwork found us heading toward town—seemingly the wrong direction—in his pickup truck. However, as we pulled into the city dump, all became clear. I counted fourteen black bears under the moonlight, all sitting atop a pile of fresh garbage, and every one of them ripe for a shiny new radio collar as far as Doug was concerned. Lying in the fetid dump alongside him as he took shots with his tranquilizer rifle, the job didn't seem quite so appealing anymore. But as we jumped to our feet in pursuit of a target bear, my heart raced like it had never done before. Bears fled in every direction through the garbage, mowing down shrubs and small trees as if they were stage props. It seemed like complete insanity to me—like something you should only have nightmares about—to be chasing large carnivores across a putrid dump and into a thick black forest. Although Doug seemed to know what he was

doing, I began to think that I was the only volunteer mad enough to join him.

The ingenious dart rifle Doug was using not only injected a tranquilizer into the bear's rump, but also contained a tiny transmitting device that allowed us to find the sleeping bear in the darkness—at least in theory. Just when I thought that the nightmare couldn't get any more terrifying, I found myself standing in the pitch black next to Doug with the transmitter signal pounding at full strength. Judging by the heavy breathing (the bear's that is), the sleeping animal wasn't far away. Doug wondered aloud whether it was a deep or a light sleeper—which wasn't something that calmed my nerves. As my frantic flashlight search through the trees veered toward the direction of the breathing, I could hardly look. I knew the bear was just feet away, and I sincerely feared what my light might reveal. It was rather like carefully peeking over the top of your blanket when trying to find the monster in your bedroom as a kid. Yet there she was, and she was no monster. I couldn't believe my luck—the first bear I had ever laid eyes on and she was sleeping soundly at my feet.

Then the magic happened. For the first time, I placed my hands on a wild bear, and a sensation ran through me like nothing I had ever experienced before. I felt a primeval connection I've found very hard to describe ever since. Everything about that animal was somehow in synchrony with the forest that it called home: its tree-climbing claws, muscular build, and well-adapted teeth. As my hands and eyes explored the bear, a flash of inadequacy overcame me. I realized just how removed from our wild roots humans have become and how this isolation from the natural world has made us careless about its value.

At that moment I knew this experience was going to change me forever. Although I returned to the UK later that year, by lunchtime of my first day at art college I'd already quit to start my life with bears.

I tell this story for two reasons: to share with young people the pure magic of life's unexpected turns and adventures, but also to paint a backdrop for the experiences I describe in this book, none of which would have happened if I hadn't found myself in the right place at the right time that day in New Hampshire in 1987.

Barometers of the Wild

It wasn't until years later that I really began to explore the value of bears as "barometers" of ecosystem health and as eye-catching representatives of everything wild. But in the meantime my experience in New Hampshire had triggered some of

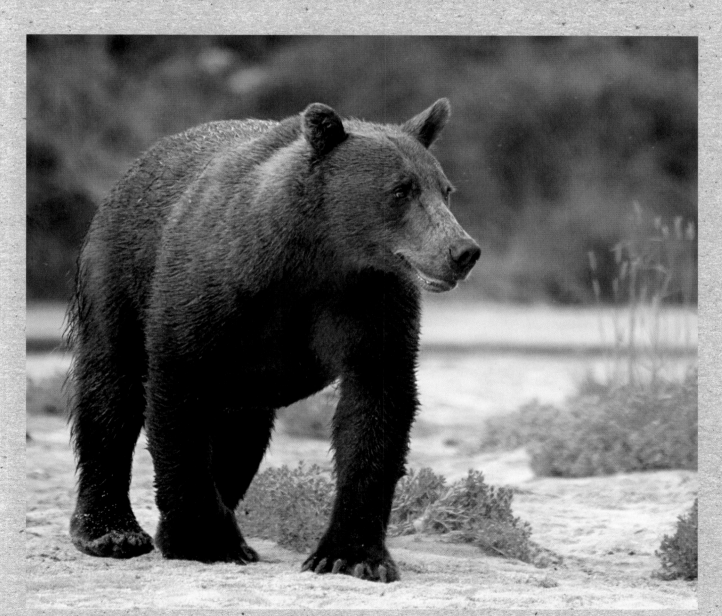

An Alaskan brown bear patrols the shores of a hidden inlet on the Alaska Peninsula in search of salmon.

the most exciting adventures of my life in search of bears and my own role as a conservationist.

Eight species of bear exist in the world today. Ranked in order from the rarest to the most common, these are the giant panda, the sloth bear, the sun bear, the Andean bear, the polar bear, the Asiatic black bear, the brown bear, and the American black bear. They are found on every continent except for Australia and Antarctica and range across a dazzling array of ecosystems from tropical rain forests to deserts and from pack ice to oak forests.

Although bears were eliminated from the UK around one thousand years ago, I was thrilled to discover that they still roamed the mountains of Europe's last wild places, and that is exactly where my mission to learn more began.

Having visited Spain's southern beaches and villages on numerous occasions, I thought it an unlikely country in which to find large carnivores, but my research pointed in the direction of the Cordillera Cantabrica, a beautiful region of mountains and pastures unknown to most tourists. Northern Spain harbors only around one hundred brown bears, and in the summer of 1991 I took it upon myself to find one.

At that point I had no idea such wild mountain ranges still existed in Europe. The distribution of brown bears there provides quite an accurate representation of the remaining wilderness. Bears were already helping me to discover my own backyard in Europe. In the case of Spain the beautiful oak and beech forests of the north provide sufficient shelter for bears

There was no stopping me when I discovered that Europe had its very own brown bears. Exploring the mountains of northern Spain in search of brown bears, 1990.

from ever-expanding European development. With the help of two wonderfully encouraging biologists, Tony Clevenger and Francisco Purroy, I began to absorb everything I could about this untamed and mysterious place. As I explored these mountains, I fell in love with a side of Spain that I never knew existed.

Pulling my bright yellow camper van into some of the most rural villages in Europe certainly raised some eyebrows. On one occasion I opened the van door to a bustle of excited children—they thought I was selling ice cream! When they found out that I was instead an Englishman searching for bears, several children scurried home to find their parents, which led to some very colorful conversations about these mysterious animals. As I was to find out elsewhere around the world, bears trigger all kinds of emotions across the scale from positive to negative. But every person I encountered in northern Spain, including scientists who had been studying this population of brown bears for several years, told me that I would never see one. Hundreds of years of uncomfortable coexistence with humans had made these bears practically impossible to find, in large part due to their elusive nocturnal behavior.

During the several months I spent scouring Spain's mountains, my image of the bear took shape. And one day, as I tromped twenty-five miles around a tiny reserve, my thoughts were interrupted by a brown flash of fur running across the trail. My heart pounded and my legs nearly buckled—it was a Spanish brown bear. I dashed up a tree for a better view but saw nothing. The bear had obviously been planning to cross the trail, spotted me, and hastily powered into full speed to escape. I took this extremely

rare sighting as a sign: Bears were simply meant to be a big part of my life.

Hardy, Adaptable, and Tough

The experience left me overwhelmed with the urge to do all I could for dwindling bear populations around the world, and during the years that followed I worked on projects in some wildly unusual places. My college years provided an opportunity to aid a research team led by grizzly bear and wolf biologist Peter Clarkson for six months in the Canadian Arctic to study the needs of barren ground grizzly bears. Helping to tranquilize bears from a helicopter in the open tundra of the Northwest Territories gave me an incredible respect for bears and their ability to thrive in a myriad of different habitats. The species was the same as the one I had become familiar with, but in no other way did these arctic bears have anything in common with their Spanish cousins. In this harsh landscape, they had to rely upon their intelligence, memory, and ingenuity when it came to finding sufficient food—mostly in the form of roots, berries, and the occasional caribou carcass. It was a tough life sustained by tough animals.

Even the cubs seemed to have an attitude born of arctic hardship. As the capture team began to fit a radio collar on one female that was already anesthetized and sleeping, Peter threw me a fishing net and asked me to bring in the cubs, both of which were hightailing it across the tundra at a rate of knots. I gave chase, and the cubs seemed to know it, speeding up every time my sloppy rubber boots carried me within scooping range. I finally threw away the net and rugby tackled the first cub as a last-ditch effort. My gloating

quickly turned to terror though as the cub spun around within its neck skin and slashed its claws at my face and bit at my hand in a final protest. Never again did I underestimate the ferocity of even a twenty-five-pound grizzly bear.

Bears as Ambassadors

One of the most culturally enlightening experiences I have ever had was the opportunity to join a research team in northern Pakistan for two months in the early nineties. The Deosai Plateau, one of the highest plateaus in the world, nestled among giant Himalayan peaks, harbors one of the world's least known brown bear populations. Like their relatives in Spain and the Canadian Arctic, these bears are well adapted to their local environment: in this case, an incredibly hostile treeless plain at 14,000 feet where a diet of sedges and whistling marmots makes life possible. My time here opened my eyes to

the passion that people from different walks of life have for bears.

The team of Pakistani men I was working with was a colorful bunch of committed conservationists, and despite being the only Westerner, I seemed to fit in well. Leading the team were two incredibly dedicated individuals: Dr. Anis Rahman, a dentist, and Vaqar Zakaria, a chemical engineer. These dynamic men had taken it upon themselves to find out more about the bears of the Deosai, the existence of which many people doubted.

On our first morning at base camp we walked up a nearby hill to survey the scene on the other side, not really knowing what to expect. Less than half a mile down the shallow valley in front of us was a female brown bear and two spring cubs! We were dumbfounded. It was immediate evidence of bear presence if ever I saw it. The experience proved to be a wonderful icebreaker, and I remember vividly the

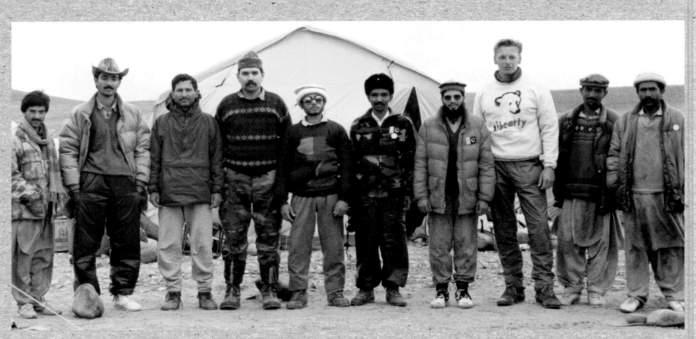

In 1994 I joined the Himalayan Wildlife Project team to help find out as much as possible about the mysterious brown bear of the Deosai Plateau in Pakistan.

dancing and hugging that followed our moment of disbelief. Cultures, religions, and nationalities united in a moment over the joy of seeing bears. It was another lesson about the power of these creatures to break down barriers among the humans who are inspired by them.

The work of this committed team in Pakistan triggered further scientific studies and even the establishment of a new national park—further evidence for me that bears were a potentially critical tool in the fight to conserve large areas of wild land.

What's Good for Bears Is Good for People

After working on my master's degree at the University of Durham in England, I spent time in two places that really highlighted the huge overlap evident between the needs of humans and bears: Ecuador and the Canadian Rockies.

Most bears need space—lots of space. In the case of a male grizzly bear in an inland North American ecosystem, this amounts to perhaps five hundred square miles, sometimes more. This means that bears make perfect "umbrella species": Protect them and you will incidentally protect countless other species of plants and animals that happen to utilize smaller areas within a bear's home range. Bears also function in two other ways ecologically: as indicator and keystone species. As an indicator species, bears provide a litmus test for the health of an ecosystem, and as a keystone species, they actually play an important role in maintaining that ecosystem's health.

Until I witnessed some of these qualifications firsthand, I wouldn't have given bears a second thought as representatives for conservation. But what I found in Ecuador and the Canadian Rockies spun my head as the possibilities became clear.

Ecuador is one of five South American countries to harbor the world's most ancient bear species: the Andean or spectacled bear. To this day, so little is known about this species that it remains as shrouded in mystery as the mountains of its cloud-forest habitat. I spent many months over the course of several years searching for a wild Andean bear, but the forest never revealed a single one.

Since it was clear that we could not rely on sightings as a basis for research, I designed a project that utilized local knowledge and the field sign that bears leave behind. In the case of Andean bears, clues include claw marks on trees, tracks, and even the beds that they create high in the treetops. With much collaboration and help from many colleagues including Luis Suarez and Francisco Cuesta of EcoCiencia in Quito, a wonderful project emerged that blended field research, environmental education, and employment opportunities for local villagers. The pieces of the conservation puzzle were falling into place.

In the Canadian Rockies I was honored to join a team put together by bear research and conservation guru Dr. Stephen Herrero. When he picked me up at the Calgary airport in 1994, I felt like I was meeting a rock star. But Steve's humility put me at ease, and he welcomed me into the giant experiment that was the Eastern Slopes Grizzly Bear Project. Here, in a famously busy valley along the Bow River, grizzly bears and people live alongside each other—not always effortlessly, but in a way that has become the front line for testing the limits of both bear adaptability and human tolerance for large carnivores.

The Canadian Rockies might *seem* like a haven for grizzly bears, but they are up against a suite of disturbances including oil exploration; golf course, ski resort, highway, railroads, housing developments; and forestry operations—all of which are occurring in the grizzlies' backyard. Not surprisingly, the scientific name for measuring the impact of this array of activities is called a "cumulative effects analysis." Anyone can envision the effect that a single human activity might have upon a bear population, but what happens when you add them all up and throw them at a population simultaneously? This was the question the project sought to answer.

Although I had assisted with bear capture work before, this was the first time I was involved with an intensive ground-based effort using foot snares, a simple foot-treadle device used to capture and tether a bear to a tree. "Weeks of tedium interspersed with moments of absolute terror," my capture team boss, the late Ian Ross, described it to me on the first day of work. He wasn't wrong. A grizzly bear can be so hard to capture that it sometimes seems like there are none around at all, but when you do succeed, all hell breaks loose.

Our study area in the Canadian Rockies provided the most vivid example of humans "coexisting" with bears. One day I was radio tracking a large male grizzly around the roads of Kananaskis Country, and the bear's signal led me to a nearby vacation resort. By the time I reached the golf course, the signal was coming in loud and clear. I realized that the bear was right next to the fairway, if not actually golfing, probably grazing on the lush grasses kindly provided by the resort. As I stepped out onto the golf course, three

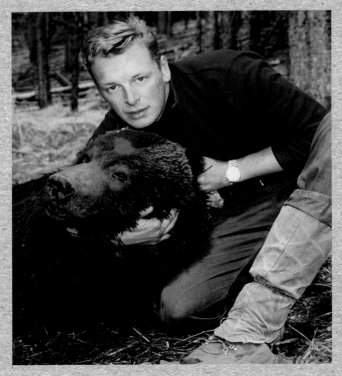

Fitting a radio collar to an anesthetized grizzly bear in the Canadian Rocky Mountains to learn more about the effects of human activities on their habitats, 1995.

golfers paused, one midswing, with a quizzical look.

"What ya doin?" one asked.

"Tracking a grizzly," I replied.

"Oh, up in the mountains is he?" the golfer gestured hopefully, about to resume his swing.

"No, just off the fairway."

I've never seen the 18th hole evacuate so quickly in my life.

With my good friend and colleague Dr. Hugh Robinson, I hiked nearly two thousand miles over two seasons, tracking grizzly bears through snow, heat, and knee-blowing terrain, piecing their lives together from the field signs that provided clues about their daily lives. We got to know the bears very well, but the bigger picture also became clearer: Conservation cannot succeed without a careful blend to meet the needs of both bears *and* people.

Digging out hundreds of pounds of earth from a collapsed grizzly bear winter den in the Canadian Rockies in 1995. We were happy to discover that the bear had pulled her radio collar off before exiting the den just in time.

In 1997 I moved to Washington State, where, thanks to my friend Joe Van Os, I developed a love for guiding expeditions into the grizzly and polar bear country of Alaska; Churchill, Manitoba; and Svalbard, Norway. I later began to teach ecology classes at Western Washington University and have worked to bring attention to the handful of grizzly bears that remain in the North Cascades on my doorstep here (see chapter 7 on conservation). This giant wilderness harbors fewer than twenty individuals, and their future is precarious to say the least. It provides the starkest contrast to Alaska that I can imagine. In the Cascades, even the discovery of a single track is very, very big news.

Very early on it became clear to me that bears, and the wild places that they represent around the world, need exposure. If we can't find a place for these majestic icons, what hope

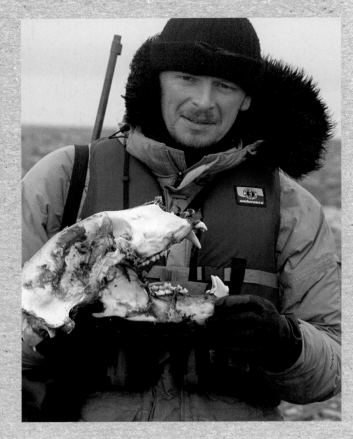

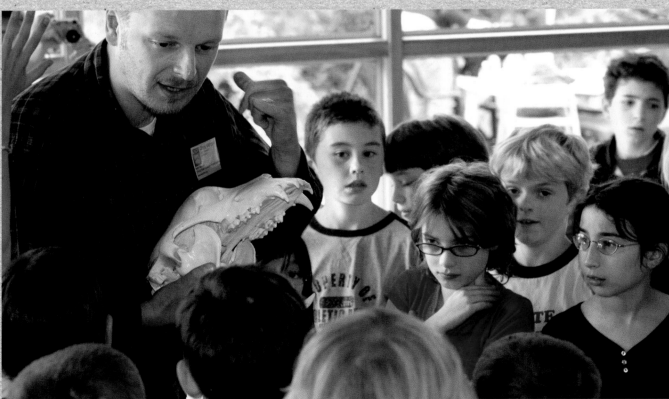

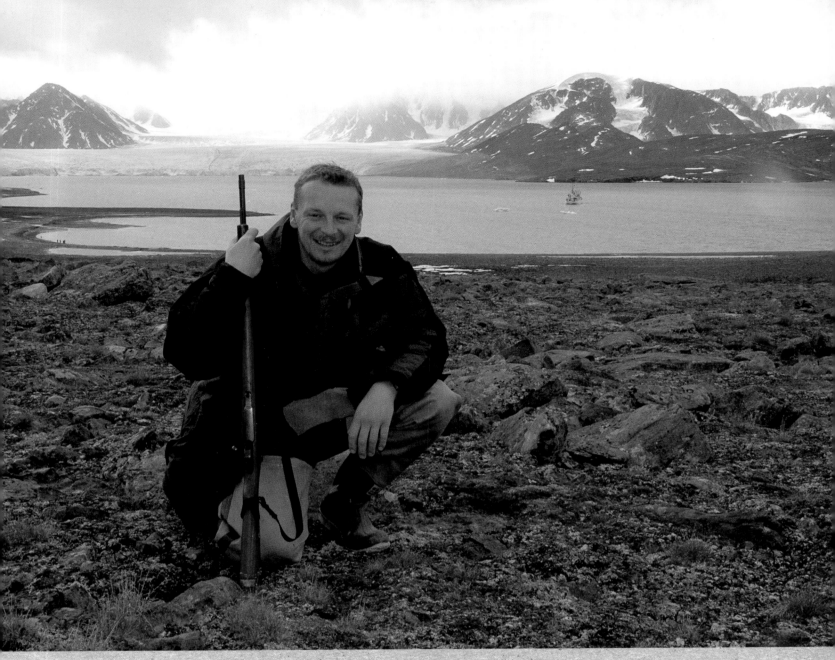

Guiding in Svalbard in 2006, on the search for polar bears in the beautiful
European High Arctic.

opposite, top I started guiding trips into bear country in 1997 when I moved to the
United States. I quickly realized how much I love sharing my passion with others
interested in wildlife. Here I am holding the skull of a polar bear that we found
during a trip to Svalbard in 2006.

opposite, bottom The more I learned about the endangered North Cascades griz-
zly bear, the more I wanted to help people understand these mythical creatures. I
cofounded the Grizzly Bear Outreach Project (GBOP) in 2001 to do just that.

do other species have? Not only that, but the incredible people who have committed their lives to bear conservation need funding and help too. This is when the potential for film began to appeal to me, starting with *BEARTREK*, the first film I was involved with, which is a "conservation story wrapped in adventure." This feature-length film and global campaign follows my journey by motorcycle to some of the wildest places on the planet to find bears and the people dedicated to saving them from extinction.

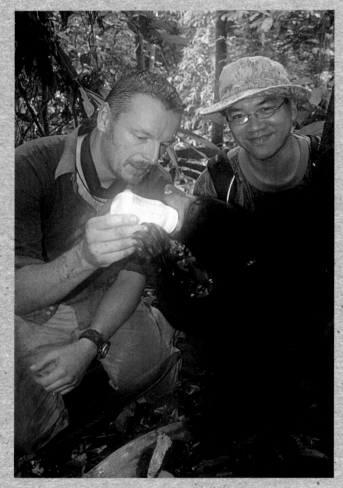

My experiences around the world exposed me to some incredible places, people, and bears. I wanted to tell their stories in a way that would draw people into the world of conservation. Here I am pictured with sun bear biologist Siew Te Wong and an orphaned sun bear cub during filming for *BEARTREK* in Malaysia, 2007.

For as long as can remember I have ridden motorcycles, and mine has become a tool of the trade. For years I've taken it on the remote forest roads of Washington State laden with camping gear, backpack, and research equipment in search of grizzly bears and wolves. There are few trailheads my bike isn't able to reach, plus it was always more fun getting there on two wheels. It's almost like saddling up and jumping on a horse for me. Later, featuring the bike on film was a natural step. Among the locations I visited for *BEARTREK* were Borneo, Peru, the Arctic, and Alaska—places where bears are on the front line of conservation.

BEARTREK also triggered the incredible journey to Alaska that is described in this book, and our work with PBS *Nature*, an organization that is deeply committed to wildlife conservation and beautiful storytelling.

And So, A Journey Through Alaska

And so our journey through the world of Alaska's bears begins. In many ways it is a culmination of the thoughts, ideas, and conservation steps I've taken since entering that world in 1987.

Alaska supports three of the world's eight bear species—polar, black, and brown/grizzly bears—and unlike many of the other places I have visited and worked in, they occur in some quite healthy numbers across much of the state. The local mountain range where I live in Washington harbors fewer than twenty grizzly bears in an area of 10,000 square miles, but I have seen as many bears along one two-hundred-yard-long stretch of Alaskan beach. The scale and numbers involved when talking of Alaska's

wild places and animals defy the imagination. And many parts of the state really do represent the world as it once was.

Joe and I immersed ourselves in bear country over many months during the year and a half that it took to film *Bears of the Last Frontier*. During this time I got to know these animals and their habitats even more intimately than I had anticipated. And I got to know the *real* bears, not those that are the stuff of myth, legend, and folklore.

The bears of Alaska, like their cousins elsewhere, persist and thrive in a wide range of ecosystems, from the wildest, most isolated parts of North America in the mighty Brooks Range to the city parks of Anchorage. They wander the sea ice to Russia and through the thick, forested ecosystems of the taiga, and in every one of these locations they have adapted impressively to their surroundings.

Alaska's wilderness allowed us to step back in time, to a place where mountains, bears, wolves, and caribou dominate the land and a place that is no kinder to a person than it is to a bird or a bear. Alaska has a tendency to level the playing field and punch the ego out of you . . . bear country makes you humble.

During our expedition across Alaska, Joe and I traveled more than 3,000 miles by road and many more by helicopter and plane. The journey took us through five major ecosystems and the habitats of all three bear species that Alaska supports. We met gold miners, Alaskan Eskimos, hunters, biologists, writers, photographers, bush pilots, fishermen, skippers, and lodge owners. Our aim was to reveal the real lives of bears in a place that is still wild enough to accommodate them.

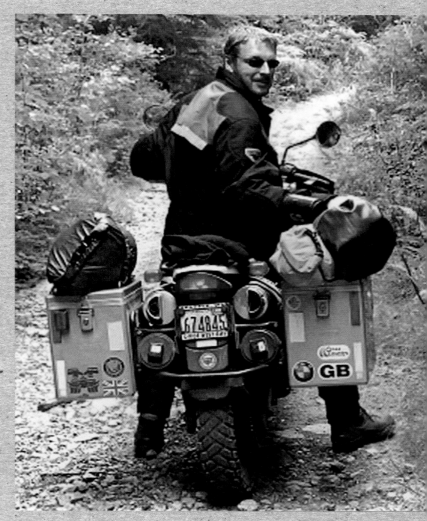

I bought my motorcycle in 2001, and my two-wheeled exploration of bear country began in the North Cascades of Washington State near where I live.

It was also a journey that put us to the test as we hiked, camped, and lived among the biggest bears in the world, chased black bears through the streets of Anchorage, followed grizzlies on the prowl for immense caribou herds, and searched for polar bears across huge expanses of pack ice. Together we set out to discover what it takes to be a bear in North America's last frontier—Alaska.

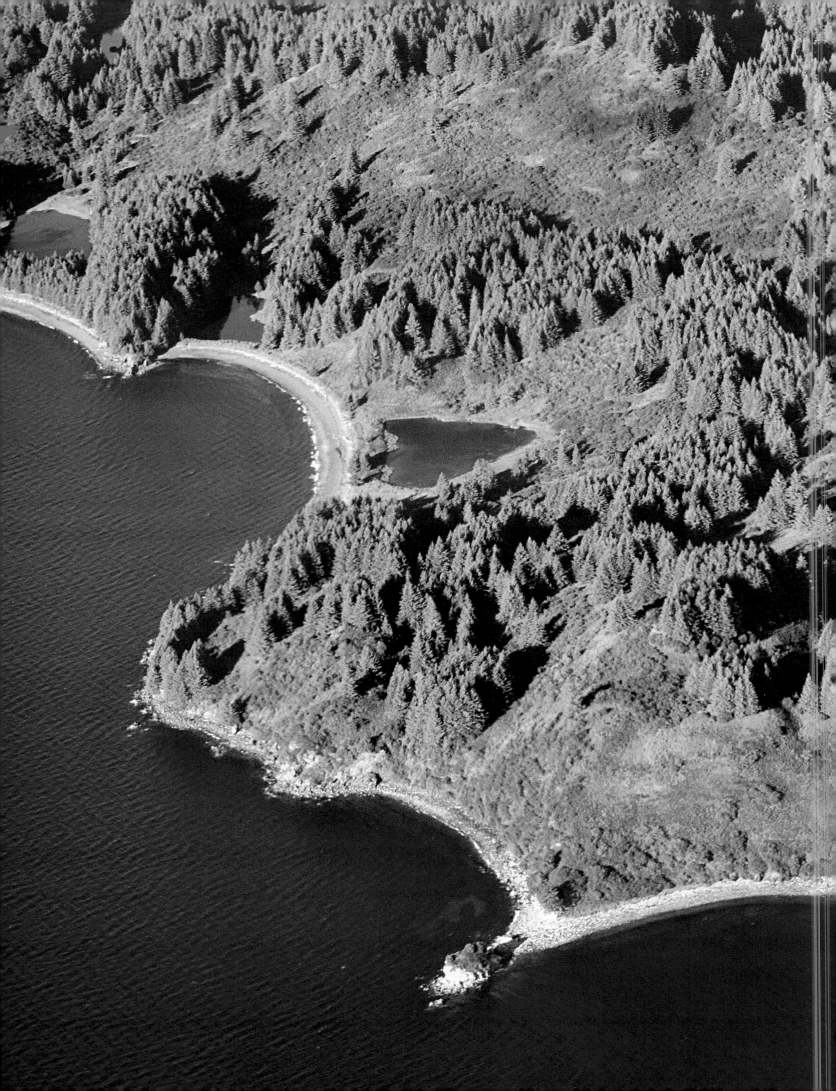

ONE

GIANTS OF THE ALASKA PENINSULA

If I Were a Bear . . .

The Alaska Peninsula is a special place. If I were a bear, this is where I'd want to live. It's as close to paradise as it gets for a large mammal that demands space and plenty to eat. In this isolated region of southwest Alaska the Pacific Ocean delivers rich nutrients to beaches and estuaries that feed verdant coastal sedge meadows. These in turn give way to a spine of volcanoes that stretch nearly 500 miles along a coast that has changed very little in thousands of years. It's the perfect backdrop for a "city of bears."

From the very moment you set foot on the beach here you are in bear country. Around 9,000 of them live on the Alaska Peninsula. In fact, there are so many bears, and the

place feels so wild that it offers a rare opportunity to step back in time, to a landscape that still feels like the Pleistocene of 1.6 million to 10,000 years ago when dire wolves, mastodons, and giant short-faced bears roamed. But more than that, it is the emotional recalibration that draws me back to this place every year. In 2001 I began guiding small groups to this coast to experience the pure magic of bear country as part of an operation run by my friend John Rogers. It is a place that effortlessly reminds you of your own fragility and insignificance. It's a place where you can feel all at once in tune with the natural world and completely irrelevant.

In places, the white beaches and turquoise waters could be mistaken for the Caribbean, but that's where the similarities end. Volcanic mountains rise from the sea as testament to past geological violence. This was the site of the twentieth century's largest eruption and one of the five largest volcanic eruptions in recorded history. When the Novarupta volcano blew in 1912, it darkened the city of Kodiak for three

page 14 The Alaska Peninsula coast is beautiful and isolated and the perfect backdrop for one of the densest populations of brown bears in the world. We were to spend an incredible nine weeks among the bears in this one place alone.

One of our base camps was located here at the edge of an enormous sedge meadow. We found the perfect place to camp, with great views of the sedge meadows, beach access for safe cooking away from our sleeping area, two flat areas of sand for tents, and within a two-mile hike to the area with main bear activity.

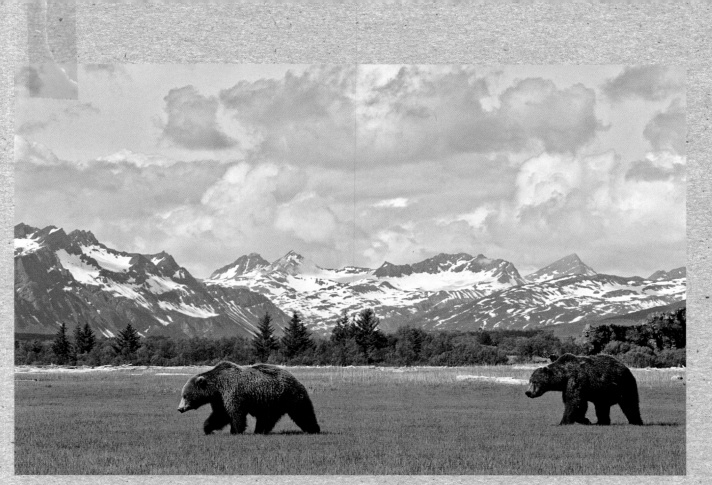

A large male pursues a female across a sedge meadow during the breeding season in early June.

days and released six cubic miles of ash over an area of forty square miles. Some of the ash deposits were 700 feet deep.

When I'm here, in bear country, all sense of anything but the immediate moment leaves my mind, and I drift into a focused single-mindedness to stay careful, alert, safe, and respectful of the wild place I'm entering. The Alaska Peninsula delivers this feeling at maximum dosage. The clutter of everyday life melts away and things become simple again. This is the bears' world. It is almost as though the uncomplicated life of the bear rubs off on you and your mind is able to think swiftly and clearly. The place has a way of taking your mind back in time.

At every turn there seems to be a bear, and that's why we chose this part of Alaska as our first location. Although the same species (*Ursus arctos*) as their grizzly bear cousins dwelling inland and along the Arctic, these coastal brown bears differ in several ways. But it mostly comes down to size. A large male can weigh in at 1,500 pounds, double the heft of even a large grizzly. Quite logically, the size of a bear partly depends upon diet, and the enormous differential in coastal brown bears comes down to access to an abundance of calories in the form of salmon and the occasional washed-up whale carcass. On a good day, a bear on the Alaska Peninsula can consume 25,000 calories—about the equivalent of ninety Snickers bars, or fifty personal-size pizzas for a human.

We timed our arrival to coincide with the peak of mating season in June, well before the arrival of the year's first salmon. June is a time when great numbers of bears gather to make the most of the lush emerging sedges (which are surprisingly packed full of protein) and the simultaneous

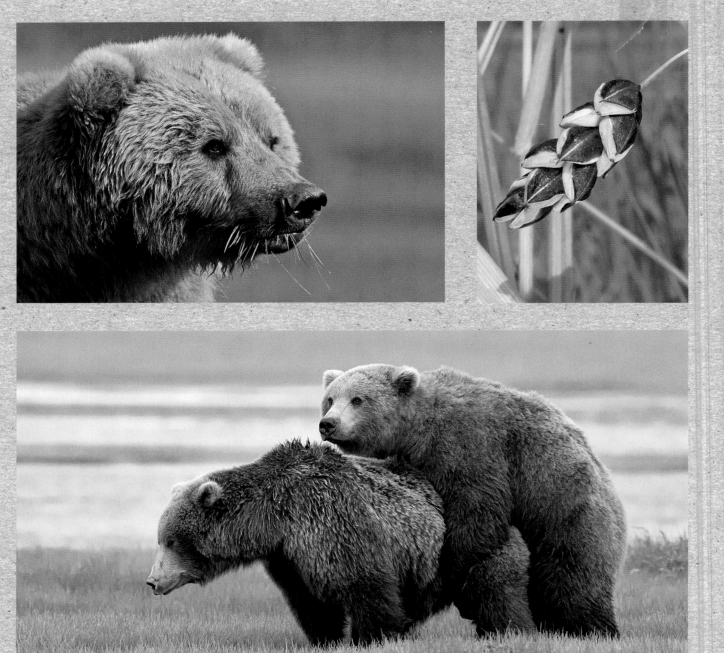

The meadows become very active in June, with complex rituals emerging among the brown bear population to determine which individuals will have the opportunity to mate.

top left Many people are surprised to hear that a significant part of a bear's diet is made up of vegetation, including grasses, sedges, berries, and roots. Large molars enable them to grind cellulose effectively. But no matter how preoccupied with grazing, bears in this environment are ever watchful for other bears—as targets for mating, competitors to confront, or individuals to avoid.

top right The humble sedge plays an important role in the life of a bear. Much of their grazing is focused on sedges, which are packed full of protein.

opportunity to find a suitable mate. Bears are usually considered quite solitary animals, but that becomes hard to believe when surrounded by a dozen or more individuals at this time of year. While camping in various bays that I was familiar with along the coast, our sense of complete immersion was very real. We strung electric fences around our tents and used barrel-size bear-resistant food containers for our provisions, and it became completely normal for us to spot bears before we had even left our tents in the morning. As the weeks passed I became very much at home in this surreal setting.

A complex dance plays out among the bears during the breeding season. It takes many days of observations to interpret accurately, but even then much of the behavior remains mysterious. It is also a time to see new generations of bears as mothers introduce six-month-old cubs to the social life of the coast and the many dangers that lurk there. Born in the safety of the winter den, these "spring cubs" or "cubs of the year" (COYs) must feel a sense of excited bewilderment as they venture out into the world for the first time under the watchful eye of their ever-present mother. We were privileged to spend

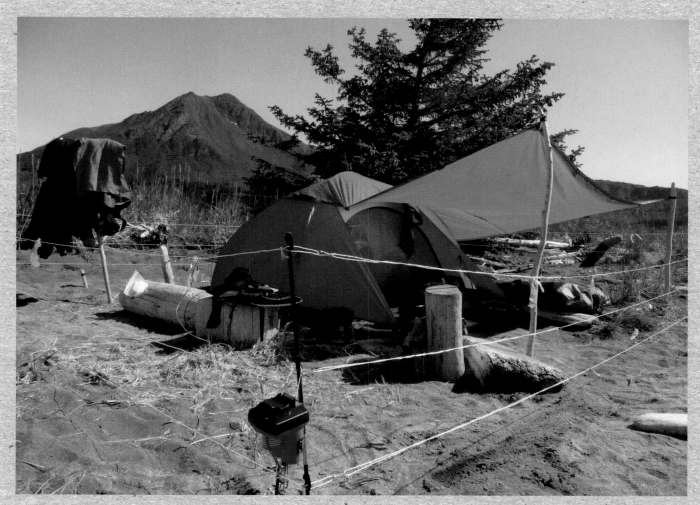

The electric fence around my tent was specially designed for use in bear country. It delivered a brief 6,000-volt surprise to any bear that wanted to check out my belongings, and it provided great peace of mind for me.

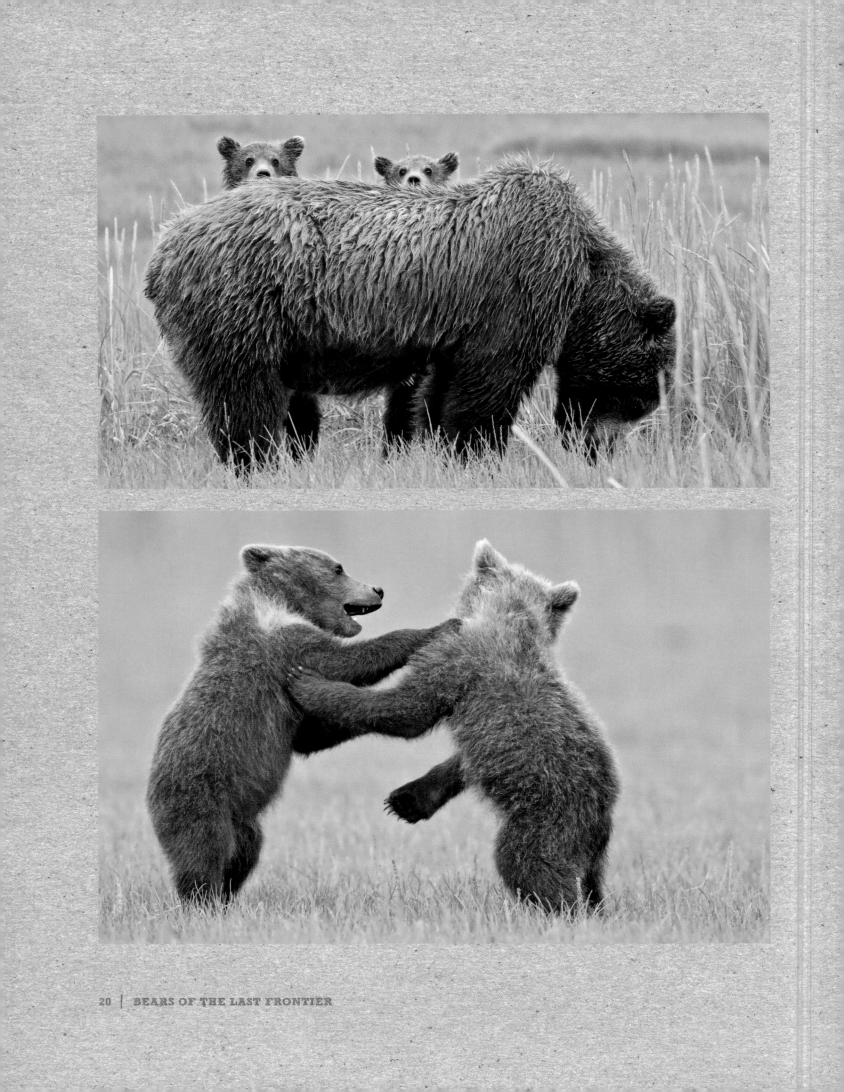

time observing and filming one female with spring cubs for a period of several weeks. During this time the youngsters evolved from being overly preoccupied with the curious-looking bipeds to completely ignoring our presence.

Once this season of intricate mating rituals and family dramas is over, a period of calm comes to the peninsula—but not for long.

The second wave of excitement begins along the coast as early as late June with a very special homecoming. The annual return of salmon brings life to coastal Alaska in more ways than one. For me, it is the most exciting time to be among the bears as they charge through rivers giving chase to giant fish. The energy is electric as the bears sense a time of plenty, but also the urgency to replace some of the many calories burned during the mating season and begin gaining weight in preparation for winter denning.

At this time of year a large bear can consume twenty or thirty ten-pound salmon in a day, becoming exclusively focused on this essential source of fat and protein. The salmon also bring with them a very real source of nourishment to this verdant coast in the form of nitrogen and other nutrients from the marine ecosystem to replenish habitats.

When the salmon runs begin, the bears voraciously wolf down every morsel, eagerly consuming this new source of annual fat. Male, female, big, small—any fish will do, and every calorie is welcomed. But as the weeks pass their palette becomes a little more discerning. A bear can smell a fish underwater. But more than that, many bears can actually choose which one is worth the chase, because in fact not all fish are created equal. If you're a coastal brown bear

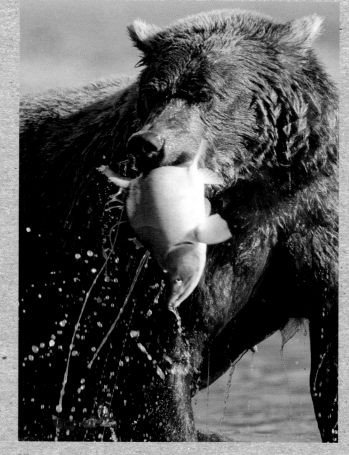

When the annual salmon runs return each year, the bears shift to a diet of fish almost overnight. This female brown bear has caught a pink salmon and will likely consume the entire fish. Later in the season bears tend to become more choosy, selecting salmon eggs, skin, and the brain for the best sources of fat and protein.

opposite, top During our time on the Alaska Peninsula we got to know bears as individuals, and some very distinct personalities emerged, especially among the cubs. Here, two spring cubs, or COYs (Cubs of the Year), take cover behind their grazing mother.

opposite, bottom From an early age, bears show clear signs of competitiveness. These sibling cubs are only around six months old, but already they enjoy frequent bouts of wrestling and games of chase, behavior that will endure into adulthood.

trying to pack on the pounds, it's the fish laden with the most fat that you want. So, when caviar is up for grabs, that's what you grab. The quickest way to a 25,000-calorie day is fat-rich eggs, delivered conveniently by female salmon returning to spawn. And it is truly remarkable to watch a bear nosing the air, searching a stream thick with fish, and then exploding into a chase with a single target in mind. The energy quickly spreads among the bears, especially the subadults that are trying their hand at fishing solo for the first time.

At times a bear's chase would culminate just feet away from us and the end of Joe's camera lens. It's tough to tell who is more surprised in these cases as the bear raises his head, fish flapping furiously in his jaws, to find us staring at him, eyes wide as saucers.

As the salmon season progresses, changes are under way. The bears gain so much weight that they have to dig holes in the sand to accommodate their giant bellies. And now they can afford to be choosy. After catching a fish and vacuuming up the eggs, they strip the oily, fat-rich skin from the salmon, bite off the brain, and let the remaining perfect salmon fillet float away downstream much to the delight of the scavengers below them in the pecking order. Kittiwake gulls, foxes, bald eagles, and even wolves all benefit from the choice "scraps" the bears leave behind. In fact, the whole ecosystem remains healthy and whole here due in large part to the bear-salmon relationship. Tree growth depends upon nitrogen, and in ecosystems like this almost 20 percent comes from salmon, and more than 80 percent of this is delivered to the landscape via bear urine and scat. This fish fertilizer and the leftovers that remain from fish dragged

ashore by hungry bears make for healthy plant growth. It also makes for a smelly hike as the entire coastline seems to reek of fish, and I begin to swear I'll never eat another salmon again.

As the salmon runs finally fade each year, usually in mid to late September, bears are seriously preparing for the next major event on their calendar: winter sleep. Bears need adequate fat supplies to see them through this annual physiological miracle, and the sense of urgency among them is palpable. You can see it in their faces.

Clams are a favored diet item for bears along the coast, especially in the spring before the salmon arrive. Bear claws make very effective excavation tools on the beach, or in the hills while digging for roots.

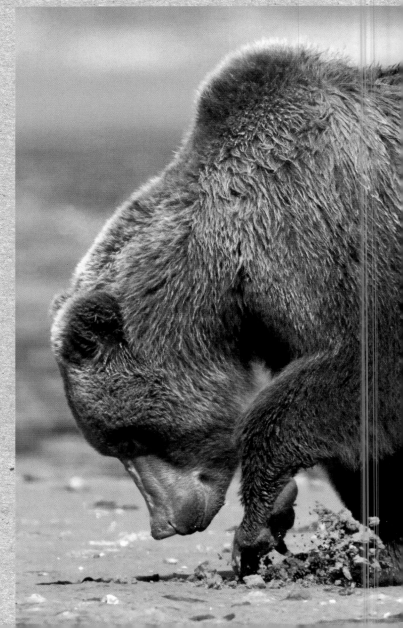

It is a particularly critical time of year for those females that mated in the spring, as they need to enter their winter den in top physical condition to pull off the demanding task of motherhood. One theory suggests that females that have *not* accumulated sufficient fat will reabsorb fertilized eggs, canceling full pregnancy before it begins. This system helps to ensure that only adequately healthy females take on the role of feeding and raising cubs. They accomplish this through "delayed implantation," whereby eggs are fertilized during the mating season in the spring but do not implant in the uterus wall to begin proper pregnancy until the late fall, by which time it is clear if the female's fat stores are sufficient to sustain her *and* her cubs-to-be. If she is not fat enough, egg development goes no further. Delayed implantation may also allow females to postpone embryo development until food sources are more plentiful later in the season.

It is easy to understand why a system like this is important when the true pressures of being a mother bear are understood. First, she gives birth to her cubs (litters of one to three, with twins being most common) in December or January, midway through her period of winter sleep. At this point she may be burning through 4,000 hard-won calories per day from her fat reserves. The milk she immediately starts to provide for the ravenous youngsters contains 33 percent fat and around 13 percent protein (in comparison, cow's milk contains, on average, 4 percent fat, around the same as that of humans). In addition, she may lose 40 percent of her overall body weight during her six-month denning period, a time when she depends solely upon the weight gained prior to denning (bears do not eat or drink during almost seven months of winter sleep).

The physiological stress that this places on mother bears is unimaginable. But at this point the commitment has only just begun as the cubs will remain under their mother's watchful eye for three and a half years, sometimes four and a half, if they survive the 50 percent mortality rate of the first year. During this time she ensures their safety among threatening males and continues to nurse. Even though they are close to being weaned, I've watched three-year-old cubs, two-thirds the size of their mother, belly up for a free meal.

The social dynamics are so complex in a place like the Alaska Peninsula that my friend Brad Josephs and I have wondered if females occasionally keep cubs with them longer in order to ensure that their young are adequately prepared for life in this busy ursine community. Also, perhaps such a high density of bears demands extra caution. A female does not breed again until she separates from her cubs, which makes it easy to understand why female grizzly bears become notoriously defensive of their cubs. Each is protecting her investment.

In early September, the fall weather begins to close in and our nine weeks of filming on the Alaska Peninsula come to an end. It is an experience I will never forget. I've been coming to this part of Alaska for many years, but I've never had the opportunity to immerse myself in the ecosystem as I did during this journey. Camping and living among these creatures has taught me how little I know, and it has also reminded me how precious these wilderness gems are— the last wild places on earth, represented perfectly by the wildest creatures I know and love.

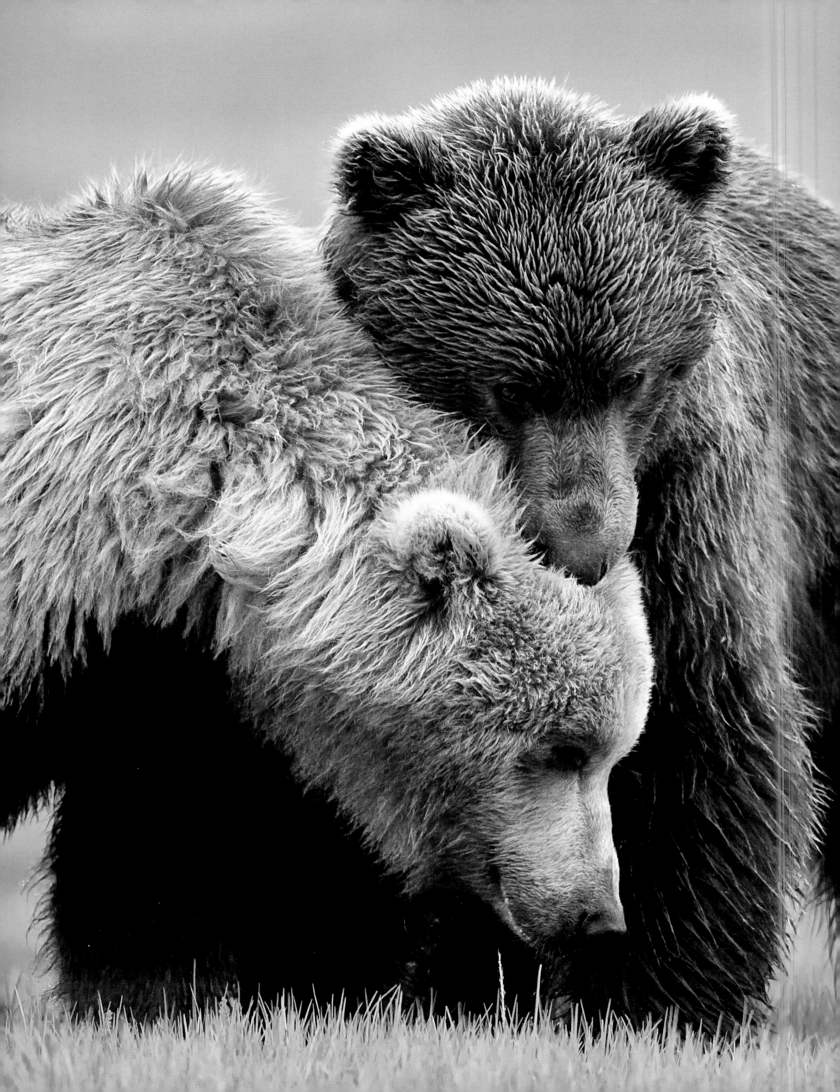

Journal Entry, Alaska Peninsula

Part I: The Mating Game—
Brown Bears on the Alaska Coast

I thought courtship was complicated for *people*, but not any more. I've watched the brown bears play the game for over a month now and I'm beginning to think we have it easy.

It seems to be all about bravado for the boys and playing hard to get for the girls. Include a little bluffing, a copious amount of scent marking, and the odd scrap, and the scene is beginning to look like something you'd see in a pub. It has been a busy month for the bears, and for us too. Trying to keep up with the action has been intense. But with base camp just a mile and a half from the main meadow, we've had a price-less front row seat. It is particularly rewarding as most of the behavior is new to me. I've never seen so many bears all in one place at one time—sometimes there are fifteen or twenty on the sedge meadow, the main gathering place that I have nicknamed "the love zone."

When we first arrived on the scene, it all appeared quite innocent. A mass of bears milling around, and all of them busily grazing sedges. But every one of them seems to have a glint in their eyes, and something else in mind.

In this setting it is easy to forget that bears are generally solitary animals, but watching more closely, I've observed the dozens of little tricks and signals they employ to avoid nasty confrontations with each other. They will do almost anything to avoid a brawl, using all kinds of body language including ear position, head movement, hip swagger, jaw popping, huffing—all effective communication devices for a bear. Now, during the mating season, it pays for every single bear to be fluent in the art of communication. This is evidently no place for a rookie.

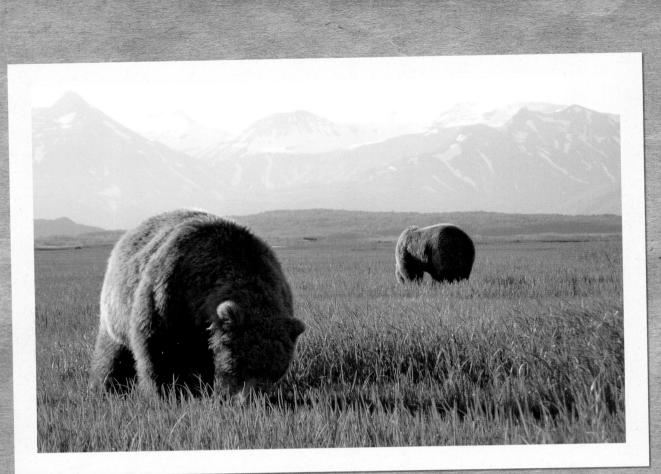

Two young bears busily grazing in an area that I coined "the love zone." Much of the time bears were genuinely focused on eating, but at times, when large numbers of bears made the dynamics between them uncomfortable, the grazing became an interesting form of displacement behavior.

page 24 A young male and female bear nuzzle in what appears to be a very affectionate way. There are so many different interactions occurring at any one time on the sedge meadows during breeding season that it can be quite difficult to keep up with the action. Subadult bears (not quite adults, but no longer with their mother) interact a lot and especially like to engage in play fighting.

A pattern emerges on the meadow that has had me transfixed. The bears enter the scene over a giant log pile, pausing as if walking into a saloon and assessing the competition. Some bears scatter, while others quit munching momentarily to size up the newcomer. The biggest males confidently resume grazing while the intermediary bears leave the scene quietly, gingerly looking over their shoulders in the hope that the females weren't watching them retreat.

Pushing through the "saloon doors," a giant male entered the scene today and every female looked up. They all seemed to be trying to catch his attention, coyly turning in circles before sitting on their rumps, and wandering back and forth toward and then away from him in the hope that he might follow.

The big fellow had an air of supreme confidence about him, and he immediately pulled out some of his best moves to impress his competitors, starting with a bear's typical cowboy swagger. Elvis, eat your heart out. The hip gyrations on this guy caught everyone's attention, including another large male that was already copulating with a female. His female glanced toward the handsome newcomer, and paid for it with a jealous bite on the ear from her frustrated mate. She let out a growl of pain and sure enough, Elvis clocked the commotion and came shuffling over as fast as his swagger would allow.

There's only one thing that makes a male bear more attractive than the hip swagger and that's when he urinates all over his feet to spread his scent as widely as possible with each stride. Yes, this guy really knew what he was doing. Walking his scent all over the meadow certainly got some attention and put the other males on notice. Females took note left, right, and center. Only one thing stood between him and his chosen female: the male that had already claimed her.

Suddenly, the action turned from slow motion to quick draw: in an explosion of power and testosterone the clash of the titans thundered before us. One of the males swung such a forceful left hook that all four paws left the ground for a second. Definitely no small feat for a thousand-pound lover. Teeth, claws, saliva, muscle, and flying fur—it was like a small bomb went off in the middle of the wilderness. The female frantically circled the battling males just three feet away like a tiny referee, scoring the fight, psyched at the idea of leaving with the winner. Wads of fur flew, backlit by the evening sun, and then, just ten seconds after the first punch was landed, it was all over. It was as much as either of them could take. The behemoths separated, exhausted and breathing heavily, standing on all fours just ten feet apart, heads held low. Slowly, the newcomer turned to walk away without pausing for a moment to look over his shoulder. He was the new champ.

In the bear world, only the winner has the confidence to do this; it is a key piece of body language. The female fell in behind him and left the scene with her new male.

I finally took a breath and turned to Joe, who was filming beside me. "Did you get that?" "Yup," he replied with a grin.

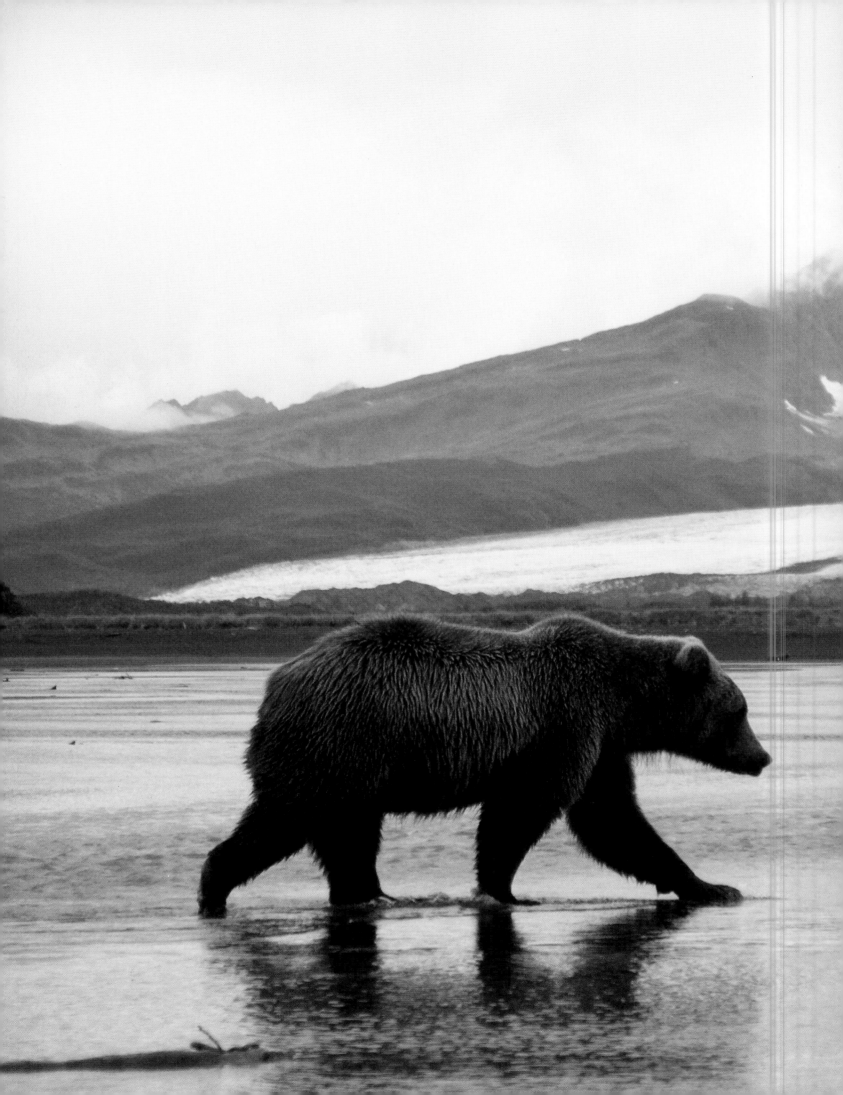

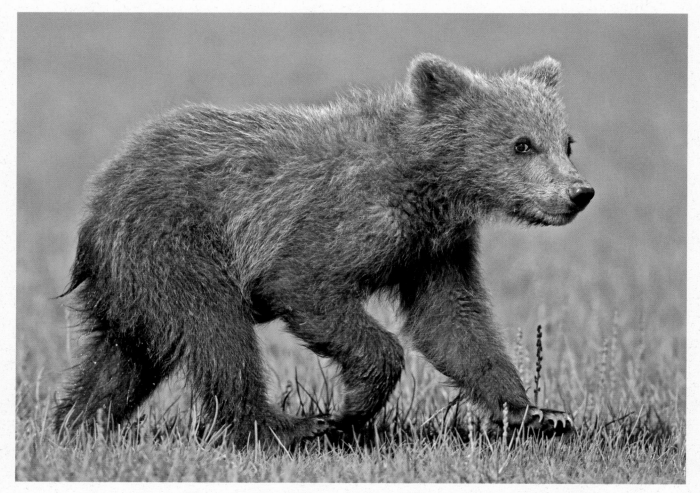

Spring cubs have to be extremely careful out in the open meadows, especially early in the season when they first emerge into the "social scene" with their mother. It is not uncommon for adult males to kill young cubs. Mortality among cubs in their first year of life can be as high as 50 percent.

previous pages Coastal brown bears gather in unusually large numbers in this part of Alaska. as the habitat is highly productive. Look closely at this photograph and you will see at least ten bears gathered to feed on the first salmon run of the season.

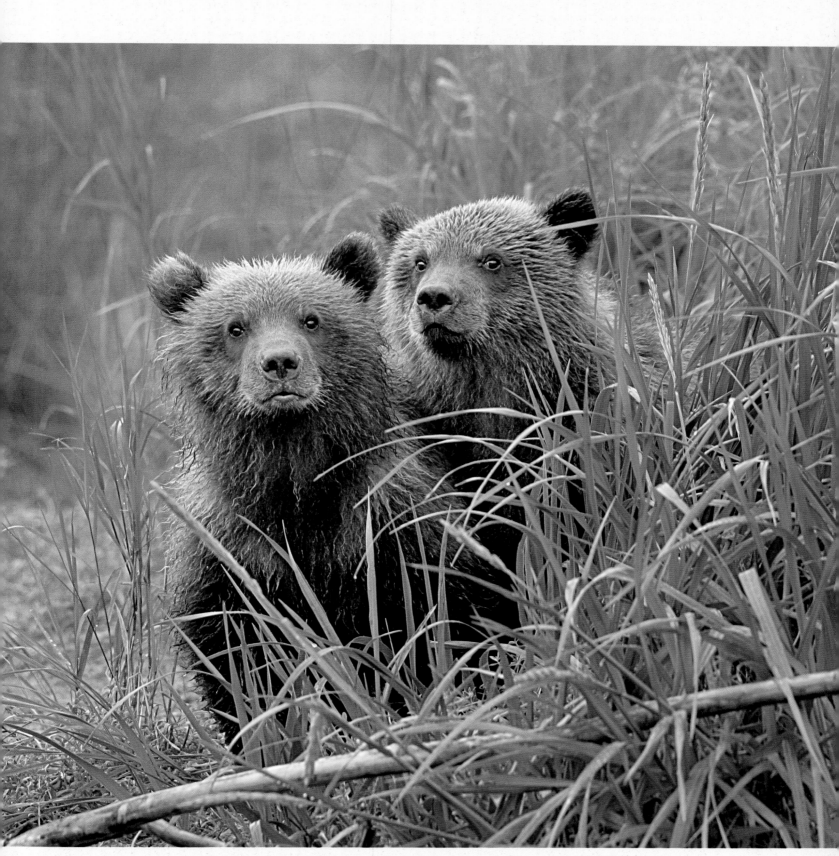

Despite the playfulness of cubs—especially young ones—they become deadly serious when necessary. In this case their mother left them on the riverbank while she went to fish. You can almost see the concern in their eyes as they try to keep a low profile among a dozen adult bears.

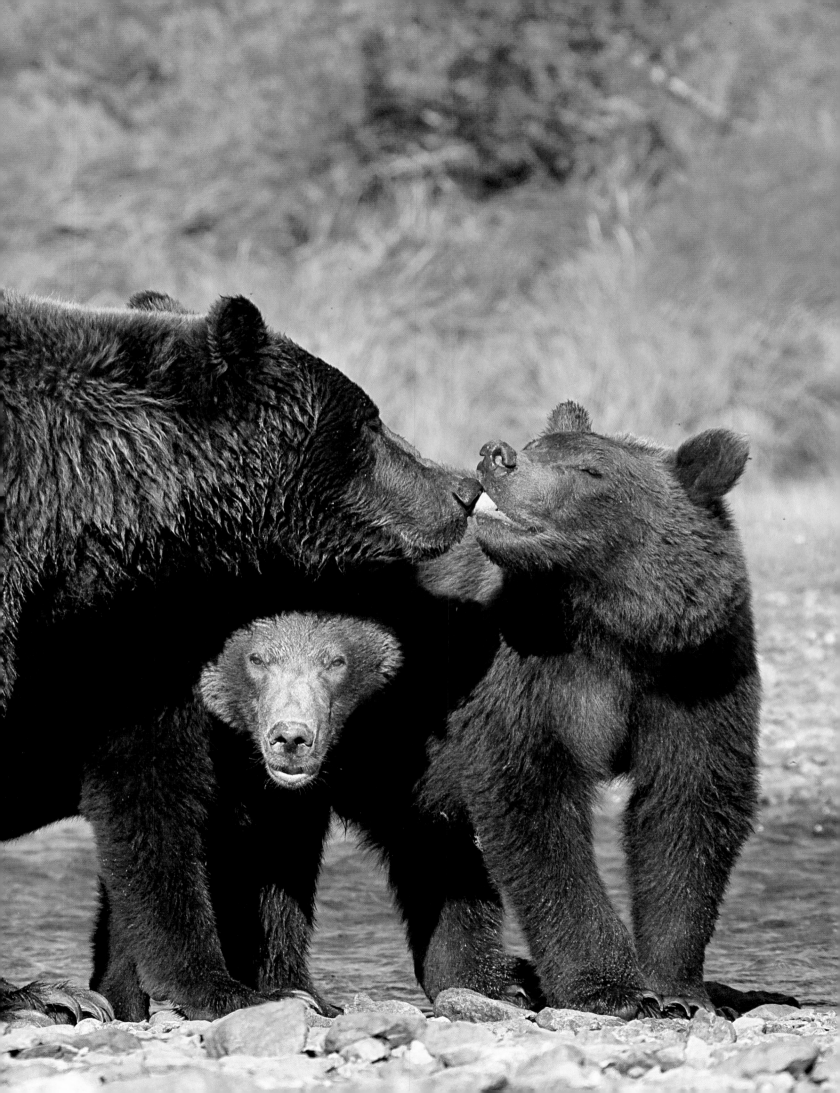

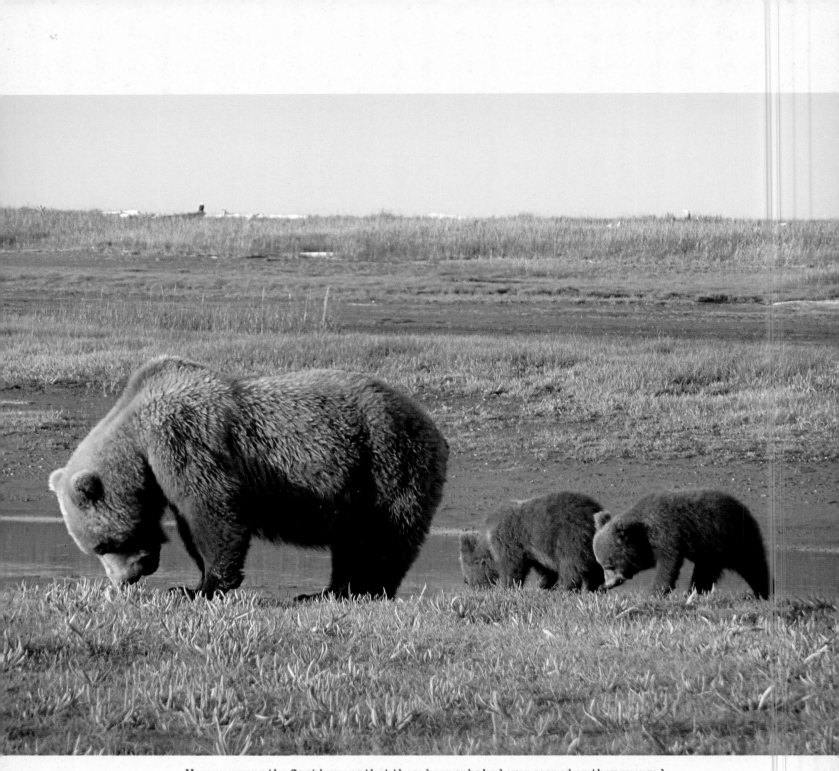

We were among the first humans that these bear cubs had ever seen when they emerged on the meadow in late June; it was a privilege to watch their mother "teach" them that we posed no threat. Initially they were very cautious but after several weeks they became completely carefree and would play for hours in front of us. At times like that I wouldn't want to be anywhere else on earth.

previous pages Females and cubs have exceptionally strong bonds. For three and a half years they eat, sleep, and den right next to each other until the female is ready to breed again, at which point she makes it very clear to the cubs that they are no longer welcome. That must be a *very* confusing time for the cubs.

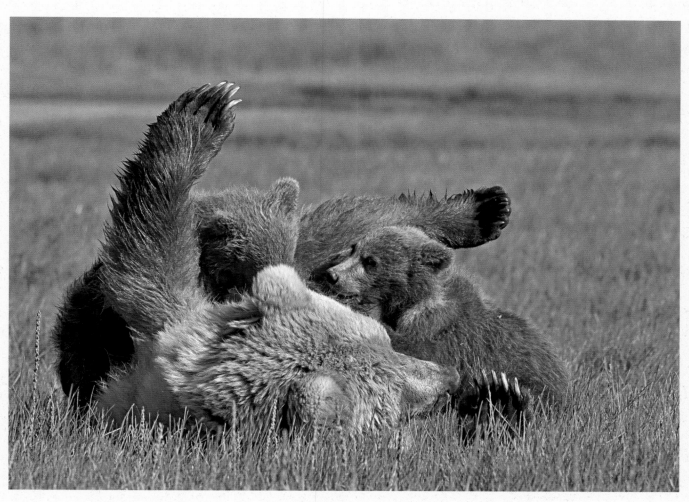

It is a certain sign of her comfort with us when a mother bear nurses her cubs nearby. But she remains watchful for males that may threaten her cubs.

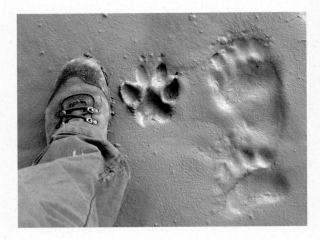

It is a rare thing to find brown bear and wolf tracks alongside each other, but here on the Alaska Peninsula we ran into them all the time. For me, this photograph encapsulates just how wild this place is.

right This incredible photograph, taken by my friend Brad Josephs, captures a wonderful moment when a wolf approaches a female brown bear. These species are quite used to each other in this area, but opportunities to photograph this type of interaction are very rare. Brad has spent more time among these bears during his many years of bear-viewer guiding than anyone I know.

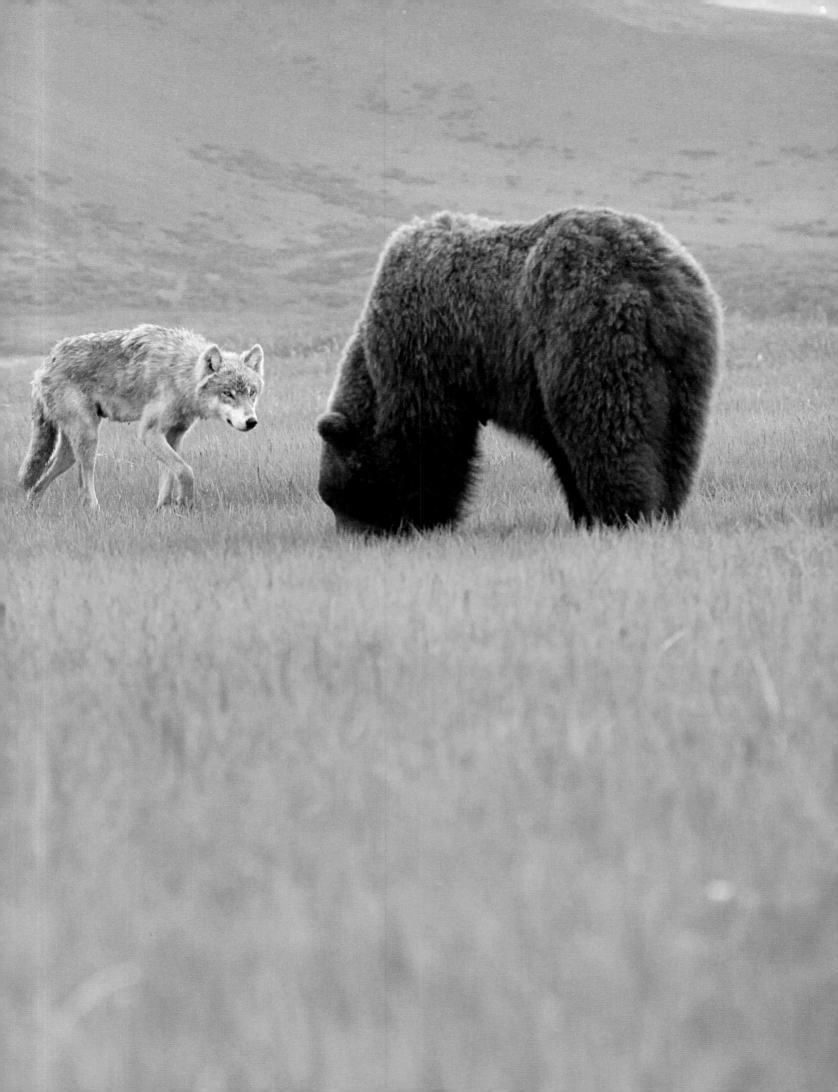

Our experiences with the wolves of the Alaska Peninsula were incredible. Here, a wolf howls from one of the rocky promontories frequently used as a safe haven by female bears with cubs.

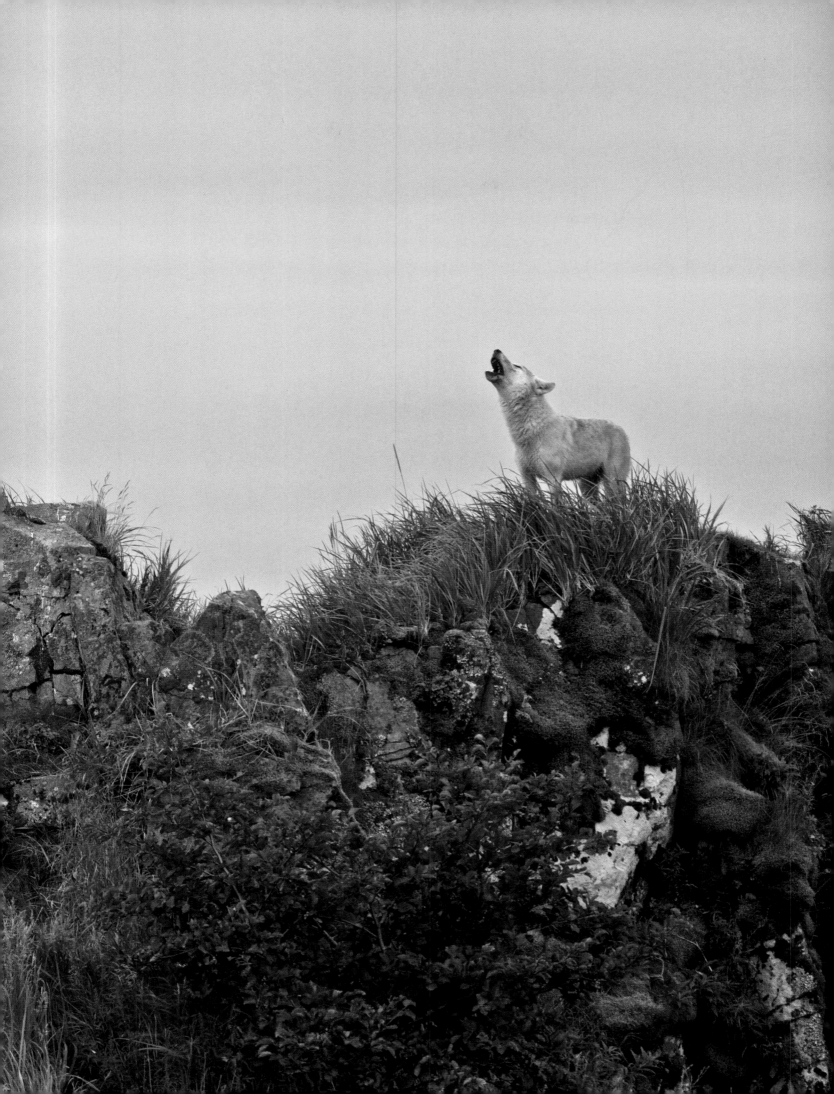

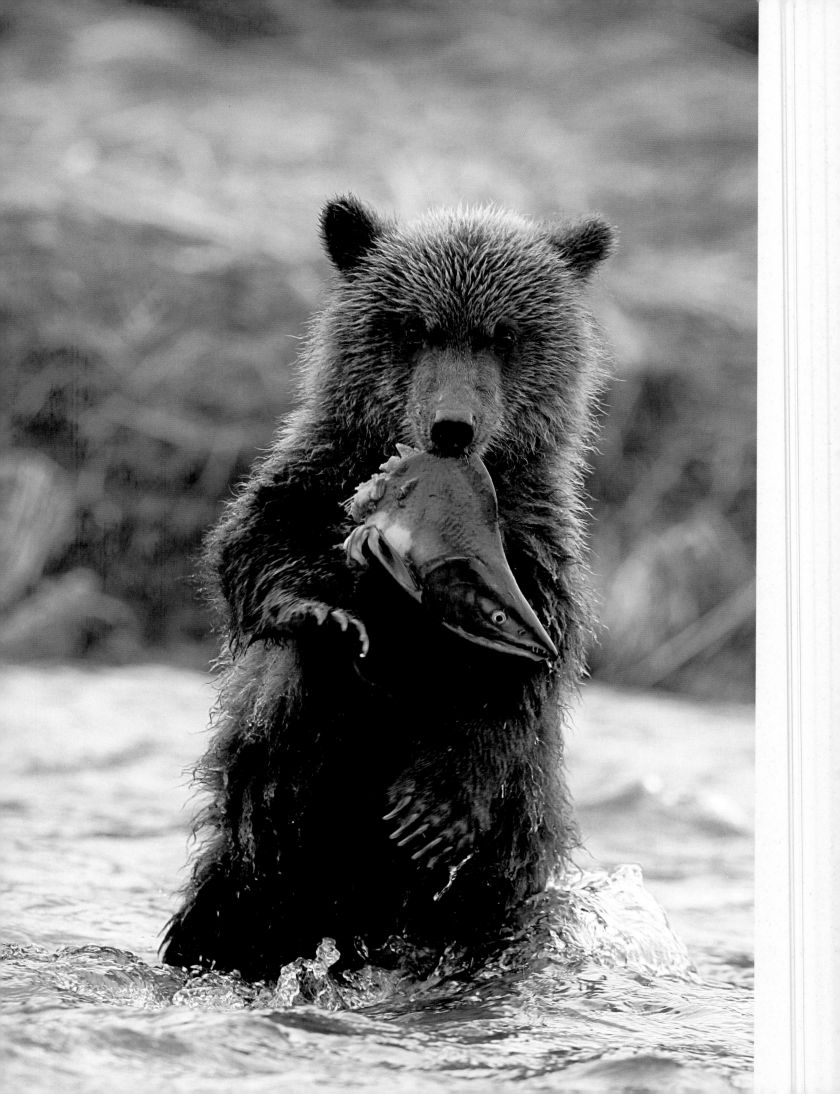

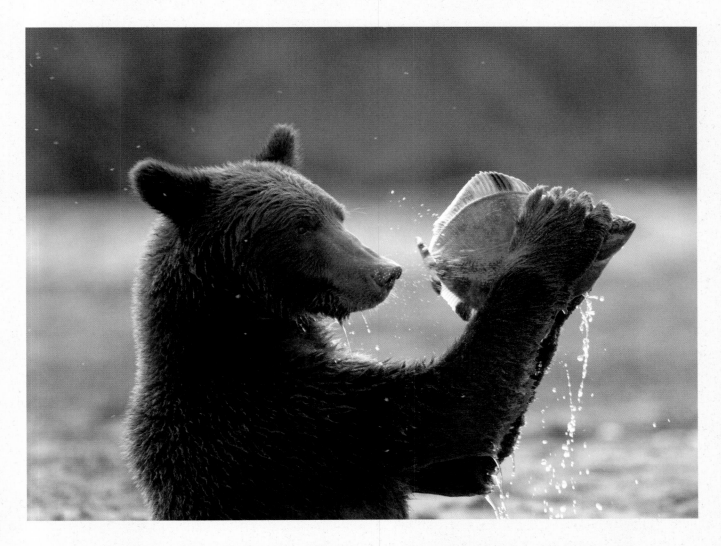

Some young bears need time to get up to speed with fishing. We watched this sub-adult successfully catch a fish—not a salmon but a flounder. He puzzled over what to do with it for a while before crunching on it and realizing there wasn't much meat to be had.

opposite Cubs learn about all aspects of life from a very young age. Here, a spring cub tests his skills with the remains of a pink salmon.

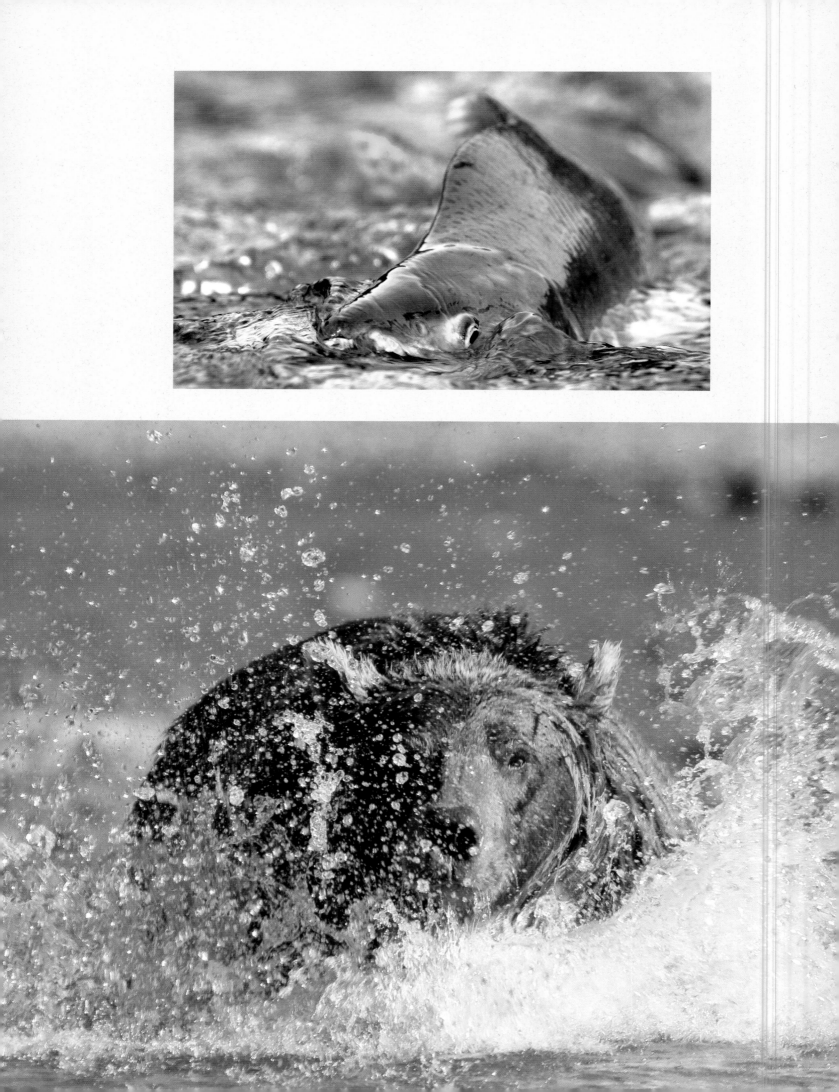

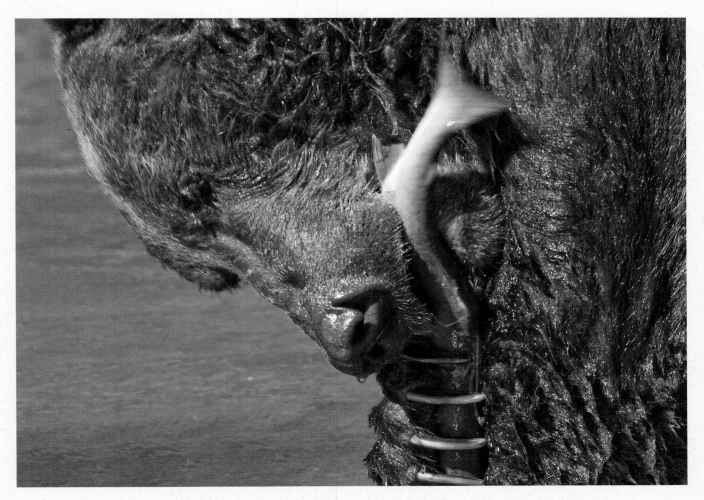

Another successful catch. Bears are smart consumers and will readily vacuum up the fat-laden eggs from the female salmon. A few of them are visible in this photograph.

opposite, top The relationship between the salmon and the bear is an important one on the Alaska Peninsula. Salmon, when eaten, deliver marine nutrients to the terrestrial environment in the form of bear scat and fish carcasses. The nitrogen and other nutrients fertilize coastal and riparian (riverside) ecosystems that, in turn, continue to provide healthy, vegetated habitat for both bears and salmon, and countless other species too.

opposite, bottom The energy among the bears during the salmon season is electrifying. There are times when you don't know which way to look as bears thunder across rivers in pursuit of fish in every direction. The bears are visibly agitated and excited about the return of this annual influx of calories and sometimes become a little overenthusiastic. One day I saw a male bear pounce on one salmon, then crouch down to consume it, but before the bear could do so, it slapped its front paws on two additional salmon for a total catch of three. This incredible photograph was taken by my friend Chris Weston, and it beautifully captures the strength, speed, and power of a determined bear.

overleaf With intense focus, a male bear on the Alaska Peninsula heads toward a fertile female during the breeding season.

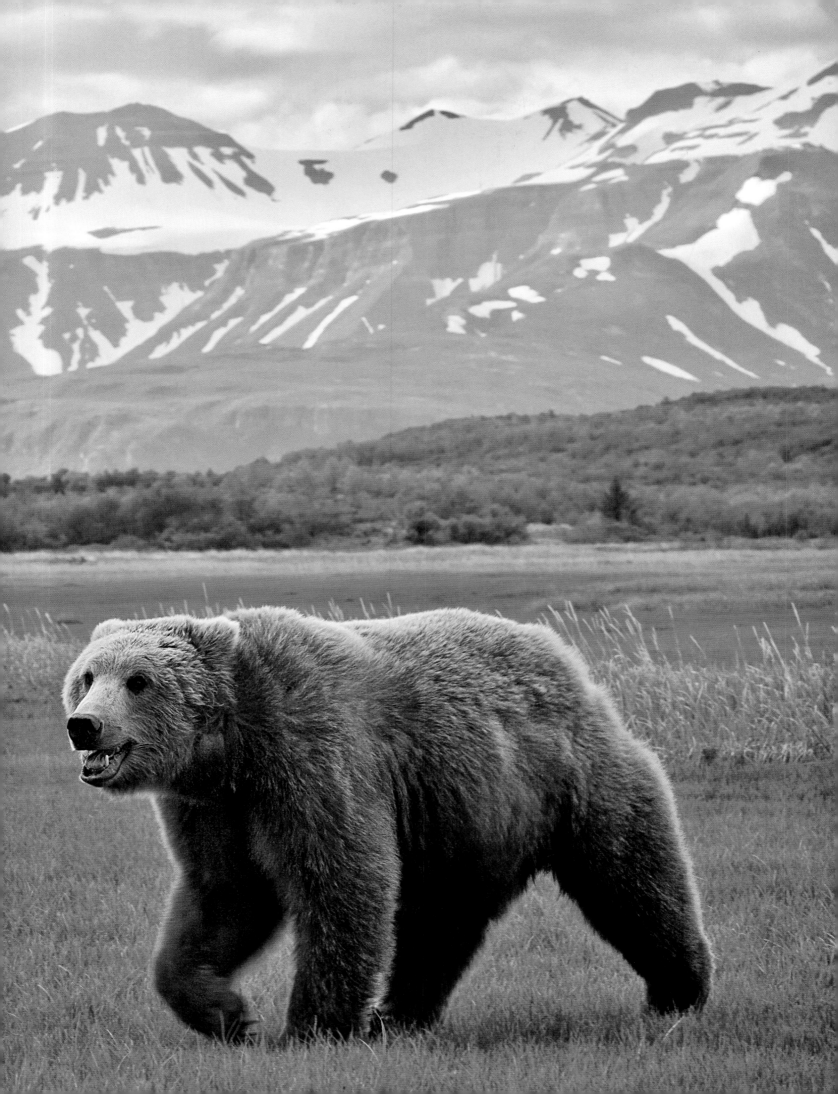

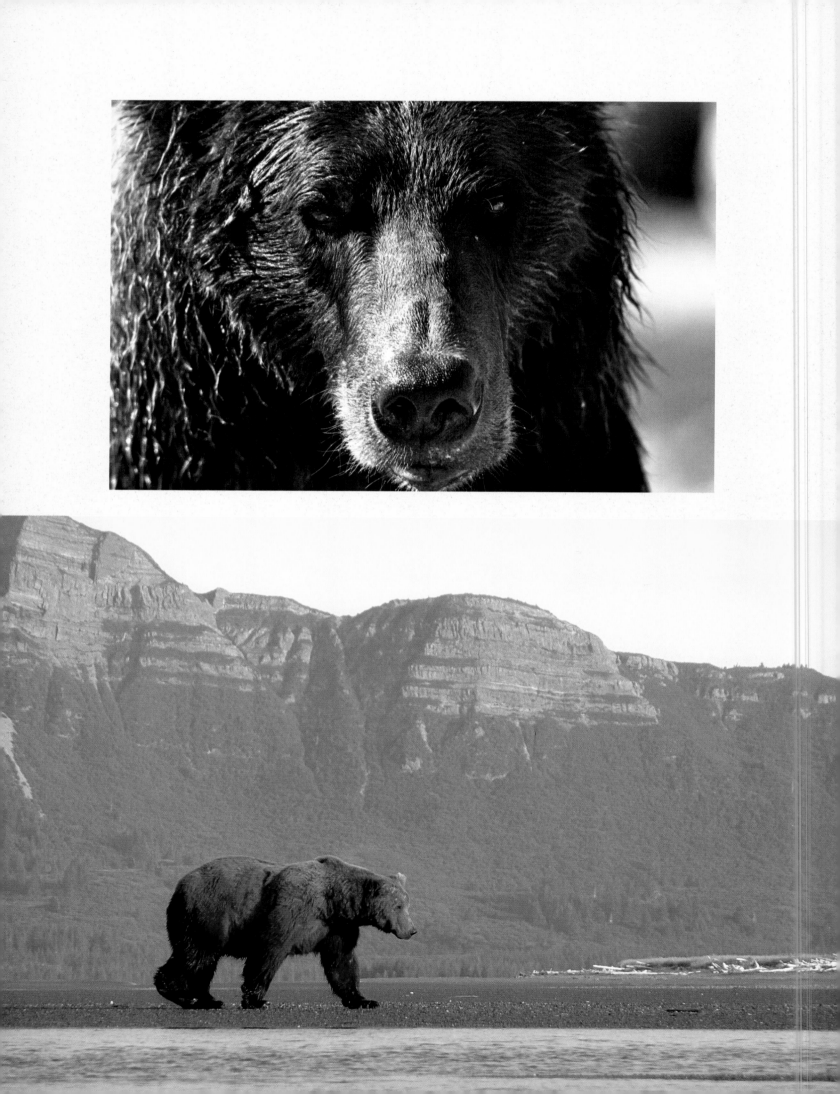

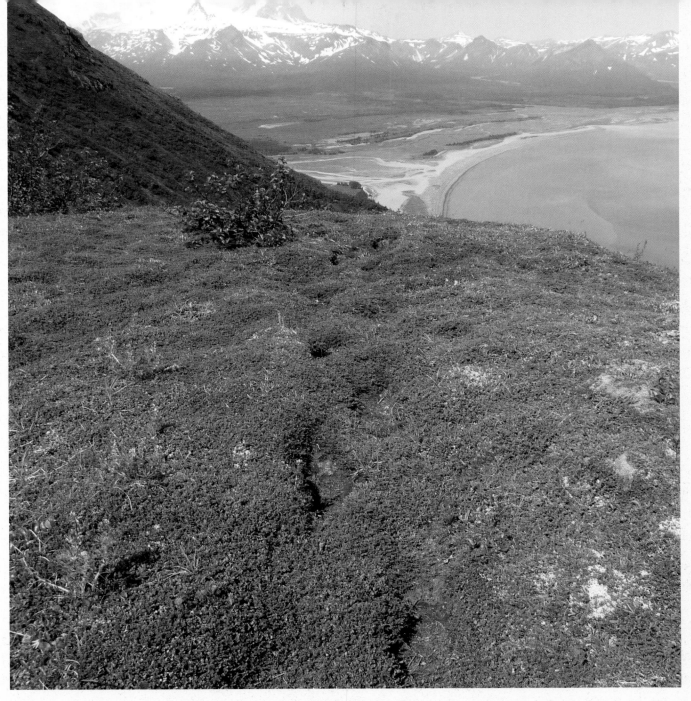

Even on high mountaintops I found well-worn bear trails, in this case around 1,500 feet above sea level (our base camp is located in the distant background). This type of trail is particularly associated with males during the breeding season; they habitually step into the same paw tracks and spread their scent by urinating on their feet.

opposite, top During the breeding season, mature males are besotted with females, pursuing them relentlessly with a single-minded focus. But the end of the breeding season coincides with the arrival of the first salmon runs, and almost overnight the males lose interest in anything but eating.

opposite, bottom We watched this huge male bear patrol the shore expectantly one morning in July. He seemed to know that the salmon were due to arrive, which they did later that day.

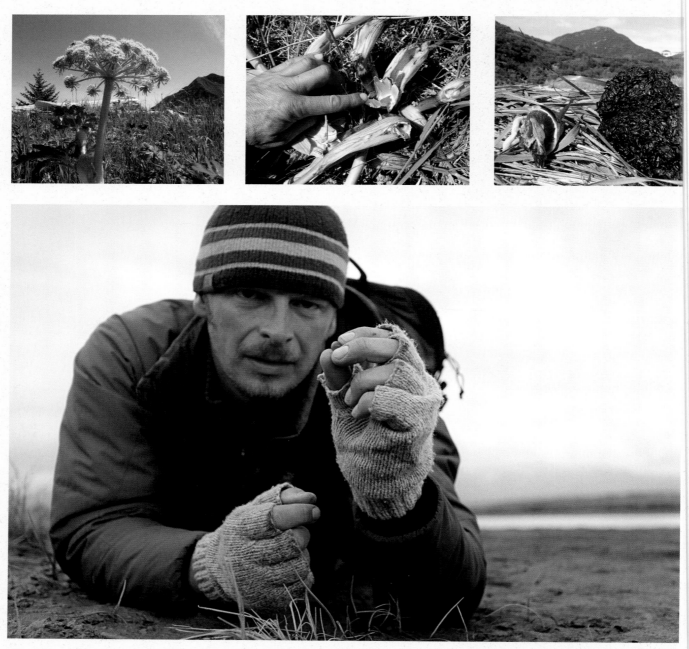

Bears play a key role in this ecosystem by not only distributing nutrients in the form of salmon remains throughout the forests and sedge meadows, but also by distributing seeds. In this case the bear has been eating cranberries, which have been deposited in bear scat, along with a convenient pile of fertilizer to help it on its way.

top, left and middle The angelica plant is one of the bears' favorite foods on the Alaska Peninsula. The middle photo shows the chewed stems left behind by a grazing bear.

top, right Another example of the bear's role as a seed disperser, as evidenced in this bear scat.

The route we took while filming aerial scenes was intended to be beautiful, not direct, as witnessed by my GPS unit.

I love to piece together the behavior and lives of bears from the field sign that they leave behind. This is a favorite "rub tree" not far from our camp, where bears vigorously rub in order to leave scent, and also simply to enjoy a good scratch. This old spruce tree has been so well used that the bark has been worn off, and all the branches on one side broken by enthusiastic bears.

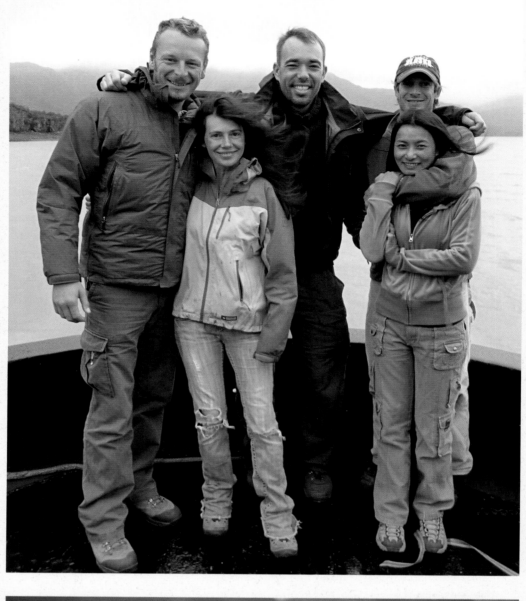

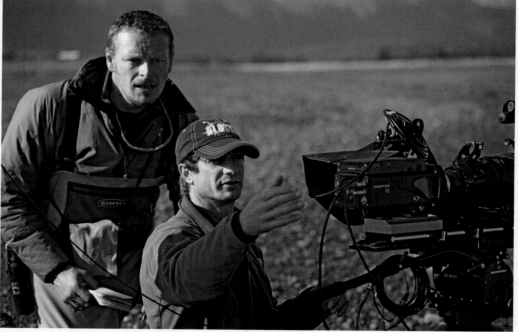

Joe adjusts my microphone while bears busily fish in the background.

opposite, top The extended film crew on our last day on the Alaska Peninsula coast before sailing back to Homer: me, Brenda Phillips (additional camera), Dean Cannon (associate producer/second camera), Joe Pontecorvo (producer/director of photography), and Nimmida Pontecorvo (sound).

opposite, bottom Joe with the high-speed Phantom camera that is designed to obtain very sharp, super-slow-motion video. Just the ticket for filming bears charging through water in pursuit of salmon.

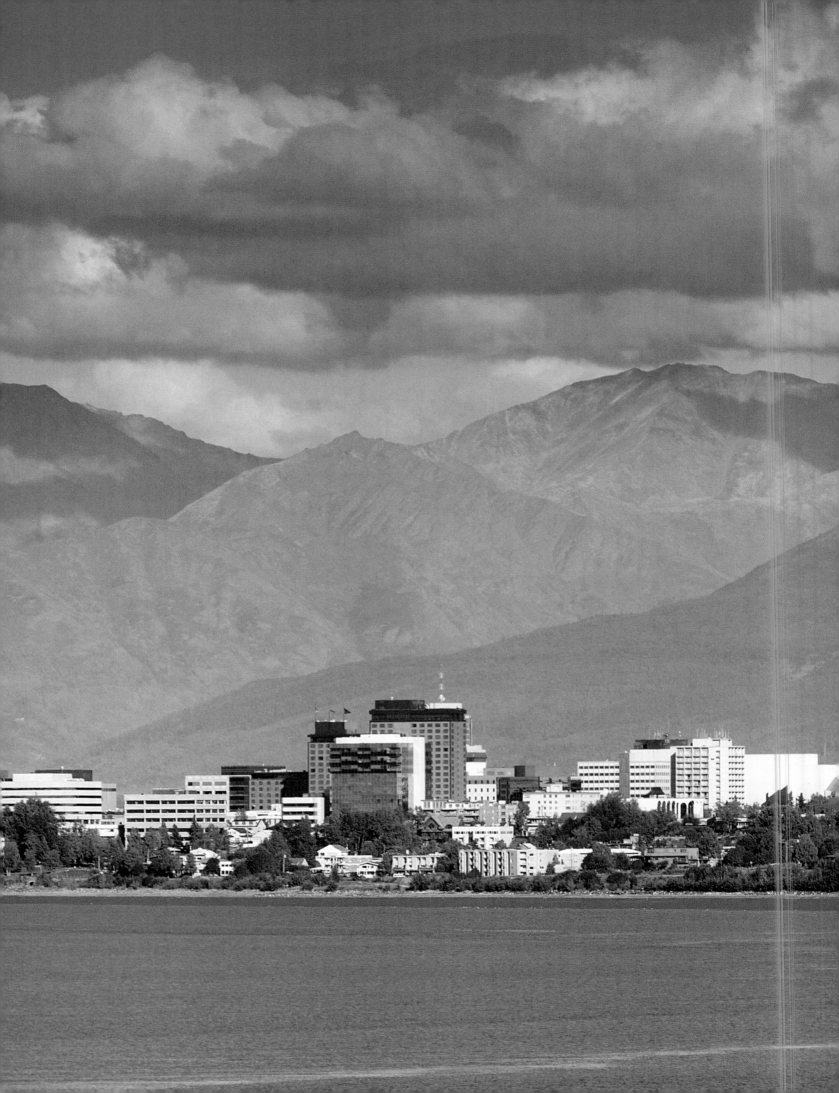

ANCHORAGE

Urban Grizzlies and
Bird Feeder Black Bears

The next leg of my journey was going to take a shift in attitude. I was in for a culture shock. After spending nine weeks immersed in the bears' world along the Alaska Peninsula, I rode my mud-splattered bike 225 miles from Homer at the southern end of the Kenai Peninsula northward into the heart of Alaskan civilization: downtown Anchorage.

The overwhelming flood of signs, noises, lights, and mayhem was quite surreal. I felt like I'd arrived in Manhattan. But this too was bear country.

This city's human population is 280,000, which might not seem like a lot compared to Lower 48 standards, but if you take into account the fact that only 700,000 people live

in the entire state of Alaska, the perspective becomes very clear indeed. Some 40 percent of Alaskans call this home.

Busy as it is, Anchorage is merely a dot of civilization in a sea of wilderness. The city is nestled in a stunning setting between the Cook Inlet and the mighty Chugach Mountain Range. It is these mountains, stretching some 300 miles east of Anchorage, that provide shelter for healthy moose, wolf, and brown and black bear populations. And on their doorstep, big-city temptations can draw bears in. Following rivers and creeks that are often laden with spawning salmon, bears can find themselves in some very human habitat with garbage and bird feeders simply too hard to resist for an animal hardwired to vacuum up calories.

It is estimated that 4 wolf packs, 1,500 moose, more than 65 brown bears, and 250 to 350 black bears call the municipality of Anchorage home. Tune in to the local news during any summer month and story after story about bears raiding garbage cans and bird feeders can be heard. At times the media make it sound as if the city is under attack.

Two well-known individuals—Rick Sinnott and Jessy Coltrane, wildlife biologists with the Alaska Department of Fish and Game—are on

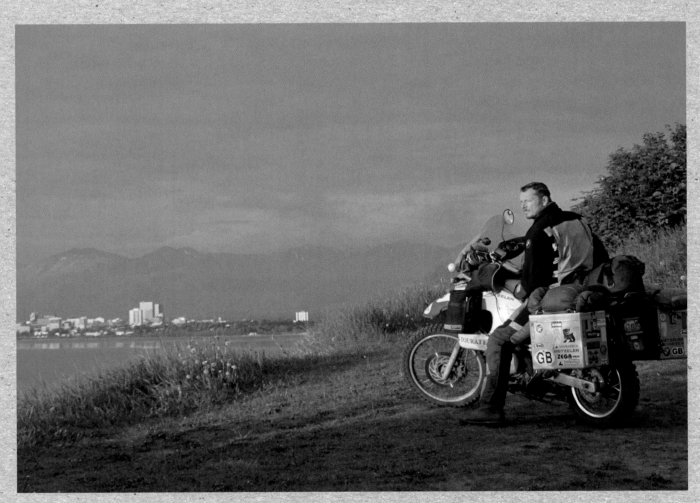

The population of Anchorage is 280,000 people. Only 700,000 people live in the entire state of Alaska. To me, Anchorage was like a dot of civilization in a sea of wilderness.

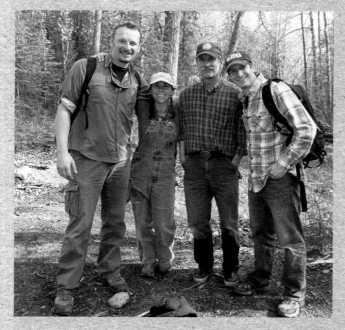

Joe (right) and I (left) with Jessy Coltrane and Rick Sinnott of the Alaska Department of Fish and Game, checking remote-camera traps in an Anchorage park. It was incredible to me that both black and grizzly bears were common in these urban green spaces.

the front line every day. As the ambassadors between wildlife and people, Rick and Jessy have to be experts not only in wildlife management, but in human psychology as well.

Joining them in the field reminded me of the tough work we also face in Washington State preventing conflicts along the human-wildlife interface, trying to ensure space and safety for people *and* bears. One eye-opening difference for me though was the fact that Anchorage residents deal with not only the common black bear, but also the more serious brown bear, a species so rare in my state that even finding a *track* in someone's backyard would be the discovery of a lifetime.

Rick and Jessy's work ranges from monitoring the bears' use of riparian (river) ecosystems in and near the city with automatic remote

cameras to wrangling moose calves in an attempt to reunite them with mothers that may have become separated by a backyard fence. As you can imagine, they are a lot of fun to be around, and the phone never stops ringing.

On one call Rick was asked to deal with a black bear in a tree. Not unusual at first glance, but the person calling in this "complaint" was in her second-story apartment and the bear was eyeballing her through the window. Rick's low-key response was enough to calm even the most rattled caller. He gently asked her what she thought the bear was doing there. The phone went quiet for a moment; she really had no idea. "Do you feed the birds?" asked Rick, and at that point even I could hear the moment of revelation going on at the other end of the line. Rick and I headed down to the scene of the crime, and sure enough, we found a healthy-looking female black bear atop the spruce tree nestled among dozens of busy apartments. There are almost no limits to what a bear will do to reach black oil sunflower seeds.

Of course, Anchorage's urban bears are just doing what they do best: consuming the highest number of calories for the least amount of effort. When fat-rich human food scraps are available, or even better, energy-packed black oil sunflower seeds, no sensible bear will walk by. But this natural scavenging can become troublesome—and potentially dangerous. When a bear first decides to explore a human neighborhood, it usually does so under the cover of darkness, in stealth mode. But as the bear's behavior is rewarded with treats, it becomes bolder to the point where some animals make forays in the middle of the day, completely unfazed by people, traffic, and noise.

Bear psychology usually moves through two separate but related phases when it comes to being around humans and seeking human sources of food. When a bear's home range and search for food starts to include human habitat, the bear quickly adapts to any human response—especially in the case of black bears. If they are shot at, chased away by dogs, or even spooked by humans yelling, they retreat and may not come back. But if their experience is not unpleasant, over time a bear may become "human-habituated." That is, they begin to see humans as relatively benign aspects of the landscape. Once this is the case, it is not a huge leap toward a much more serious mind-set for the bear: food-conditioning. A human food–conditioned bear is one that relates human areas and a human presence to potential sources of food. This is when things can spiral out of control for bears and they can become a serious concern for people who live in or near bear country. I liken it to a dog begging at the dinner table: One reward, and where will that dog be every time you sit down to eat from that moment on? Right there at your ankles, waiting for the next scrap from your plate. It is much the same with a bear that finds a reward of garbage, compost, pet food, bird seed, or suet: One reward is all that it takes to keep that smart bear coming back for more.

It can be upsetting for residents who find property destroyed by a ravenous bear, but more often than not it is the bear that loses out. Between 2000 and 2009, an average of eleven black bears per year were killed every year in defense of life and property[1]—usually habituated and human food–conditioned bears that needed to be removed in order to prevent them from becoming a serious danger to people.

The interface between wild and urban bears and people in Anchorage is huge, as the city is

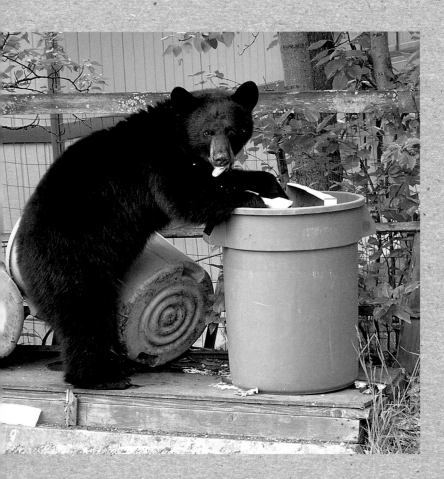

A black bear raids a garbage can. For a bear it is all about obtaining the highest number of calories for the least amount of effort. Unfortunately, this can result in the death of the bear if human attractants bring it into neighborhoods.

opposite Jessy Coltrane and Rick Sinnott of the Alaska Department of Fish and Game have their hands full trying to keep both wildlife and people safe in Anchorage. Much of their work involves moose, which are often seen barreling through town without a care in the world.

1. This number includes bears killed by Anchorage residents, state troopers, the Alaska Department of Fish and Game, and the Anchorage Police Department.

located squarely in the middle of excellent bear habitat *and* offers a maze of bear highways in the form of rivers and creeks that feed animals from the mountains and wilder outskirts of the city right into town. Bears end up popping out of the sheltered riparian surroundings right into civilization, a little like I did when I arrived. On top of that, large city parks provide excellent staging areas for bears as these are packed full of plants, salmon, and moose that are part of the bears' natural diet.

Having said all this, people here take their wild neighbors largely in stride—in fact, impressively so. There seems to be an Alaskan frontier attitude that prevails, even in this big city, and I love it. This mind-set makes people proud to live in a place where they have bears and moose in their yards. For the people I talked to, living among large, wild mammals was just another indicator that life is a little different up here, and that was just fine. But more than that, there's an air of self-sufficiency about Alaskans that makes their hardy nature even more appealing. They seem to complain less and rely on themselves and each other more, rather like anywhere that is isolated from the outside.

It's a normal part of life for Anchorage residents to carry bear pepper spray during a stroll in a city park, to look left and right when leaving the house, and to cross the road when the sidewalk is blocked by a thousand-pound moose.

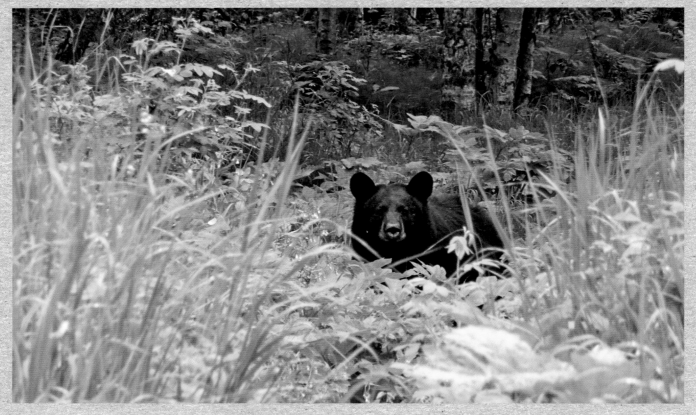

The bear family became so used to us that they played, relaxed, and even slept in our presence. We talked in low, calm voices for much of the time and this actually seemed to ease her concerns. Whenever I made a noise by snapping a twig underfoot, she looked around, perhaps thinking that it could be a brown bear, but seemed relieved to find that it was just me. Black bears have to be very cautious around their larger brown bear cousins, which can be aggressive toward them.

This female black bear with two cubs at the top of a nearby cottonwood tree was clearly used to being around humans and allowed us to film from a sensible distance in the forested park all day.

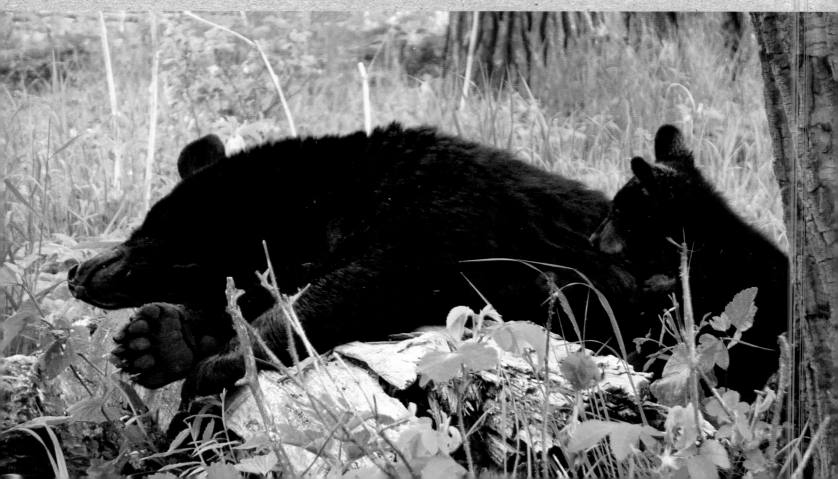

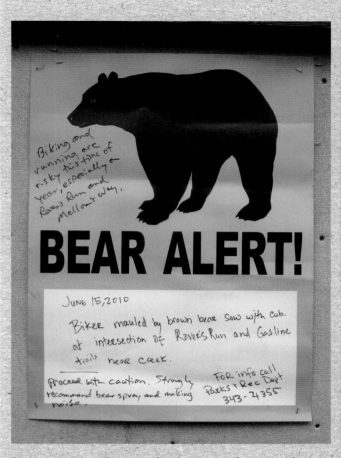

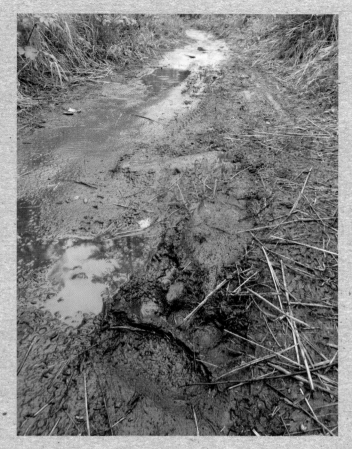

A sign warns park users about a recent bear incident in an Anchorage park. Sudden encounters with potentially defensive brown bears can be particularly dangerous so it is always advisable to make lots of noise in bear country to warn bears of your approach. Most of the time they want to avoid you as much as you want to avoid them.

I took this picture while checking out one of the trails in Far North Bicentennial Park in Anchorage a few days after a man had been attacked here by a mother brown bear. Brown bears can become quite aggressive in defense of their cubs, especially when surprised.

One day in Anchorage I was riding around the city in search of urban bears, phone close at hand so I could contact Joe if I came across anything interesting. I headed to the Far North Bicentennial Park, a large urban wild space that is known to harbor both brown and black bears, and a place that Joe or I scouted at least once a day. Even in this sizable piece of green space the rumble of traffic and the occasional police siren can always be heard, a constant and surreal reminder that you're in bear country *and* Alaska's biggest city all at once.

No more than a mile down the road into the park I skidded my motorcycle to a halt when a small black shadow bolted through the trees in my peripheral vision. As I struggled for a better view between the trees, I spotted a black bear spring cub scurrying from one cottonwood to the next, playing it safe in case a scramble to the safety of a treetop was needed. A moment later a second cub appeared, and then the mother, who was calmly grazing clovers along the roadside. The youngsters reminded me of the cubs we had gotten to know so well on the Alaska

Peninsula—so new to this world of scents, sights, and stimulation and under the calm, watchful eye of an experienced mother.

Little did I know what a remarkable day was to unfold with this bear family.

Joe arrived and we positioned ourselves at a safe distance to film, starting from the parking lot at a nearby trailhead. For the next five hours we observed their every move through the forest. They became so used to us being there that they obliviously grazed their way through the trees and small meadows, wrestling playfully along the way. At one point the cubs even began to nurse, and then the whole family fell asleep no more than fifty feet from us at the base of a giant tree. For me, that was a first. Never before had I spent so much quality time with a family of black bears, and it was a priceless opportunity to observe and film them behaving completely naturally in their own little downtown wilderness.

Joe films me in an Anchorage park. It amazed me that we were able to see and film bears in this urban setting.

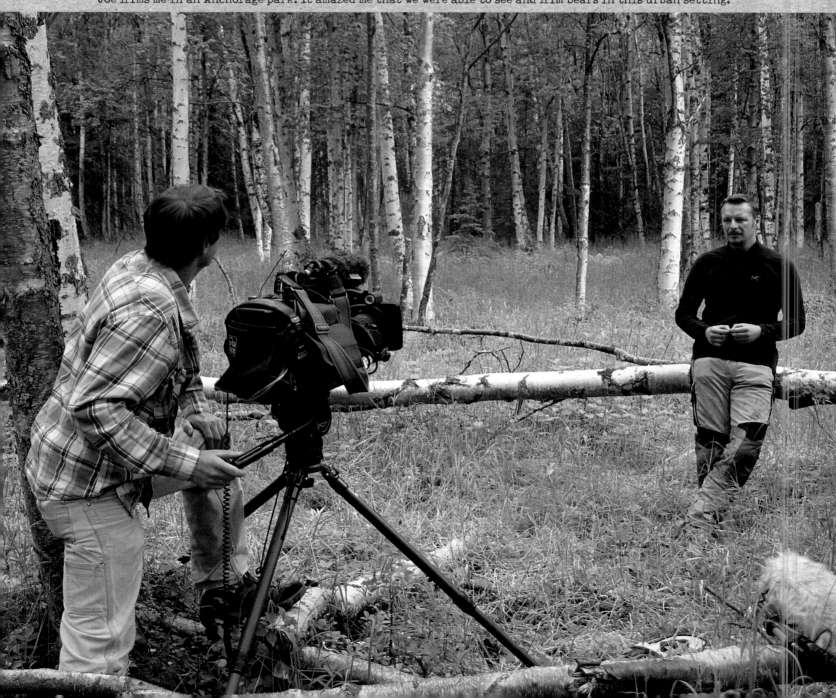

Journal Entry, Anchorage

Being in Anchorage amid this curious mix of people and bears has made me think a lot this week about the relationship that we have with the wild. It's like the front line here: the front line between bears and humans. The question is, how much of our world can they tolerate, and how much of theirs are we willing to accept?

Humans the world over have become so isolated from their common past: a time when we were in tune with the natural world, among wild animals. And in the grand scheme of human evolution, it was yesterday.

I think that we are at a critical juncture in the evolution of human society, as there is still enough wild left in the world for us to rekindle an appreciation for it, and perhaps even renew our understanding of its importance. But this window of opportunity will not be open for very much longer. If the balance continues to tip toward development, conservation will be left behind, and with it, any likelihood of our making amends with the natural world will dissolve.

The microcosm of Anchorage provides a fascinating case study of ecology, human psychology, and conservation. Residents exhibit every emotion imaginable about bears and their place in this world. I spoke to three people today who simply *love* living in Anchorage's bear country and who are quite willing to do right by bears. All of them are careful with garbage and bird seed and even help to spread the word to neighbors when a bear is on the prowl.

Then there is the other side of the argument. As I was scouting a neighborhood for bears on my bike today I came across a lady gardening in her yard. I called over to ask if she had seen any bears recently

(it was garbage day, so I knew they were around). She immediately called her husband in from the backyard, a man in his sixties. I had barely uttered the word "bear" before his entire face turned a worrying purplish color and he began spitting profanities. He clearly wasn't happy about having to share his space with bruins. I tried to calm him, but ended up politely retreating as he spewed about "darned tree huggers caring more about animals than people."

It is a tough balance for sure—especially here, where the implications are intensified because bears and people are sharing space. It's important not to pretend that bears aren't dangerous. They can be, but the risk is often wildly exaggerated and can be minimized with a few smart preventative measures in bear country.

It's one thing having a black bear in your backyard, but brown bears are another matter. They are an order of magnitude more difficult to get along with than black bears due to their need for space and their less patient temperament. But still, the majority of people here seem levelheaded.

There was a bear attack in Anchorage three days ago, and I was keen to check out the scene. A man commuting to work on his bicycle had been attacked in a classic defensive confrontation with a female brown bear protecting a cub during a sudden encounter. It all happened in an Anchorage park, not far from the black bear family that we filmed yesterday.

The trail runs alongside a river and some exceptional bear habitat. Apparently, twenty years ago it started as a game trail before evolving into a recreational trail, starting with skiers. It's an area that is well known to locals for its bear activity.

My heart was pounding pretty hard as I walked down the trail, shouting loudly every thirty seconds to warn any bears of my approach. The bear habitat here is as good as any I have seen—horsetail, cow parsnip, berries, thick meadows of grass and sedge, plus plenty of cover to hide in. It is easy to imagine how a cyclist could bump into an unsuspecting bear on a trail like this. Blind bends, vegetation, and bumps in the trail obscure everything until the last second.

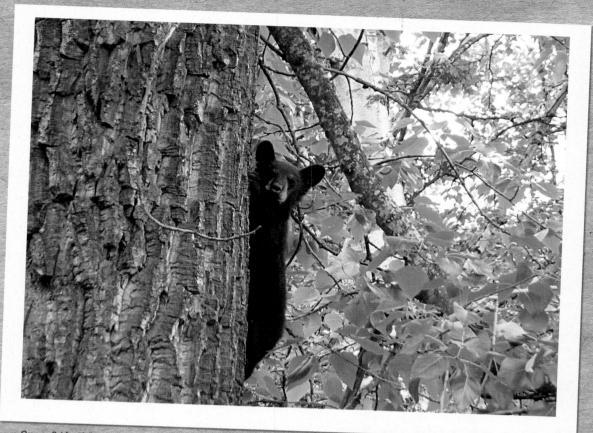

One of the black bear cubs we filmed for several hours one day in an Anchorage park. Along with his sibling, this cub will become used to the sights and sounds of the city.

Apparently the cyclist was moving quickly along the trail, rounded a bend, and encountered the mother bear and cub at a distance of less than twenty yards. When she attacked, the cyclist responded in the most appropriate way for this sudden defensive encounter by playing dead. As soon as the female sensed she had neutralized the threat, she left him alone. Despite his injuries, the victim was able to bike three miles to a medical center for treatment. Yet another example of Alaskan fortitude.

Not far down the trail I found large, fresh brown bear tracks in the mud, right on top of several bicycle tracks. I can't think of a more vivid example of coexistence. But what is most amazing to me is that such incidents don't happen more often in places like Anchorage. It is testament to the bears' patience as their world shrinks around them.

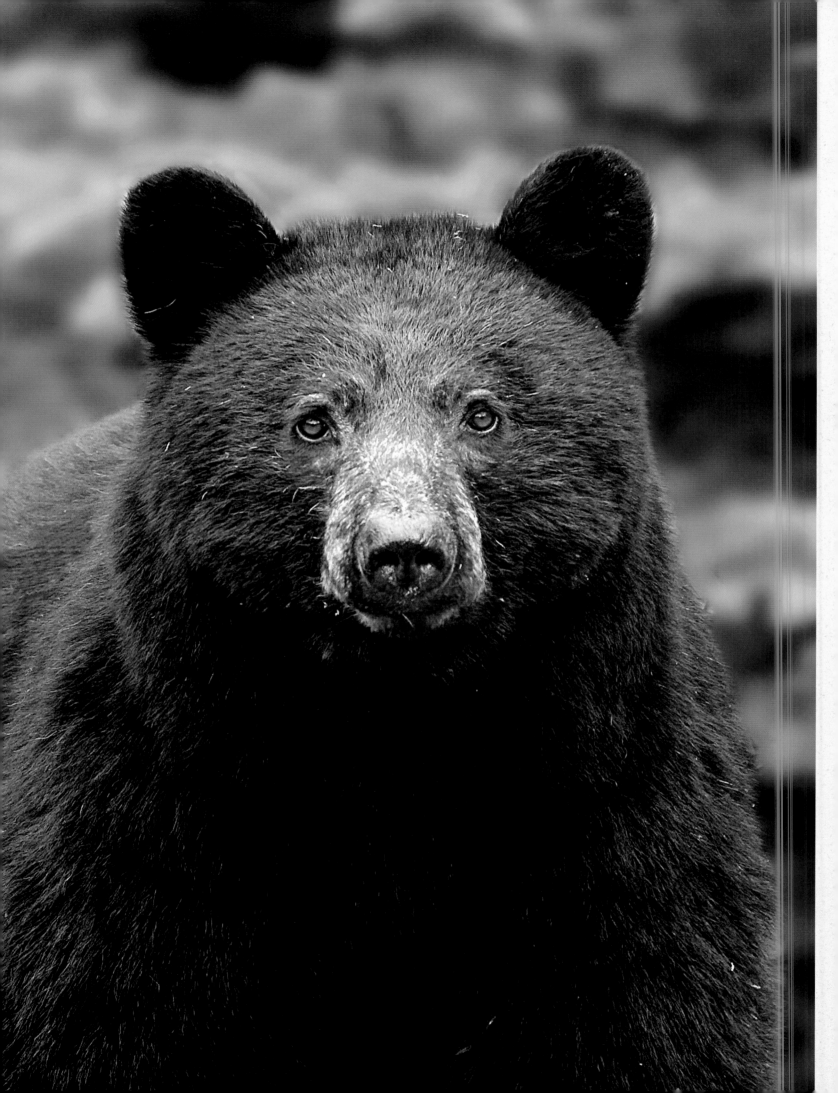

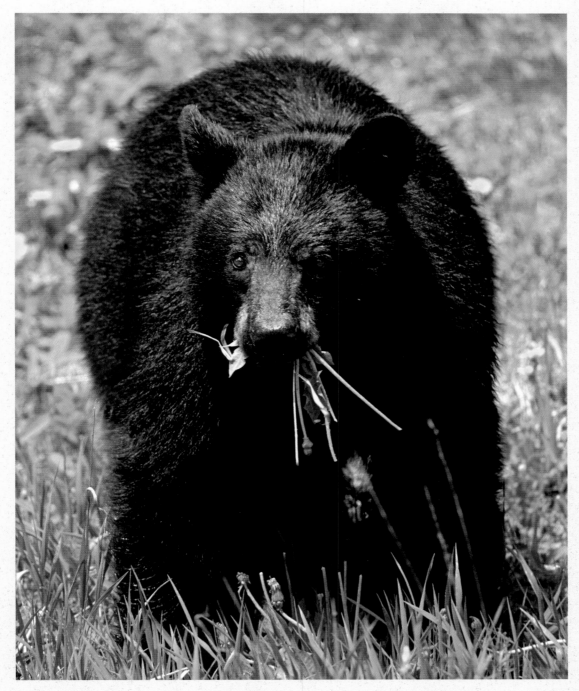

Around 90 percent of a black bear's diet is made up of vegetation—dandelions are a particular favorite.

opposite Black bears are incredibly intelligent and adaptable, and they seem to be equally at home in the wilderness or a suburban setting. Unfortunately though, many of them begin to access human foods, which can be fatal.

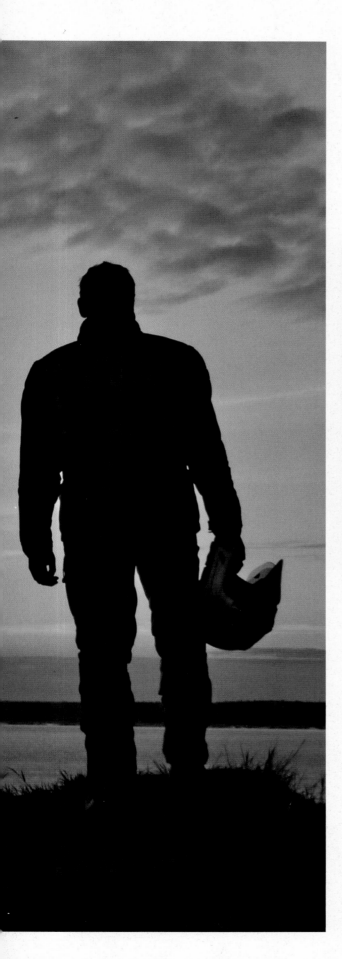

The transition from the wilds of the Alaska Peninsula to the city bustle of Anchorage was surreal, but the route took me through some beautiful country on the way.

left I arrived in Anchorage today, and although it's not a huge city by American standards, the noise and commotion after being in the wilderness is heightened. Overlooking beautiful Cook Inlet on the edge of town, I thought about what Captain James Cook might have found here, where Anchorage now stands, in 1778. It seems as though the city burst into being practically overnight.

overleaf Bears are very much at home in water. Here, a black bear makes its way across a creek.

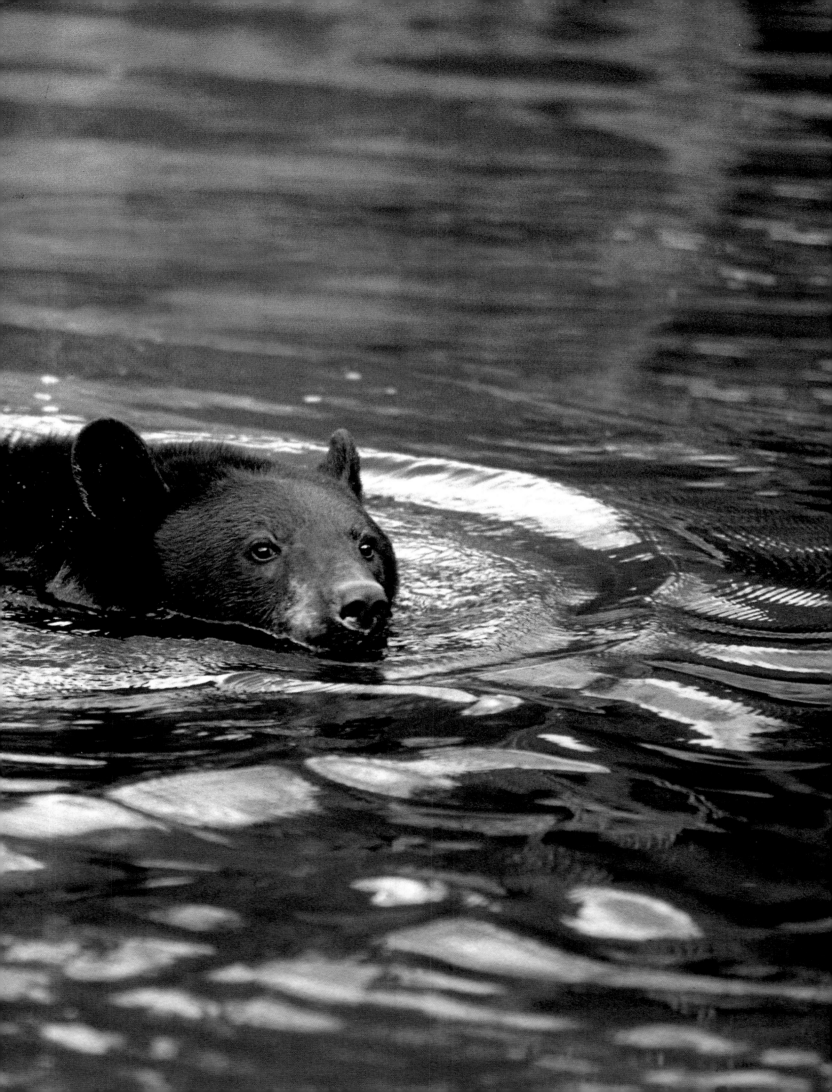

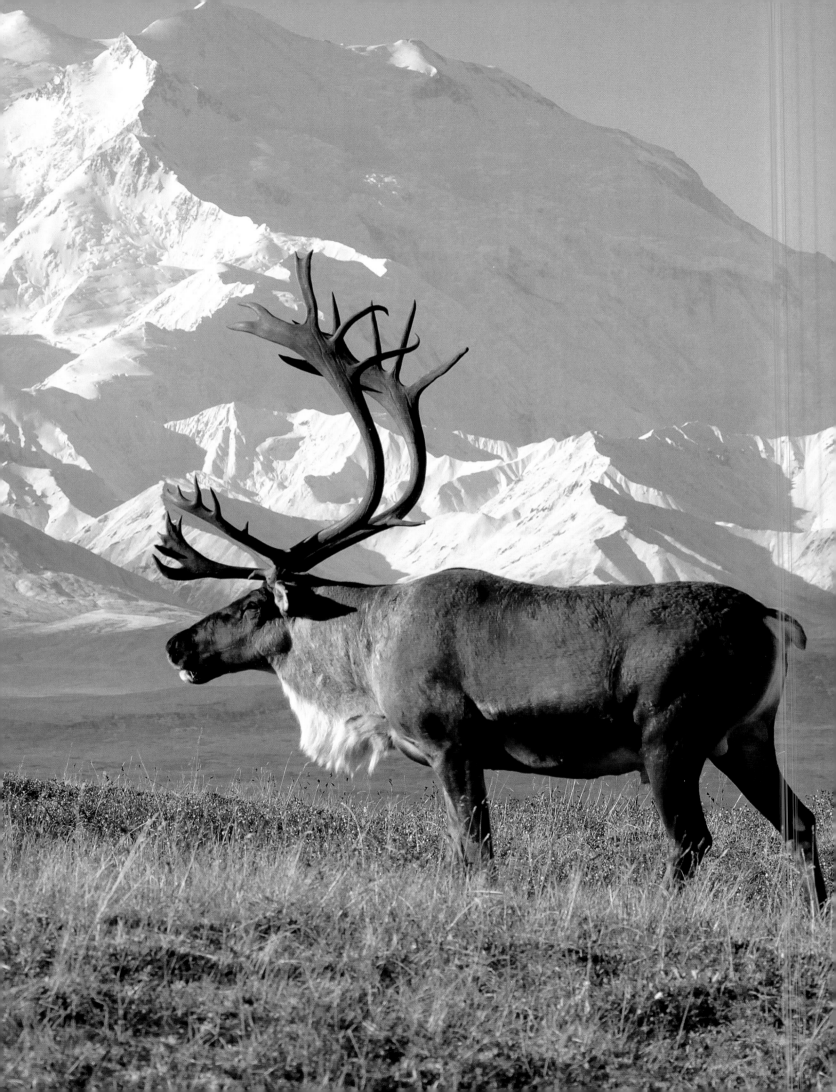

DENALI NATIONAL PARK

Inland Cousins— The Mountain Grizzly Bear

I first heard the word "Denali" when I was twenty and a student in England. Something about the name alone captured my imagination, and if I remember rightly, I added it to my wish list based on nothing more than the fact that I enjoyed it rolling off my tongue. "Denali," "the high one" as the Athabaskans named the colossal mountain, is also known as Mount McKinley, North America's highest peak at 20,320

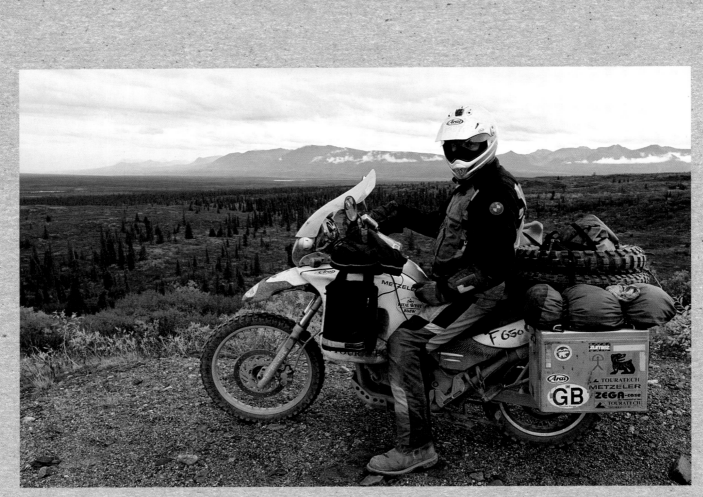

Exploring the Denali Highway near Denali National Park meant an exhilarating ride on gravel along the southern edge of the beautiful Alaska Range.

page 70: A bull caribou surveys the scene in Denali National Park.

feet, but the term can refer to the mountain, the national park, or the fault system that cuts across all of southern Alaska.

Now, more than twenty years later, I was riding northward with Anchorage behind me, and the vastness of Denali National Park's 6 million acres ahead. The scene could not have been more perfect. The mountain is only completely free from clouds for one day each month on average, and I had picked the right day. Even from the town of Willow, 100 air miles south of Denali, the peak majestically dominated the horizon. Now from my bike, it took my breath away, and I stopped every ten minutes to pull out my camera as the mountain grew before my very eyes.

A scouting ride also took me along the beautiful Denali Highway, one of the few remaining unpaved highways in Alaska and running for 133 miles east to west from Paxon to Cantwell parallel with the 600-mile-long Alaska Range to the north. Riding eastward along the dusty gravel road, I would catch Mount McKinley in the rearview mirror of my motorcycle every so often, a constant reminder of Alaska's scale. On the return westward toward Denali National Park, the great mountain beckoned me on with promises of wide-open spaces, Dall sheep, moose, and bears. I loved this area and the people I encountered along the way: There is real sense of the frontier among the gold

miners, adventurers, and hunters here, which resonates deeply with me.

Part of the feeling stems from the dramatic backdrop provided by the Alaska Range. A collision of landmasses forced these mountains skyward, and then mile-deep glaciers carved their features, leaving at every turn rock carved by ice into endless U-shaped valleys as a constant reminder. Giant, house-size boulders can be seen sitting alone in a sea of tundra—conspicuously out of place, as if deposited there yesterday. These "erratics" were in fact dumped by glaciers as they crept across the landscape thousands of years ago. And of course, the impact of glaciers is not over. They continue to recede, constantly revealing new elements of the landscape and helping to shape it as they have always done.

There's something about Alaskan roadside stops and yard sales. I got lost in places like this for hours.

The grandeur of the landscape in the Denali region seems matched by the impressive array of mammals. During the peak of the last glacial period, so much of the earth's seawater was locked up in ice that the Bering Land Bridge was exposed, providing a grassland corridor to North America. A curious exchange of species occurred between the two continents over thousands of years and led to a *Who's Who* of fascinating mammals from the past and present. From North America traveled horses and camels, which were to become the donkeys, zebras, and dromedaries of the Asia we know today. And from Asia came caribou, foxes, ground squirrels, wolves, Dall sheep, beaver, and of course, grizzly bears.

At this time, around 12,000 years ago, these species utilized the Alaskan ice age refugium, an ice-free region of interior Alaska that provided lush vegetation for grazers and, as a result, plenty of prey for carnivores. Other species found here included the ground sloth, saber-toothed cat, woolly mammoth, giant short-faced bear, and the large-horned bison.

Hot on the heels of the species that headed east from Siberia into Alaska across the Bering Land Bridge were early native hunters, who migrated from one continent to another perhaps without even knowing it. From that time onward, for thousands of years, early native peoples came to Denali to hunt, following game species and leaving evidence of their presence in the form of stone tools, many examples of which have been unearthed in the park.

The backdrop of Mount McKinley in Denali National Park provides a fittingly majestic scene for the caribou here. The caribou is the only deer species in which both sexes grow antlers. The huge antlers on a bull like this one take only five months to grow, sometimes at a rate of one inch per day during the summer months. Caribou calves and carcasses provide important protein for the bears of Denali.

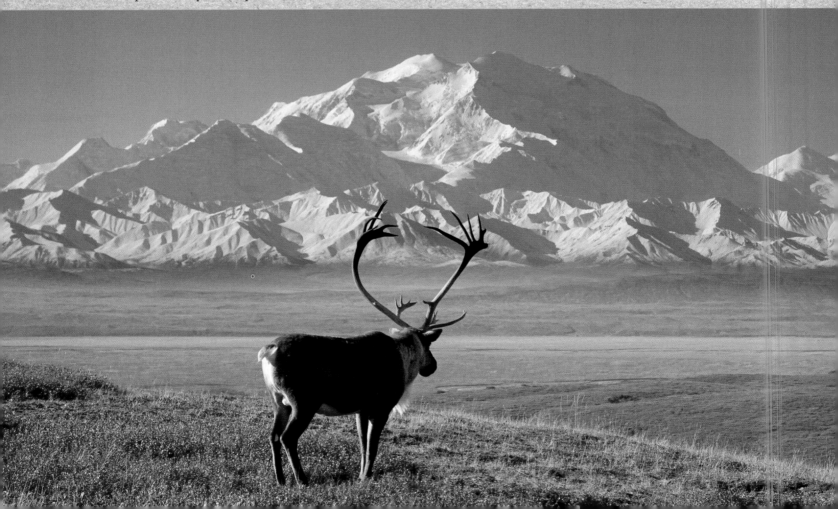

A bull moose wanders the slopes of Denali. The largest members of the deer family, moose can weigh in excess of 1,300 pounds and can make for an intimidating encounter during a hike. To avoid surprising a bear or moose at close range, I was sure to make a lot of noise when bushwhacking through the brush of Denali.

Even more impressive is the incredible array of spectacular animals from the same late Pleistocene period that *still* exist in Alaska today: moose, Dall sheep, caribou, beaver, lemming, wolf, lynx, wolverine, both the red and arctic fox, and the grizzly bear.

Like a giant, wild safari park, Denali sees most of its 400,000 annual visitors as passengers in a fleet of school buses that patrol up and down the ninety-two-mile road into the heart of the park in search of their favorite Pleistocene animals. Amazingly, most of the park's visitors leave having checked off grizzly bears, caribou, moose, and Dall sheep from their list. Some even see wolves, all from the comfort of the road.

We were lucky enough to have a special permit that allowed Joe to take his camper van into the park, but my motorbike had to be left at the entrance. I had to laugh as I replaced two wheels with four. It was so dry, so warm, so hermetically sealed—the comfort after so many wet, cold miles on the road was almost unbearable.

As we approached Polychrome Pass on the park road, I imagined the place 56 million years ago, lava spewing from a string of volcanoes dotted down the Denali fault along the spine of the Alaska Range. As it cooled, the lava formed the beautifully colored rocks that make this such a popular stop with visitors.

The land to the north of the fault, which includes most of Alaska, is still crunching eastward,

It was incredible to watch grizzly bears nonchalantly amble among traffic on the road through the national park. Visitors grind their vehicles to a halt to get a once-in-a-lifetime view of a bear just feet away from the safety of a tour bus or car. One night in the park we crawled along in Joe's van behind a grizzly bear that was walking down the middle of the road. He didn't once look over his shoulder to assess us during the 45 minutes that we were behind him. My kind of traffic congestion, for sure.

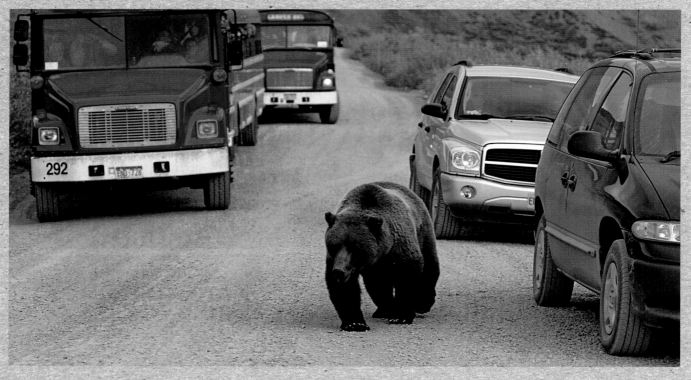

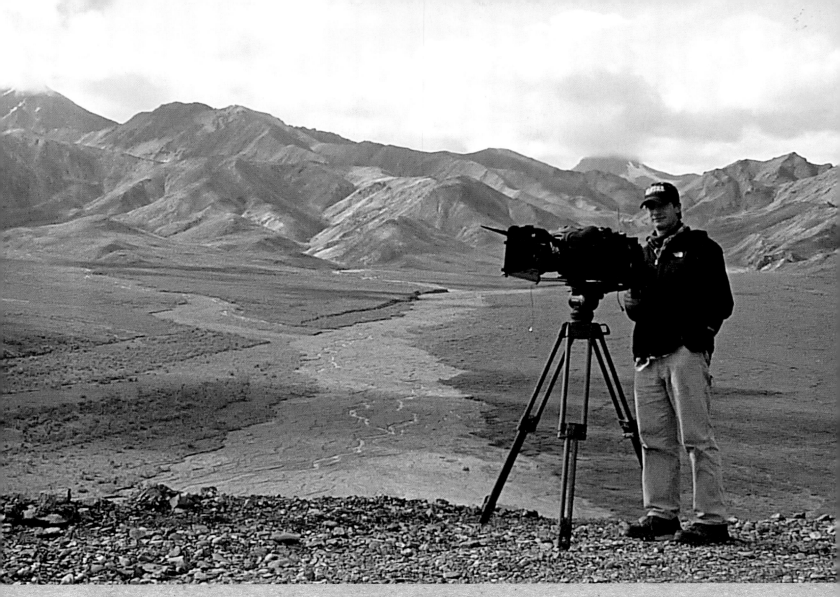

Joe films scenics from Polychrome Pass in the heart of Denali National Park. Locations like this allowed us to effortlessly tell the story of this ancient landscape and the exotic species that were here thousands of years ago, such as the saber-toothed cat and woolly mammoth.

while the land to the south is steadily pushing north and west. I pondered our tendency as short-lived life-forms toward imagining ourselves as dwelling in a stable landscape that only went through dramatic shifts in the ancient past. Far from being a static region of land, the mountains of Denali are ever changing. Even McKinley, the "high one" itself, grows 0.04 inches in height each year. The mountains still change, pushing ever skyward.

I was thrilled to be under the shadow of McKinley and excited to know more about the park's interior grizzly bears—the inland counter-parts to the bears I had come to know so well on the Alaska Peninsula. This was certainly a different kind of place—hostile and barren, with a threatening influence from the mountains. It almost felt like we were already in the Arctic.

The bears here are certainly a hardy breed, but even they have to avoid the harshness of winter by denning for as long as seven months of the year. Despite the fact that Denali has a reasonable supply of meat in the form of caribou, moose, and sheep, bears here still depend most heavily on vegetation. Around 80 or even 90 percent of their diet comes from plants, among

Plump blueberries, ripe for the picking. A grizzly bear can consume tens of thousands of berries every day during summer and fall. They are a critical food resource as bears prepare for winter sleep. They also provide the perfect snack during hikes. I'd often emerge from a hike at the end of the day with purple knees.

Crowberry is another important bear food, carpeting the drier parts of the tundra in well-drained areas.

them crowberry, blueberry, hedysarum roots, grasses, fireweed shoots, horsetail, sedge, and soapberry, an important diet item that bears can consume at the rate of 200,000 per day.

Spring sees a change in diet for the bears that have learned to kill moose and caribou calves or scavenge on the remains of those that didn't make it through the trauma of birth. Pat Owen, one of the Denali park biologists, told me that she has also seen grizzly bears halfheartedly pursuing adult moose and caribou, but usually the chase didn't last long once the bears came to their senses. Wolves of course also prey upon these ungulate species, leaving valuable carcasses behind for opportunistic bears, wolverines, foxes, and ravens.

Thankfully for the grizzly bear, the arctic ground squirrel also successfully made it across the land bridge to the new world and continues to thrive in Denali. These insignificant-looking little creatures play an important role in the eco-

system. Preyed upon by everything from snowy owls and gyrfalcons to red foxes, wolves, and grizzly bears, they have every right to be a little nervous. Weighing in at a mere one and a half pounds, the ground squirrel lives on the edge. It's probably a good thing they sleep for eight months of the year as they really have to have their wits about them for the other four.

As the taste of fall began to arrive in Denali, it was time for the ground squirrels and bears to knuckle down in preparation for hibernation. For Joe and me, it was time to press on.

The grandness of Denali National Park served as the perfect launching pad into the subarctic and arctic adventure that lay ahead to the north. Denali's blend of boreal forest and alpine tundra, and the transition of species that follows from that, gave us a taste of the ecosystems to come, and as the ride began, I became completely preoccupied with the image of the mighty Brooks Range ahead.

Journal Entry, Denali

Considering the meager amount of meat a ground squirrel provides for a bear, it is almost ludicrous to watch the effort that is involved in capturing one. First, the bear has to evade the sentries—shrieking whistle-blowers that alert the entire ground squirrel colony to the invasion. No easy task for a giant bear (it reminds me of the relationship between the whistling marmots and the brown bears in Pakistan). Before you know it, sometimes dozens of them are standing at their burrow entrances, squeaking with panic. The bear often doesn't know where to turn, faced with so many tasty morsels in every direction. It's as if the squirrels are taunting the bear from a safe haven, knowing they can bolt down a hole when he approaches.

The bear looks reasonably casual to begin with, checking out each hole for the fresh scent of a nearby squirrel, but then the mayhem breaks out. The bear shovels its way toward a squirrel at an impressive rate, as if heading directly to the earth's core. Putting those giant claws to perfect use, the bear will sometimes dig his way completely out of sight, throwing giant tufts of earth skyward behind him. It is incredible to think that his excavation can sometimes keep pace with a hyperactive ground squirrel scrambling down a hole.

The mismatch is comical: It's like the body-size equivalent of the tortoise and the hare. I can only imagine how terrifying it must be for a tiny ground squirrel, cornered with nowhere to go,

The tiny ground squirrel, weighing in at a mere one and a half pounds, makes up for its meager build by sheer numbers. Their ecological role in places like Denali National Park is important to so many species, including foxes, wolves, and grizzly bears.

A plump ground squirrel keeps a watchful eye out for grizzly bears and other threats.

in the last dead-end tunnel of his subterranean maze, facing down a bear that is three hundred times his weight. But occasionally, the squirrel will zip between the legs of the marauding bear, which triggers a high-speed chase across the tundra, squirrel bent on reaching an alternative burrow and bear determined to head him off before he gets there. What is most impressive is the bear's incredible agility and speed as he zigzags across the slope hot on the tail of his petrified target. Easy to believe at times like this that a grizzly bear can charge at forty-four feet per second.

And with a pounce it is all over. The bear sits down, completely out of breath, paws on top of its prize, looking around to see if anyone was watching, and probably trying to calculate if the squirrel he has caught contains more calories than those he *lost* during this insane chase.

For some bears it is definitely worthwhile. I have heard that researchers watched one female grizzly bear in northern Alaska dig up 396 ground squirrels in a single summer season. That's 594 pounds of squirrel—the equivalent of three large men. Not a bad season when the alternative for a northern bear might be grass and berries.

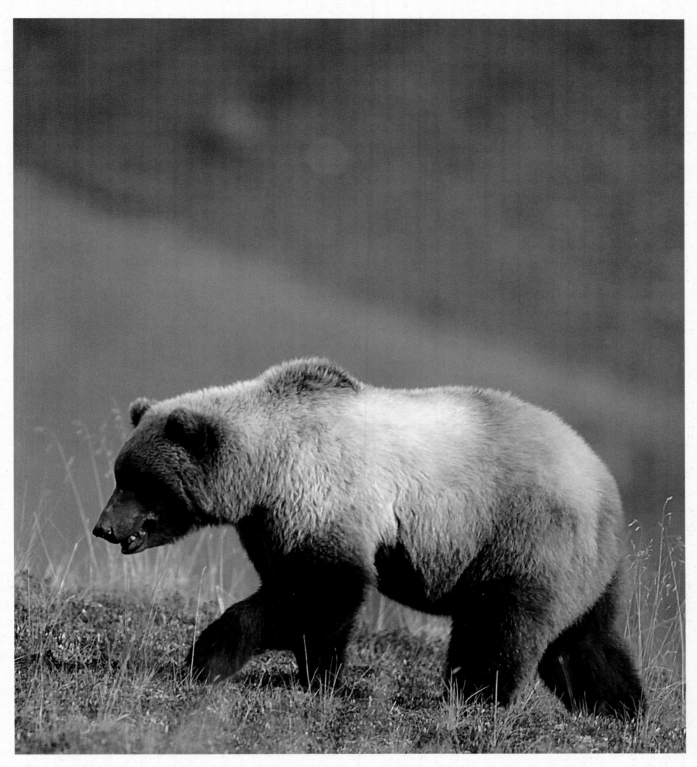

Current estimates suggest that there are 300 to 350 grizzly bears north of the Alaska Range within Denali National Park. One of the questions managers are trying to tackle is how hunting, which is legal outside the park, impacts those bears that travel within the park. It can be a tricky wildlife management scenario when trying to meet the needs of wide-ranging animals like bears that spend time in both protected areas where hunting is not permitted and zones outside those protected areas where hunting is allowed. A similar situation exists in Katmai National Park and Preserve, where habituated bears become easy targets for hunters when they wander out of the protected areas.

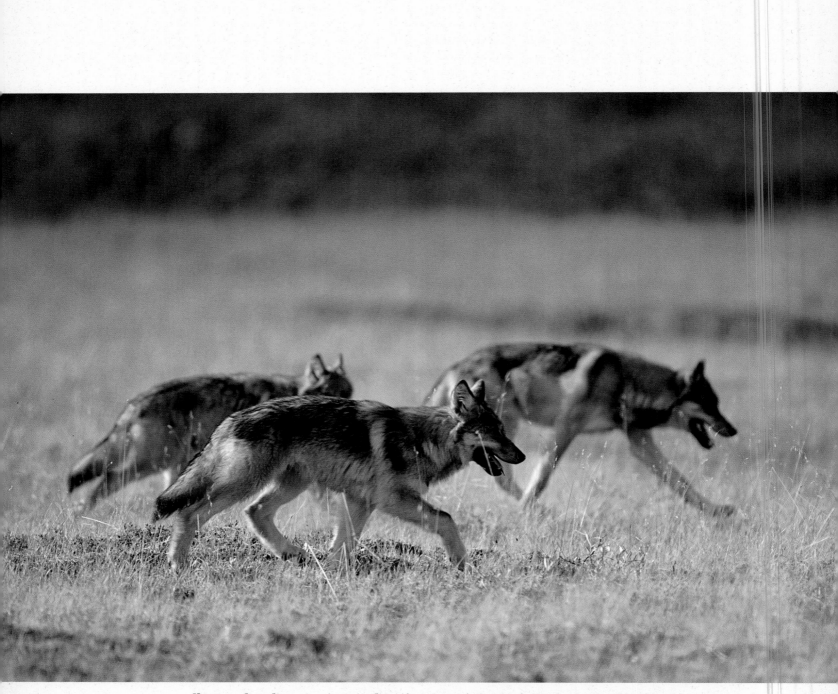

Young wolves learning to patrol in their search for food. Hundreds of wolves have been radio-collared since 1986 in Denali National Park in an attempt to learn more about their movement patterns, diet, and the threat of poaching. The density of wolves fluctuates according to hunting conditions and prey availability, but is generally around 9 wolves per 1,000 square miles—a low density that reflects the harshness of Denali.

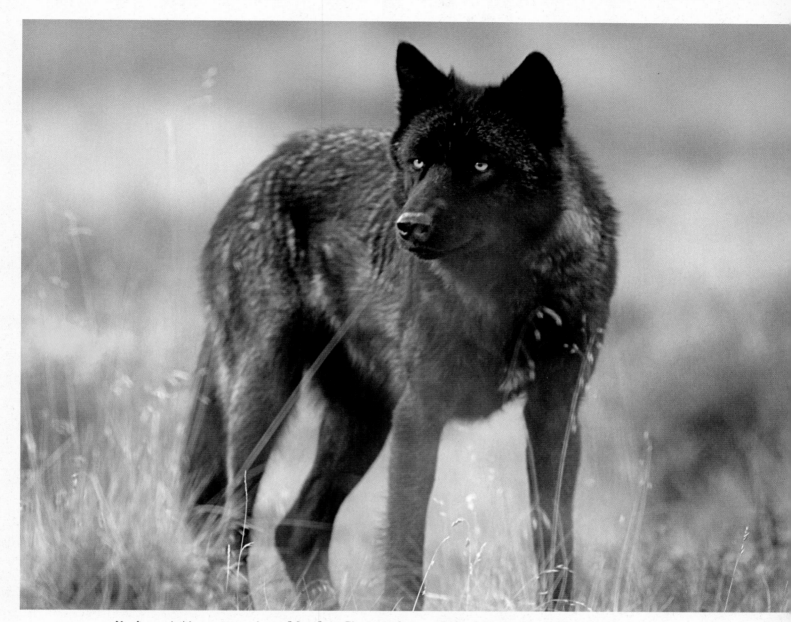

Much variation occurs in wolf color. It reminds me of tracking radio-collared wolves from the air in the Northwest Territories of Canada in the early nineties. On one occasion I was unable to see the wolves on the ground despite the signal booming in. Finally, as we banked steeply to get a better look I noticed that the pack of eight wolves had split and were watching us, motionless, the black ones in the shadow of the spruce trees, and the white and gray ones on a snow bank. I couldn't help but think they were intentionally trying to conceal themselves from us. Wolf research in Denali Park began with Adolph Murie in the late thirties. His painstaking studies included countless hours of direct observations and scat analysis and helped to clarify the role of these essential carnivores in a healthy ecosystem.

above I met this gold prospector at a roadside stop on the Denali Highway. I couldn't believe the chunk of gold that he pulled from his pocket. He went on to explain the hardships of his way of life, but there was a twinkle in his eye the whole time. The romance of the search for gold is alive and well for him and many others.

left I explored the beautiful road to Petersville on my way to Denali and discovered gold panners, old sluicing equipment, and a comfortable bed for the night in a classic old roadhouse.

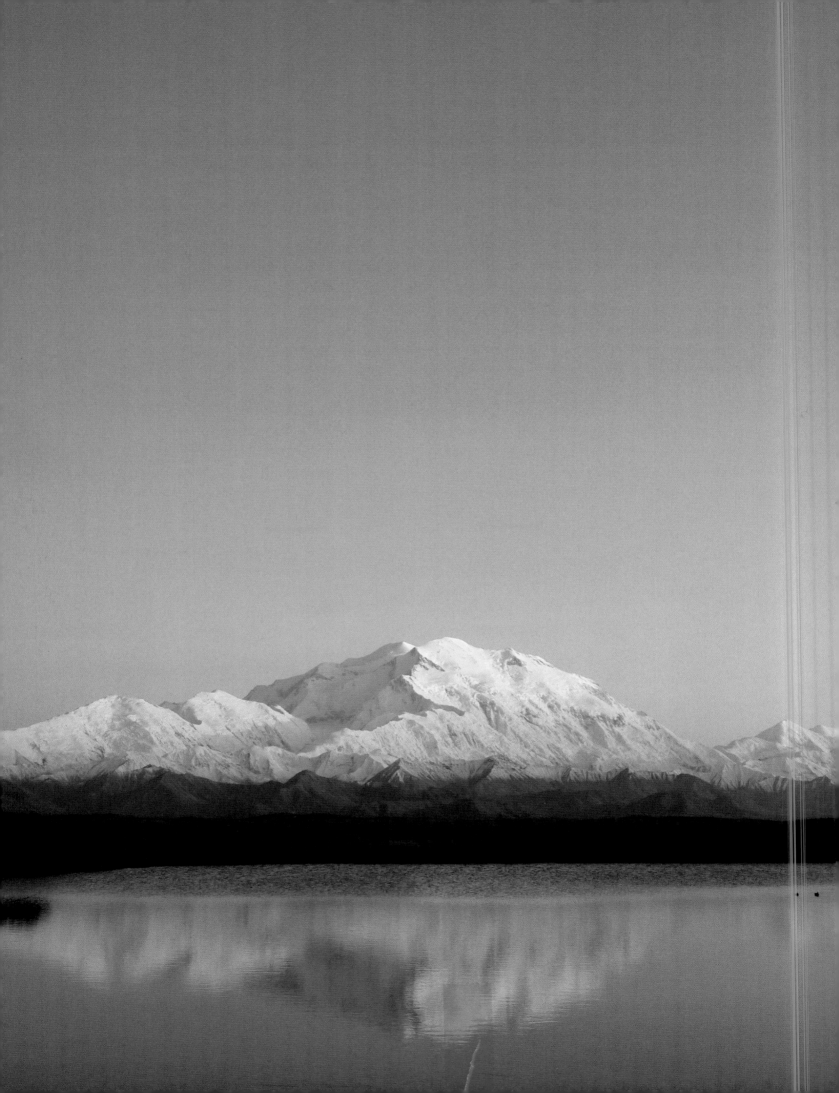

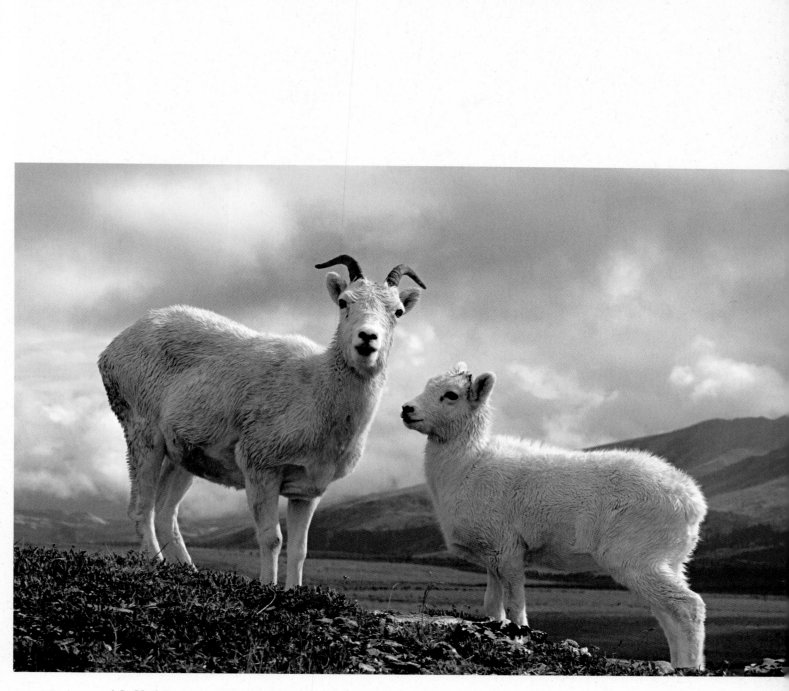

A Dall sheep ewe and lamb at home in the high country of Alaska.

opposite We were lucky enough to see Mount McKinley in its full, clear glory on many occasions. Its vastness influences the entire ecosystem of the area.

right Although my ride from Homer on the south coast of Alaska to Prudhoe Bay on the north coast was 1,100 miles each way, I covered many more miles on solo scouts and explorations over the months that I spent in this vast state. Here, my trusty BMW F650 GS Dakar takes a break after an 800-mile scout from Anchorage in search of routes to film.

below Joe taking a break from filming in the park. The vastness of Denali (6 million acres) becomes understandable when you drive the 90-mile road in search of wildlife to film. The road is a sliver of human impact in a vast wilderness larger than Massachusetts.

opposite, top Fixing an electrical short that brought everything to a halt one day near Denali National Park. I was relieved to discover that I could fix the problem right at the roadside without having to wait for parts to arrive from 250 miles away. The amount of abuse that my 2001 motorcycle took is impressive. In total, I rode around 3,000 miles through Alaska, many of those miles on unpaved roads and trails.

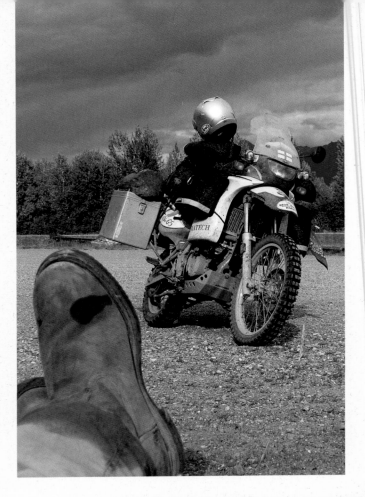

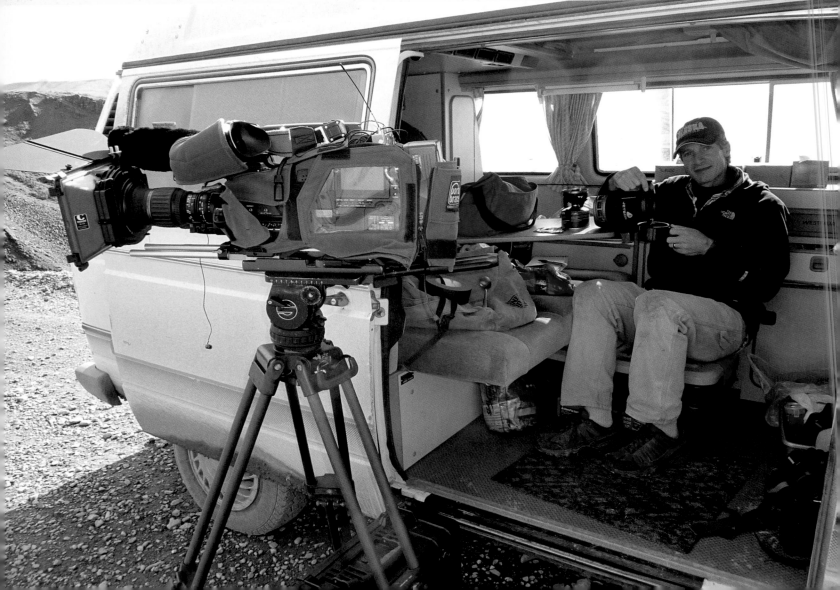

The end of a long day of filming along the Denali Highway, heading westward back toward Denali National Park.

overleaf Always on the lookout for wildlife, I would stop frequently to look for moose, bears, and even wolves. But here along the Denali Highway, wildlife is far more elusive than in the nearby national park.

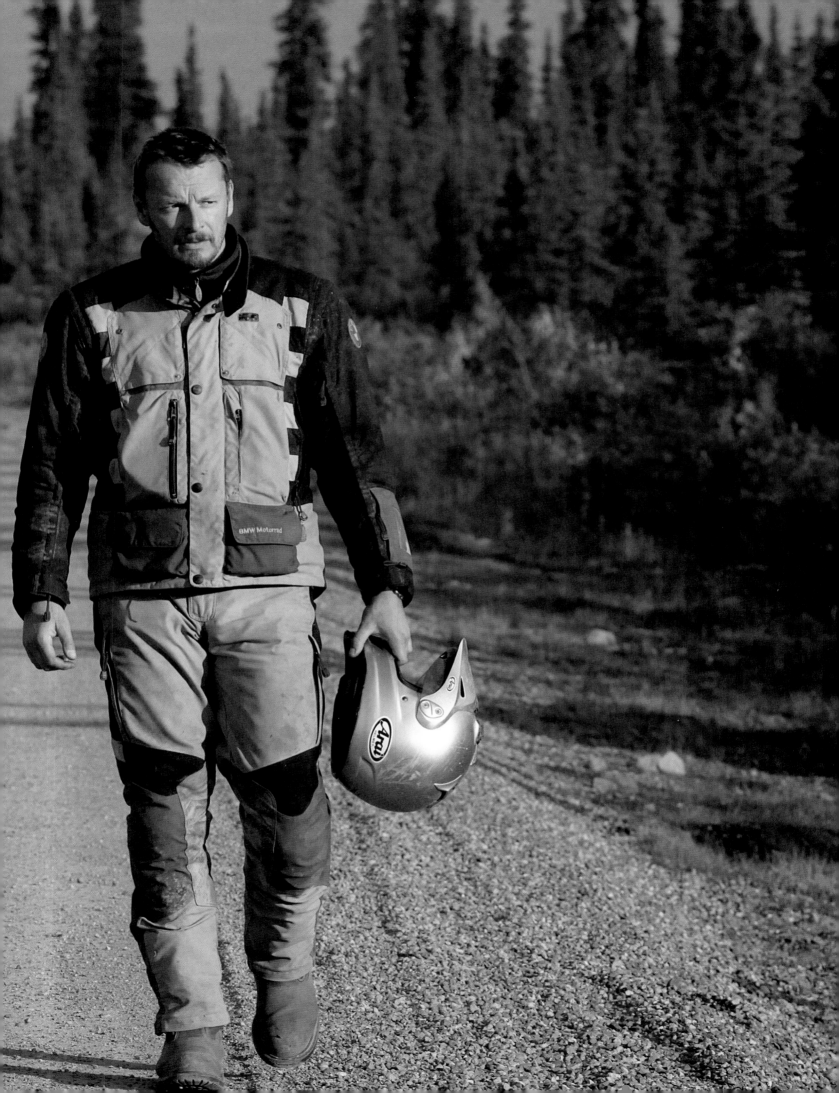

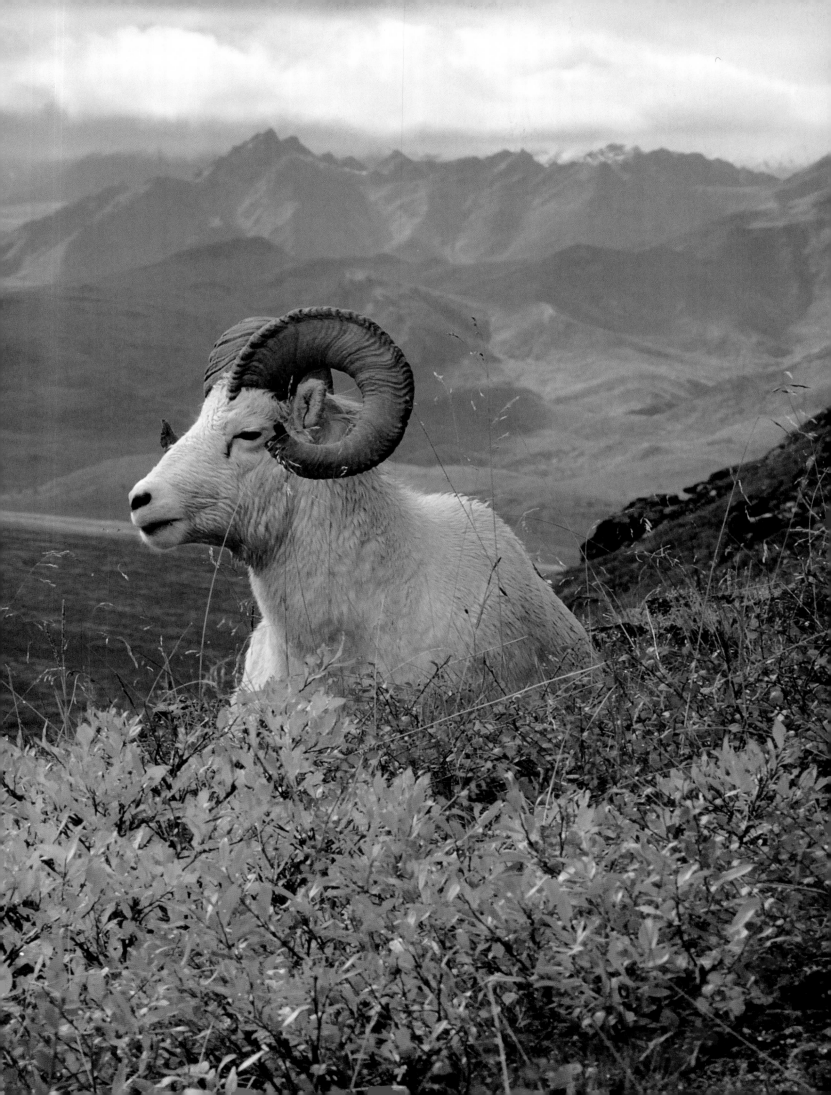

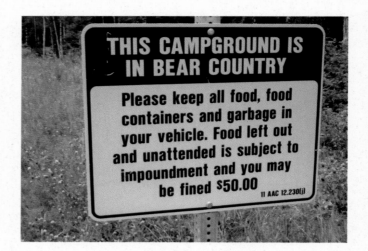

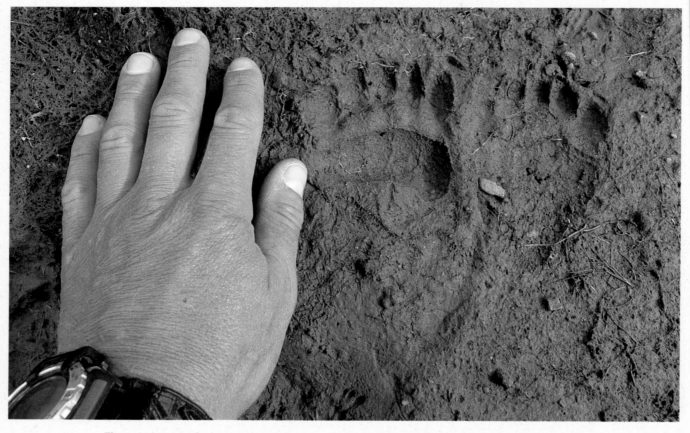

These tiny grizzly bear cub tracks were an incredible find in Denali. The spring cubs, or COYs (cubs of the year), that left them would be around seven months old at the time of the photograph. Born the weight of a squirrel in the safety of the winter den, cubs gain weight rapidly thanks to their mother's milk, which is very high in fat content. By the time they are a year old, they may be one hundred times their birth weight.

top It's hard to avoid bear country in Alaska, and everywhere you go there are reminders that bears share habitat with people.

opposite Joe films me hiking from a spectacular vantage point near Polychrome Pass in Denali National Park. At times I think he wanted to be a Dall sheep.

previous pages Dall sheep sprinkle the highest peaks in Denali, effortlessly hopping from one craggy rock to another, far above most of the predators that might threaten them. This male is surveying the scene below.

The Alaska Range was thrust skyward during a land mass collision in the ancient past, but still today the Denali fault is in motion. North of the fault (most of Alaska) land is moving eastward, while south, it crunches north and west.

top The mighty Mount McKinley stands at 20,320 feet; Denali, "the High One" as it was called by the Athabaskans, is an apt name. It urged me onward whenever I saw it, sometimes from 100 miles away.

opposite Hiking through this enormous park with McKinley and the Alaska Range as a backdrop made me feel infinitely inconsequential. I was dwarfed by an ancient being that has seen so much unfold beneath its colossal ridges.

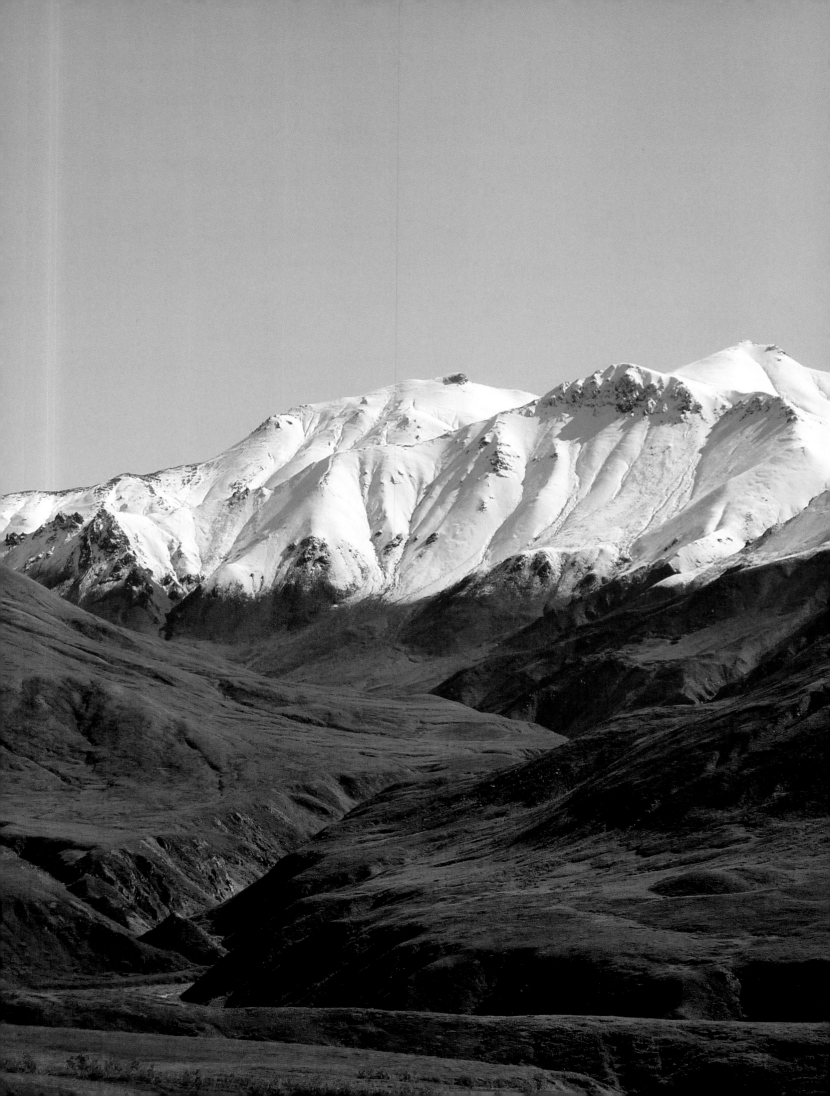

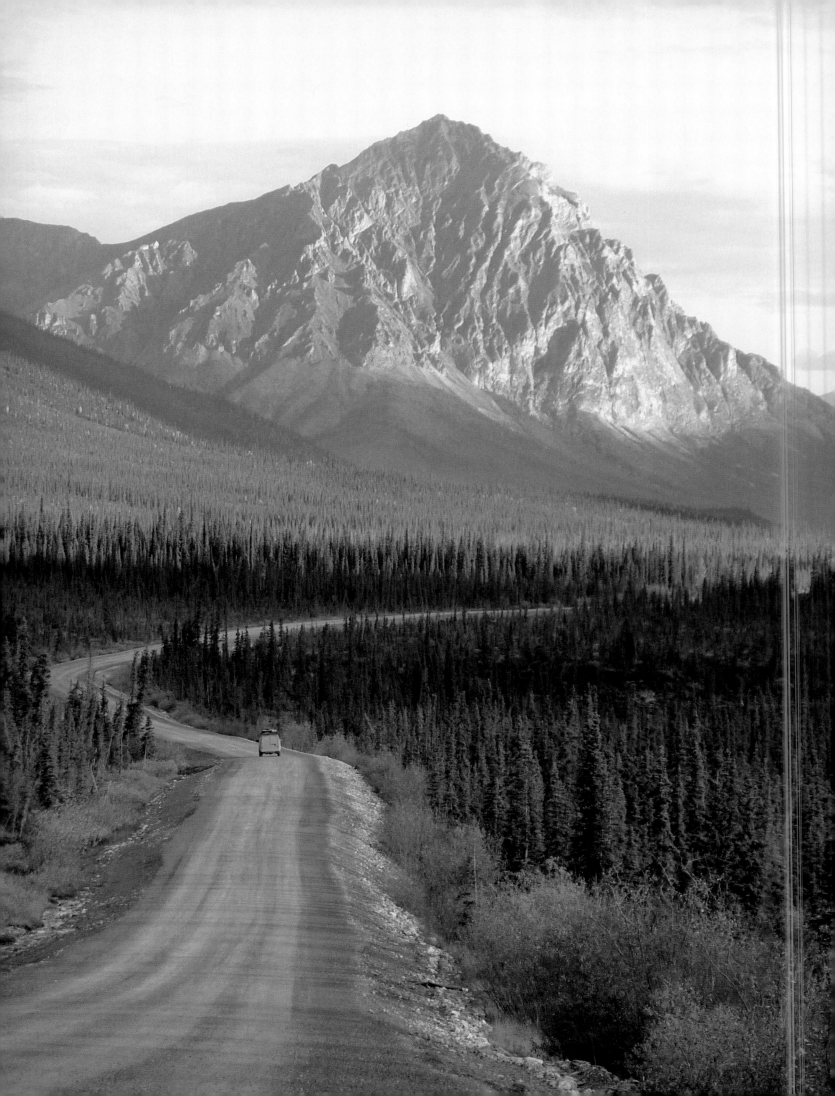

FROM GRIZZLY BEARS TO POLAR BEARS

Northward to the Arctic

"Intimidated" is the word that I would use. The next leg of my motorcycle ride across the length of Alaska was a seriously ominous prospect, but still one that I relished the thought of. As fall began to close in, I was keen to get back on the road and continue my giant transect of this colossal state, but also mindful of the fact that a certain amount of misery lay ahead. I was heading from Denali National Park, northward to the Arctic.

There is something about being on a motorcycle, opening up the throttle, and cutting through the air along a wide-open road through the wilderness. Ask any biker

to describe it, and a quiet smile will usually unfold across their face. Ahead of me lay some of the most incredible landscape in North America, and I would spend the next two weeks of my life getting to know every bump in the road.

From Denali it is a bone-shaking 610 miles to Prudhoe Bay along the only Alaskan highway to reach the Arctic. Even from Fairbanks, which is situated 360 road miles north of Anchorage, the ride to Prudhoe Bay is 500 miles, but the distance and discomfort pales as the glory of this incredible landscape unfolds.

Just north of Fairbanks begins the infamous Dalton Highway, otherwise known simply as "the haul road." This road would take me across the Arctic Circle, and also the tree line, through the Atigun Pass, and from the realm of black and grizzly bears to the northernmost part of the continent and the home of the polar bear. Simply getting my head around all of that was mind-boggling.

This highway has only been fully open to the public since 1994, so the Dalton Highway guide booklet makes for some amusing reading:

page 98 The road is as endless as the wilderness that it cuts through, but my race against the onset of winter weather has to keep me pushing northward.

below Contemplating the long ride north across the Arctic Circle, over the Brooks Range, and to the north coast of Alaska.

Joe films me riding toward the Brooks Range, the world's northernmost major mountain range, which stretches for almost 700 miles across the north of Alaska.

There are no public services at Department of Transportation maintenance stations, there are no public or emergency medical facilities, there are no banks and only one ATM (in Deadhorse, on the northern coast of Alaska), there are no full-service grocery stores, and there is no cell phone coverage from milepost 28 until Deadhorse. In 500 miles there are three service stations. Two of them are within four miles of each other. I heard that only 250 vehicles use the road on any one day—across the entire length of the highway. Many of them are trucks supplying Prudhoe Bay.

I kitted my bike out thoroughly, including a spare set of tires in case things went very wrong. Despite the fact that Joe would be tak-ing the haul road in a four-wheel drive vehicle to film much of the ride, I was treating this as a solo expedition into the unknown, and as with the rest of the trip, complete self-sufficiency was important to me.

It's an irony that the harder the biking gets, the more fun it is. Similarly, the more blood, sweat, and tears you expend packing the bike, the more satisfying the accomplishment. For best effect I like to start by laying everything out on a large area—and I mean everything: tools, sleeping bag, tent, iPod, maps, stove, mess kit, flashlight, camping mattress, rain gear, backpack, GPS, emergency satellite transmitter, food, spare inner tubes, layered clothing, survival kit, first aid kit, and for this particular leg of the journey, spare

tires, and my faithful bear pepper spray. Even as I write this, my heart rate has increased. It's not only the feeling of embarking on an adventure, but it is the thrill of doing it as a completely self-contained unit, with everything you need, no matter what the world throws at you.

There is also the pure independence and freedom that comes with being on a bike, especially one that can take you almost anywhere. Which brings us back to the journey itself, and always pondering what's around the next bend.

The Dalton Highway begins eighty miles north of Fairbanks, which itself is impressively "out there." No matter what time of year you arrive in this town, you are reminded that this is where the extremes really begin. Show up in summer and the temperatures can be soaring into the nineties, while winter lows have reached −50°F. Spruce trees, northern wetlands, and

The Trans-Alaska Pipeline pumps oil 800 miles across Alaska, from Prudhoe Bay in the north to Valdez in the south. My journey joined the pipeline just north of Fairbanks and stayed with it for more than 400 miles. I found it ironic that the road making my passage through this beautiful wilderness had only been constructed to maintain the pipeline.

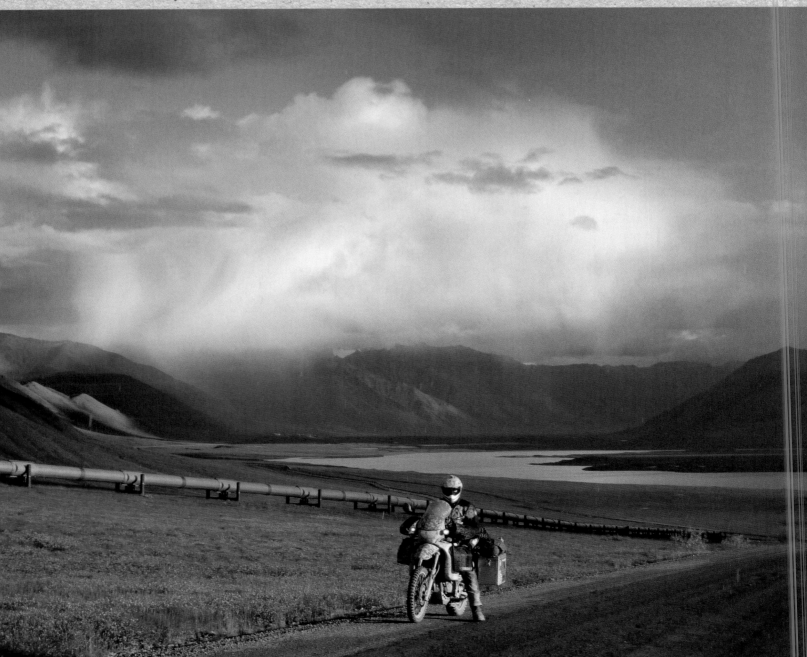

rolling alpine tundra stretch for miles in every direction, providing seemingly endless habitat for wolves, bears, moose, foxes, raptors, and countless species of migratory birds. And as soon as you leave the edge of town behind, the wilderness really begins.

The boreal forest, or taiga as it is often referred to, wraps around the world between the latitudes of approximately 50 and 60 degrees north and is the world's largest terrestrial biome. This band of largely coniferous trees covers 11 percent of the land area of the Northern Hemisphere. In North America, the boreal forest stretches for almost 4,000 miles east to west, and 300 to 600 miles north to south.

A milestone on this section of my route across Alaska was crossing the mighty Yukon River. The essence of this northern country is perfectly represented by the Yukon and its vital historical role as a transportation route for streams of people seeking their fortune during the days of Alaska's gold rush in the late eighteen hundreds. Beginning in Canada, this river, winding for 1,980 miles and emptying into the Bering Sea, has a way of making even mighty rivers look like small tributaries. Some 240 miles directly west of my location along the Yukon, the 500-mile-long Koyukuk River drains from the Brooks Range into the Yukon. Later, I would ride alongside the younger Koyukuk roughly 135 miles north of here to near the town of Wiseman.

For me the Yukon marked a psychological dividing line about halfway across Alaska. As I crossed the huge flow on a wood-decked bridge, I wondered how I could possibly still have so far to go. It seemed like I had been on the road forever.

Just sixty miles later I made it to the Arctic Circle, and despite my exhaustion, I couldn't help but feel uplifted by the idea of what this meant. Here, the sun stays above the horizon for one full day on the summer solstice, the longest day of the year (around June 21), and it stays below the horizon for one full day on the winter solstice, the shortest day (December 21).

Alongside me for much of the highway ran the Alaska Pipeline, an 800-mile marvel of engineering that was constructed following the discovery of oil at Prudhoe Bay in 1969. The pipeline carries oil from Prudhoe Bay, on the Arctic Ocean, across the entire length of Alaska from north to south to Valdez, on the Pacific. Incredibly, against all odds and northern obstacles including those −50°F temperatures, permafrost, mountains, and giant rivers, the pipeline was completed in just three years. With it came the highway that I was traveling on, but lost forever was the magical notion of an inaccessible Arctic.

Finally, the Brooks Range began to loom large ahead of me, a sign of the true north of Alaska that I had been daydreaming about for many months. For me this represented a huge step in this grand journey, a transition that took us out of the world of the grizzly bear and toward the realm of the polar bear. Although I had to remind myself that the coast and the habitat that polar bears call home were still over 200 miles away, the feeling of isolation was building quickly.

Jack Reakoff, besides being a man whose name I want to steal, provided a welcome break on the long road north. The tiny town of Wiseman was an apt place for this fascinating, knowledgeable character to be. Jack lives in the most classically Alaskan cabin I've ever seen and

subsists by hunting, trapping, and gardening. Wiseman was established in 1907 when gold was discovered in the local creek, and it has retained an incredible charm and historical magic. The gold rush brought much life to the area, but like so many northern towns that were born during the gold rush, Wiseman enjoys a much quieter pace today.

There is a point in the Northern Hemisphere at which life for trees simply becomes too hard. I was feeling the same way at about Dalton Highway milepost 235, famed location of the farthest north (sizable) spruce tree. Sadly, the 273-year-old tree was killed by a vandal a few years ago, but its legacy lives on in an ecosystem that transitions from forest to tundra. Here, even small, desperate-looking trees might be one hundred years old, weather-beaten and tormented by the constant wind and cold. Now I was really beginning to relate. The tree line approximately follows the 50°F isotherm—a line at which the average temperature of the warmest month is, you guessed it, 50 degrees. Even the toughest of trees cannot complete their annual growth cycle above this line, and the significance of this borderline was not lost on me, for it truly meant leaving black bears and their forested ecosystem behind.

A little farther down the highway I approached another landmark: the Atigun Pass, Alaska's highest highway pass at 4,739 feet and the gateway to a different world. As I rumbled up the washboard road, climbing into the mountains, I thought about another shift in my surroundings. Dipping over this Continental Divide, I began a steep descent, now in synchrony with the rivers and creeks that were flowing northward toward the end of Alaska and the Arctic Ocean.

A perfect welcome awaited me on the edge of Prudhoe Bay. A lone caribou bull witnessed my arrival and was a sign of the true beginning of my time in the far north of Alaska. To the east generally lies the Porcupine Caribou herd, and in the other direction, the Western Arctic caribou herd. Prudhoe Bay is in the heart of the Central Arctic herd.

The desolate terrain reminded me of the Himalayas and their inhospitable edge. Every mountainside appeared to be crumbling away in the face of the relentless weather. Even the rocks seemed to buckle in the harsh environment. But this too was grizzly bear habitat. The long, winding road took me across many miles of mountainous terrain and through a beautiful array of dramatic weather that all at once flashed heavy gray clouds, then deep patches of blue. It seemed like the kind of place that could turn on you in the blink of an eye, so I pushed north, skimming the western edge of the Arctic National Wildlife Refuge (ANWR), which stretched more than 200 miles eastward to the Canadian border.

Finally, the mountains gave way to open rolling tundra and the giant skies of the North Slope, where caribou and musk ox graze, providing an occasional meal for an opportunistic bear. With the mountains now behind me, the vastness of the open landscape gave me a sense of freedom and relief, a feeling that quickly disappeared as I struggled to pitch my tent that night in a relentless arctic gale. And for a magical moment my first caribou watched me from a distant ridge—a hopeful sign of the giant herds I was dreaming to find later on this journey.

As I met up with the Sagavanirktok River, my destination of Deadhorse drew nearer, but before the end of the road 100 miles to the north, the perfect introduction to Alaska's Arctic awaited me. A huge shoulder hump moving through the willow shrubs caught my eye. I first jumped to the conclusion that it was a grizzly bear, but moments later the truth was fully revealed. It was not one beast, but a herd of at least twelve musk ox, grazing their way calmly through a dense sedge wetland as if positioned to welcome me to this northernmost stretch of the road.

The end of Alaska's northernmost highway was finally in sight, but I had no idea what to expect. As my 1,100-mile ride from Homer edged me closer to Prudhoe Bay and the industrial town of Deadhorse that supports the oil field, the feeling of complete isolation in a wide-open wilderness was overwhelming. The long final stretches of straight, flat road, and my increasing exhaustion, made the unfolding scene quite surreal.

It began with flickering lights on the horizon—the first sign of any civilization for over 130 miles (and far more since the last town on my route). It reminded me of a desert mirage, as the buildings slowly took shape and the dark gray sky a few miles ahead marked the end of the land and the beginning of the Beaufort Sea and Arctic Ocean.

I slowed to a crawl to take it all in. I was suddenly surrounded by heavy industrial machinery, flaming gas flares, giant buildings, refinery apparatus, and parking lots the size of ten football fields filled with snowplows, trucks, and equipment. Even my sudden transition from the wilderness into Anchorage had been less shocking than the feeling I had arriving here. In one of the most inhospitable environments on earth, a city has emerged, and with it, the largest oil field in North America. Prudhoe Bay sits between the famed Arctic National Wildlife Refuge (ANWR) to the east, and the National Petroleum Reserve, Alaska (NPRA) to the west, as if taunting and ready to strike in either direction.

But I tried to stay focused on the things that were still to come. I was now in polar bear country.

Journal Entry, Dalton Highway

It is simply amazing to ride across Alaska. It is a giant place in every respect. The miles seem endless, and there are times when complete delirium sets in as the road screams by under my wheels. My body aches, my hands are stiff from the cold and fighting the handlebars for hundreds of miles today. There is mud and grit everywhere. Every inch of my bike is covered, and I struggle to keep my visor free from dirt for more than a few seconds at a time. Within a ten-mile stretch, the weather throws everything it can at me: bright sunshine and dust, torrential rain and mud, hail, and sleet.

Huge trucks headed for Prudhoe Bay kick rocks against my body, and I struggle to pass them on the rutted, muddy road.

This is the only sliver of civilization—a narrow human footprint of tarmac carrying me across the land. In every direction there is endless wilderness. It is liberating but daunting to think that there is no sign of human life over any of the countless hills, mountains, and ridges.

I watched my shadow dance across hundreds of thousands of trees today as the sun sank toward the horizon—an endless stream of life and home to countless animals and birds that likely witnessed my brief passing. At times the dense forest begins to thin, as if threatening to peter out, only to be replaced by another giant carpet of conifers stretching as far as the eye can see over the next rise.

And then, the Arctic Circle—66 degrees, 33 minutes north latitude, and a psychological leap toward the north. I swear my body tingled as I rode over the imaginary line. It seemed like a poignant and suitable place to spend the night, plus I was losing light fast. I summoned the energy to put up my tent and then slipped immediately into a deep sleep.

As I ride the endless miles, images of polar bears flash through my mind, and I ponder the incredible idea that they evolved so recently from grizzly bears in a northern environment like the one I am riding

The road seemed to go on forever at times, especially as I neared its end across the flat, open landscape of the North Slope. The dark clouds on the horizon mark the end of the land and the beginning of the Arctic Ocean, and the home of the polar bear.

toward. It seems so appropriate to be following that journey through the increasingly harsh world of the bear. As I ride these enormous distances my respect and admiration for the animals that live here soar. The adaptability of the grizzly bear crosses my mind. That the same animal can thrive in places as different as the lush Alaska Peninsula and here on the wide open arctic tundra reminds me that they have always succeeded where other species have not. To some extent, only we hold them back.

It is truly ironic how this road takes me north, cutting through some of the wildest land in North America, but will ultimately deliver me to a place that has brought exploration of a different kind—oil. Here in Deadhorse, a giant industrial complex feeds the needs of Prudhoe Bay, North America's largest oil field. I wonder about the impact that a place like this has on the animals that I seek. Not just the bears that are displaced from this north slope habitat, or those that stick around only to be killed following unwanted human encounters, but also those bears affected by the climate change that begins with our thirst for oil under the very ground I now stand. It is harder here than anywhere I have ever been, to maintain a balance in my mind about the needs of humans and wildlife. I am burning with anticipation to see the polar bears so that I can escape the stark visual reality of this place.

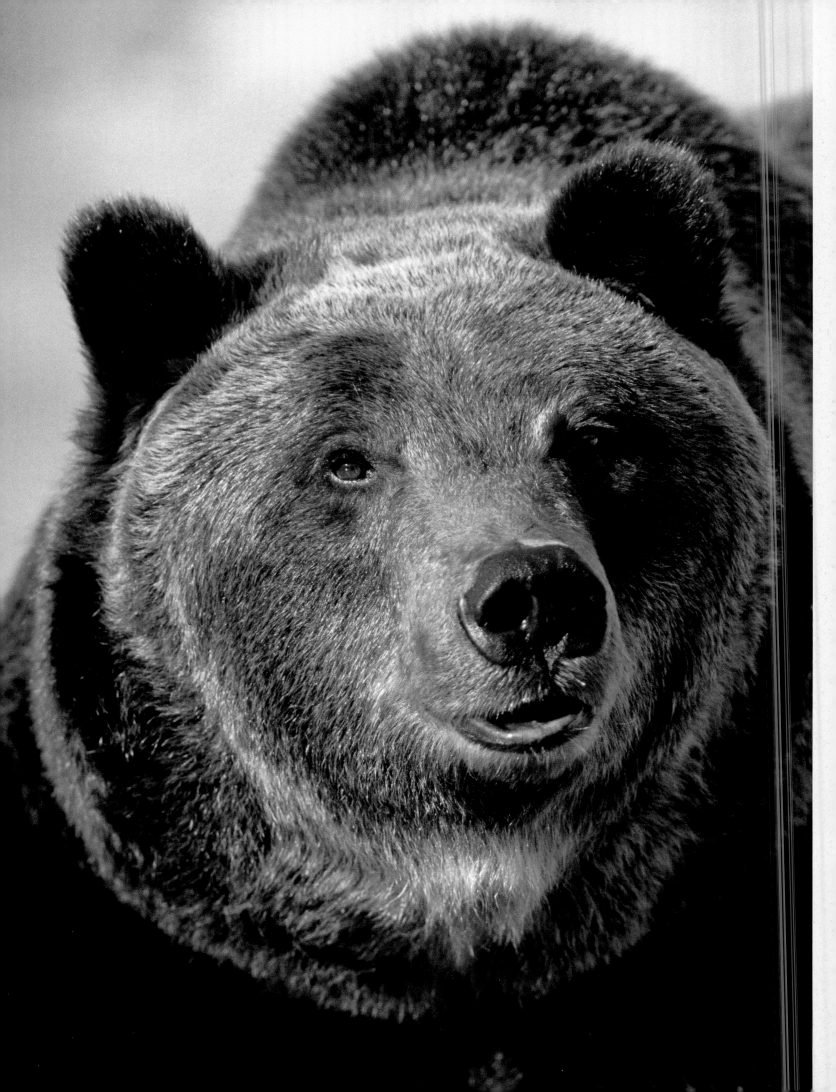

left Soapberries are a grizzly bear favorite, and they were common along many sections of the Dalton Highway. Grizzly bears have been known to consume 200,000 of these berries per day.

opposite The grizzly bear is a hardy, adaptable creature, able to thrive in a vast array of different habitats. As I rode north into more hostile country, the huge range of the Alaskan grizzly bear struck me. From the deep forests of the south to the barren tundra of the north, and even at times, the pack ice offshore.

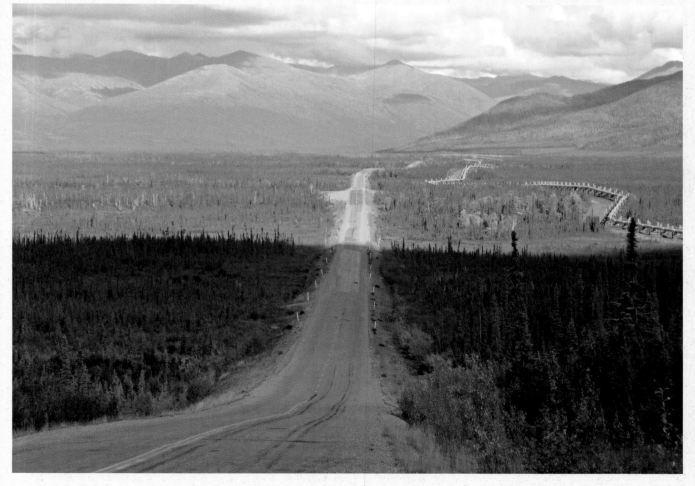

In certain places it takes all my concentration just to stay on the road; deep ruts and thick mud threaten to throw me off more than once today. And when I stop, the silence returns—only the *tink tink* of my cooling engine can be heard. Until the rumble of another giant truck thunders by, Arctic bound to the oilfield.

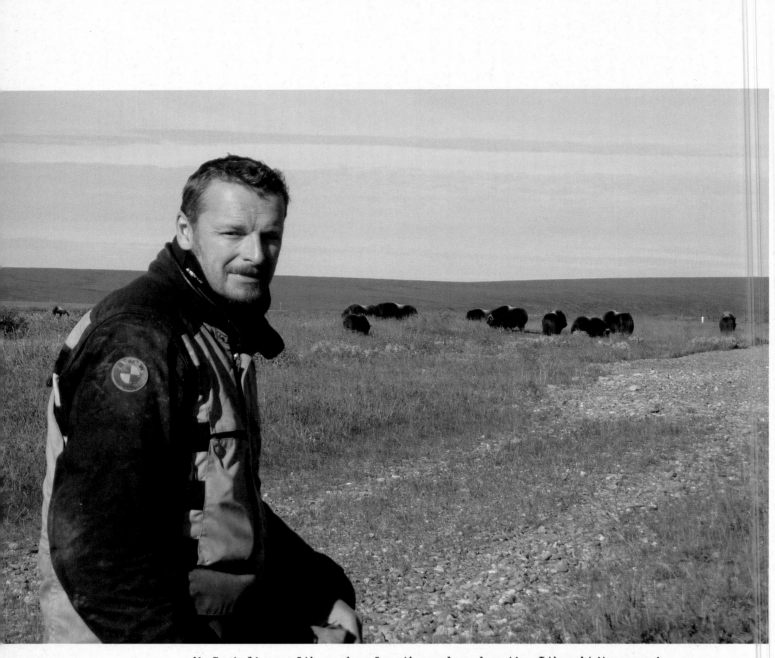

My first glimpse of the musk ox from the road was deceptive: I thought it was a grizzly bear meandering through the willow brush. But then I stopped and discovered at least twelve musk oxen grazing within 200 yards of the road. These incredible-looking animals had been eradicated from Alaska by the mid to late 1800s, but have since returned, thanks to a breeding program, begun in the 1930s, that used stock from Greenland. Several thousand of them now roam regions of northern Alaska. In this area, grizzly bears are known to occasionally prey upon calves—no small feat given the protective nature of the herds.

opposite The musk ox, or *omingmak*, "bearded one," as it is referred to by Iñupiat peoples. My encounter with them on the Dalton Highway was the first since 1991, when I had spent time assisting a study on their ecology on Banks Island in the Canadian Arctic. I would watch them for hours from camp as the males charged like ancient long-maned mammals across the tundra before clashing heads with a resounding echo around the valley. They have fascinated me ever since.

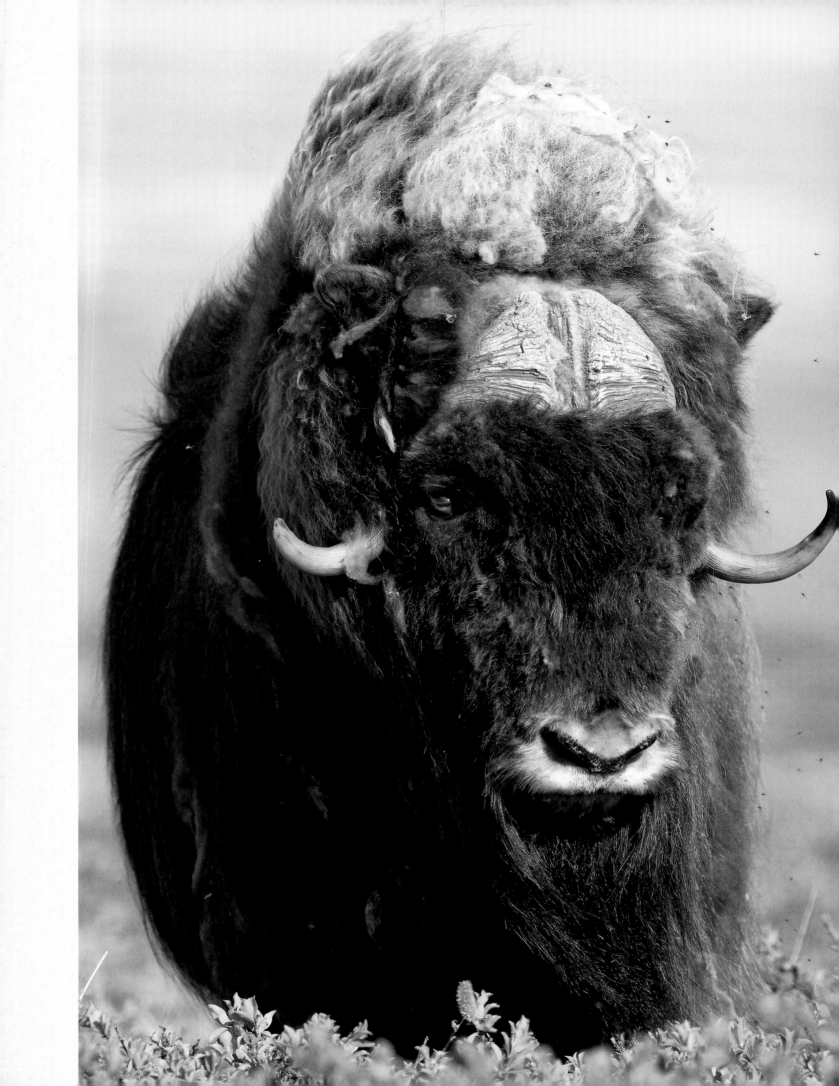

To me, the Deadhorse—Prudhoe Bay region is where the realm of the grizzly bear gives way to that of the polar bear. Both species are found in the area around town where the tundra ends and the sea ice begins. Members of both species occasionally wander through town, which can lead to tragic results for bears; they are occasionally killed in defense of life or property after being attracted to human sources of food.

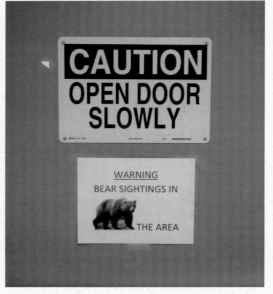

The home of Jack Reakoff in the tiny historic town of Wiseman. Jack is a man whose tie to the land is as true as any I have seen. Subsistence hunting, trapping, and gardening occupy much of his time. This photograph shows his berry collection kit. At the bottom, there's a red berry picker, a trellis to sort the berries from the leaves with the help of a fan, and two full sacks of low bush cranberries, which Jack told me are an excellent source of vitamin C as well as a decent cure for an upset stomach.

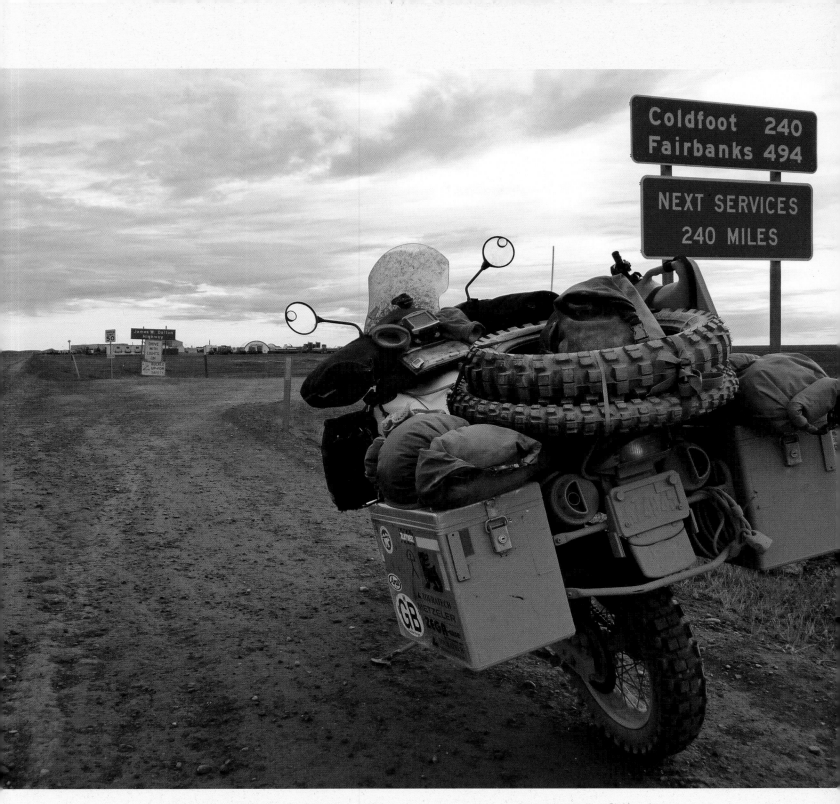

Ready for anything. My bike is loaded with camping gear, food, spare parts, clothes for any weather, tools, and spare tires. Not only is motorcycling an environmentally sound form of transport, it's a lot of fun too.

overleaf A female grizzly bear with three spring cubs makes her way across the northern landscape.

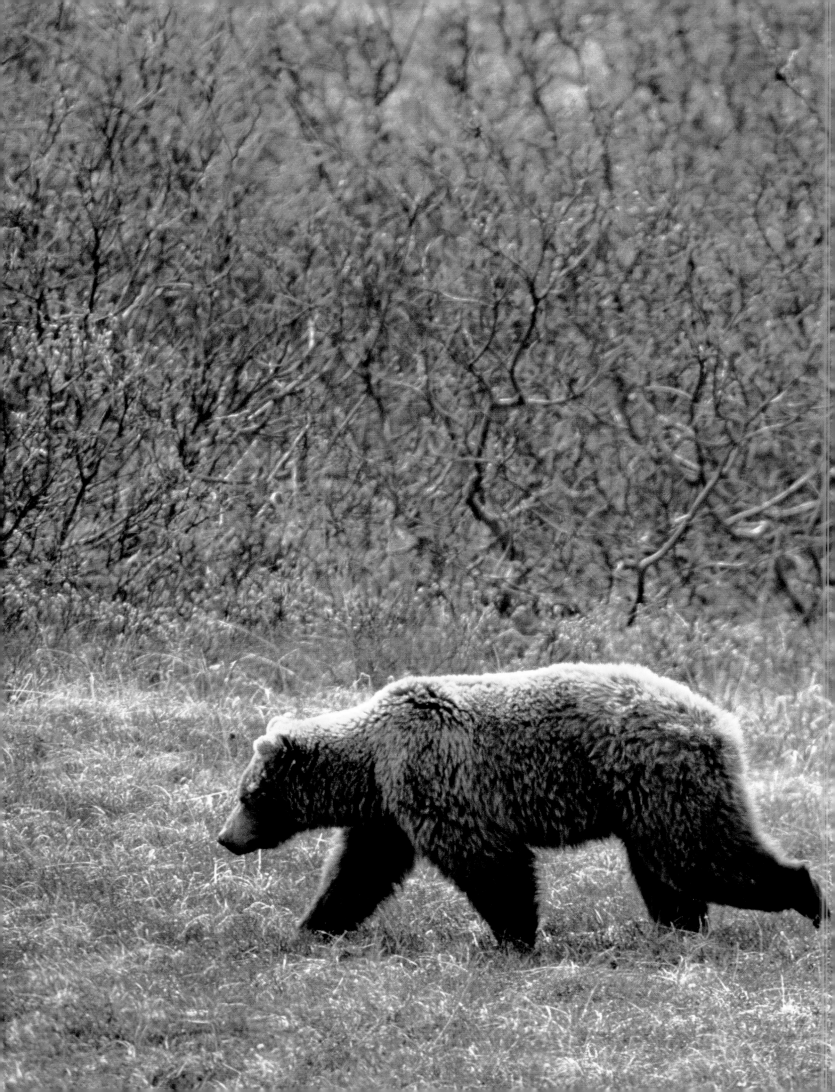

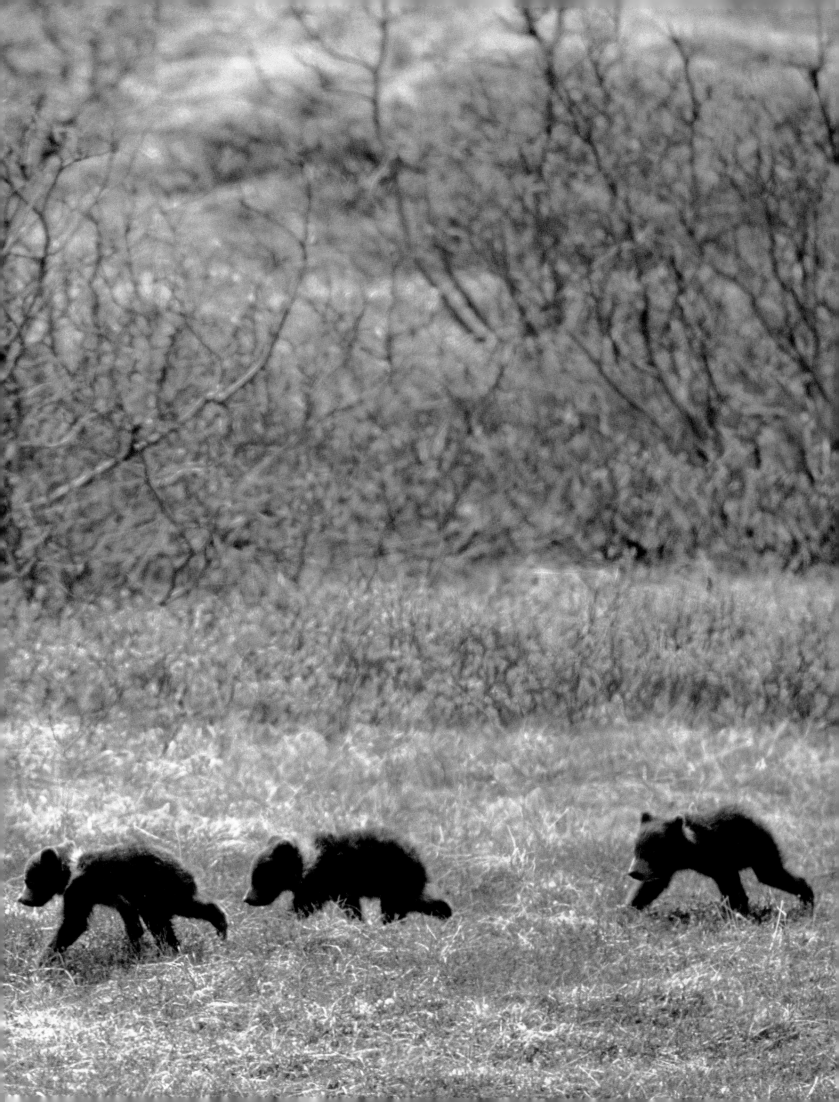

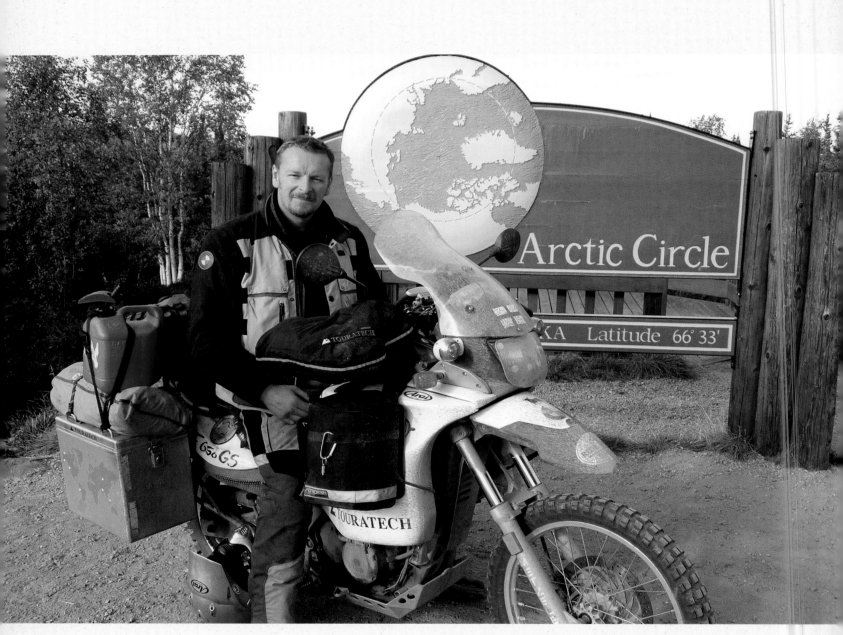

It was hard to believe I was crossing the Arctic Circle, as the weather on this particular day was very mild and welcoming.

opposite A bull caribou in Deadhorse, the town that supports the needs of Prudhoe Bay oil field.

Joe and I prepare our respective vehicles for the long trip north along the Dalton Highway.

top One of many camps along the way. This one is just outside Wiseman, nestled among the fall leaves on the banks of the Koyukuk River.

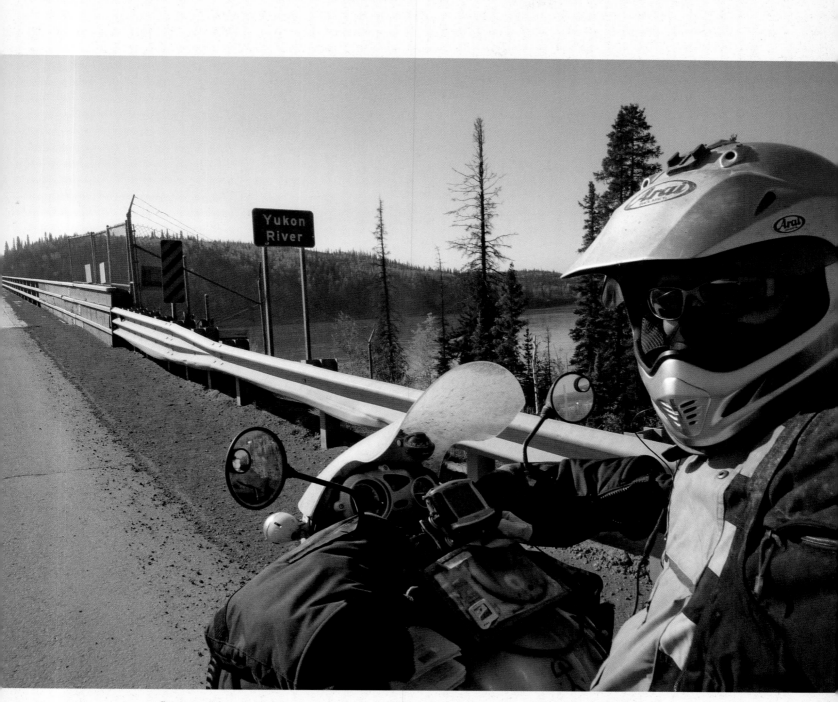

Crossing the mighty Yukon River was a major milestone, but I still had 360 miles to go before reaching Prudhoe Bay.

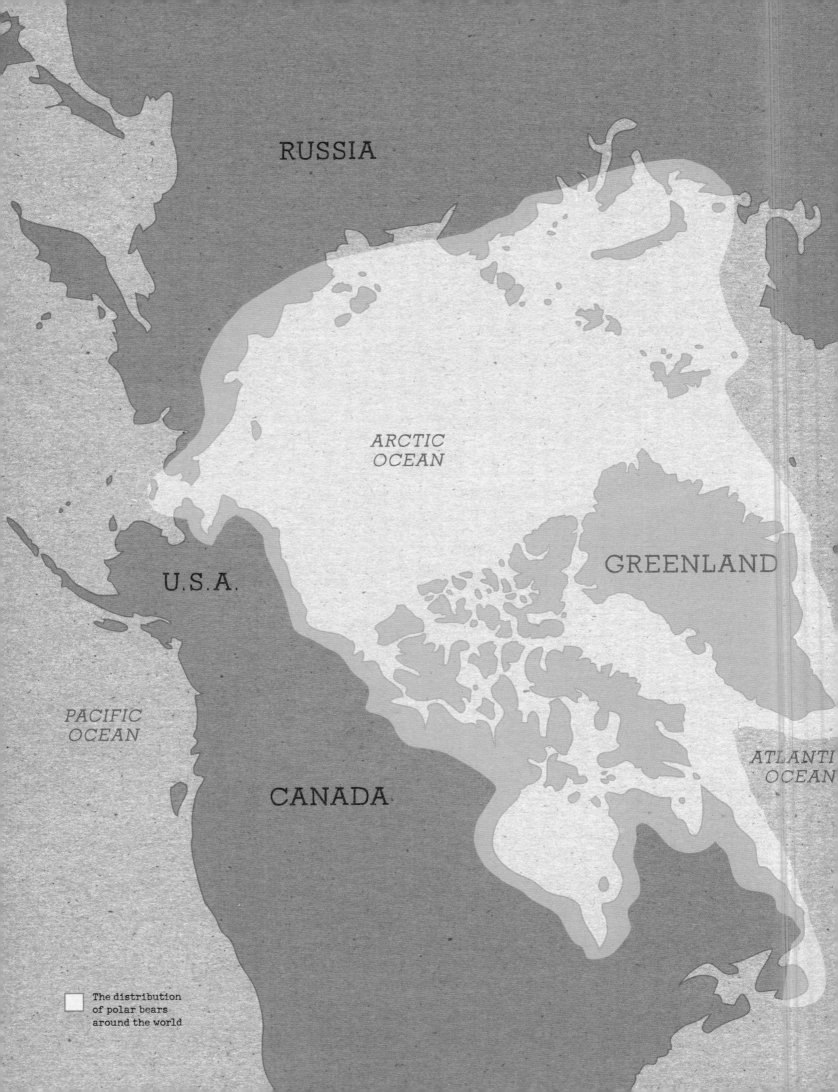

RUSSIA

ARCTIC
OCEAN

GREENLAND

U.S.A.

PACIFIC
OCEAN

ATLANTI
OCEAN

CANADA

The distribution
of polar bears
around the world

POLAR BEAR KINGDOM

Sea Ice and Northern Hospitality

Our search for the polar bear had begun in my imagination as I rode the long road north, long before I arrived in Prudhoe Bay, and was to take us to another two locations in their Arctic world in the far north of Alaska. First was the tiny North Slope town of Kaktovik, 115 miles east of Prudhoe Bay and 70 miles west of Canada's Yukon Territory as winter was taking hold in earnest.

Polar bears have always fascinated me. So in 1998, when I started guiding polar bear viewing trips to the Canadian town of Churchill on the coast of the mighty Hudson Bay, my smile was hard to conceal. Here, the "Polar Bear Capital of the World" offers visitors a chance to watch, photograph,

and learn about polar bears up close and personal, from the comfort of a specially designed bus with giant tundra tires. It is a magical experience and one that leaves thousands of people changed forever each year from their taste of the polar bear's world. I've also been lucky enough to guide trips to the European High Arctic, where polar bears roam an icy paradise of mountainous islands called Svalbard. The experience is incredibly adventurous, sailing aboard an icebreaker among the floes in search of hunting bears.

Despite the fact that I have been fortunate to see many polar bears, my arrival on the northern coast of Alaska was about to give me a whole new understanding of life for these icons of the ice. Never before had I ventured out on foot into the vastness of the pack ice in search of polar bears, and the entire experience was beyond anything I could have imagined.

Incredible as it may seem considering its impressively well-adapted physiology and behavior, the polar bear is the youngest of the world's eight bear species (the most ancient is South America's Andean, or spectacled bear). These masters of the ice evolved from northern grizzly bears in a process that split the species just 150,000 years ago during the very late Pleistocene. To put this in perspective, the earliest bear ancestor was *Cephalogale*, a small fox-like creature found in Europe nearly 40 million years before the polar bear.

The curious evolution of the polar bear is something I thought about a lot as my journey took me northward, crossing that same line that divides grizzly from polar bear. The theory is that a population of brown bears in Arctic Asia became isolated, cut off from other brown

My shadow casts across the end of the Dalton Highway. Ahead of me is the world of the polar bear, and behind I leave the realm of black and grizzly bears.

bears by an advancing glacial ice sheet around 600,000 years ago. I often oversimplify the scenario and imagine a brown bear, looking out to the sea ice, spotting a plump ringed seal for the first time, and thinking "Why not?" The rest is history as they say—or at least paleoecology if we want to get technical.

The polar bear's overnight success as a highly specialized bear came about through "quantum-speciation," a process that involves the rapid evolution of numerous physiological changes. For the polar bear these include an adaptation in fur color for camouflage, webbed toes to improve swimming ability, an elongated neck that facilitates hunting and life in and around water, hollow hairs to improve flotation and insulation, sandpaper-like foot pads to aid traction, and a thick layer of fat to keep the intense cold at bay. I've seen every one of these adaptations put to use, and combined they make for an incredibly well-designed animal.

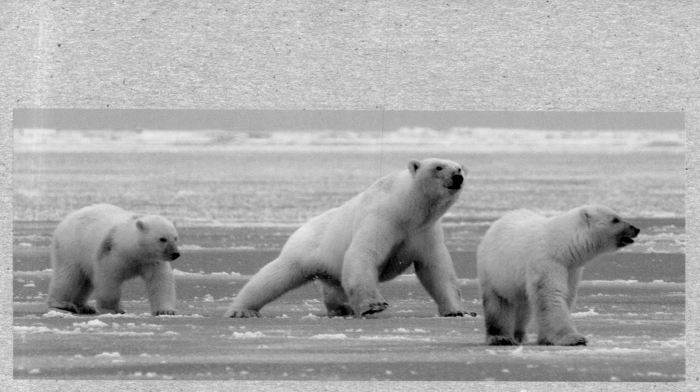

A female polar bear and cubs near Kaktovik make their way gingerly across newly formed pack ice. I've watched many polar bears in the fall as they sense the return of the ice; the anticipation is very high, and they actually seem excited. And for good reason: With the return of the ice comes the seasonal opportunity to hunt seals again for those bears that have stayed ashore during summer.

A female polar bear with a pair of two-year-old cubs patrols the shore during a fall freeze-up. Cubs usually stay with their mother for two and a half years, learning everything they need to know by watching her closely.

The problem is that this animal has become *so* well-adapted to its environment and diet that change comes hard.

Climate change in particular does not bode well for the polar bear—or any animal adapted to the cold. They spend most of their lives on the ice—a concept so incredibly alien to us that it is hard to imagine an animal being so completely comfortable on a frozen sea amid the harshest conditions on earth. They hunt, sleep, mate, and wander thousands of miles in this habitat, thriving in a world that was new to them until very recently in the evolution timeline.

I've watched polar bears climbing icebergs, dancing between ice floes, swimming frigid seas, and sprawled out casually during mind-numbingly cold arctic storms. They *always* look at home in the cold. On one occasion I watched a young male dive repeatedly into the slushy ocean from an icy platform. Time after time he would belly flop right into the sea, often jumping onto a slab of ice, a little like a giant kitten pouncing onto a toy. Seconds later he would haul himself out, dripping gallons of water from his fur, only to repeat the same flop a second or two later. I swear he had a smile on his face the whole time. It seems very apt that polar bears are categorized as pagophilic, or "ice-loving." It's certainly the impression I got from the young male bear that day.

In essence, during the last 150,000 years polar bears have diverged from their grizzly

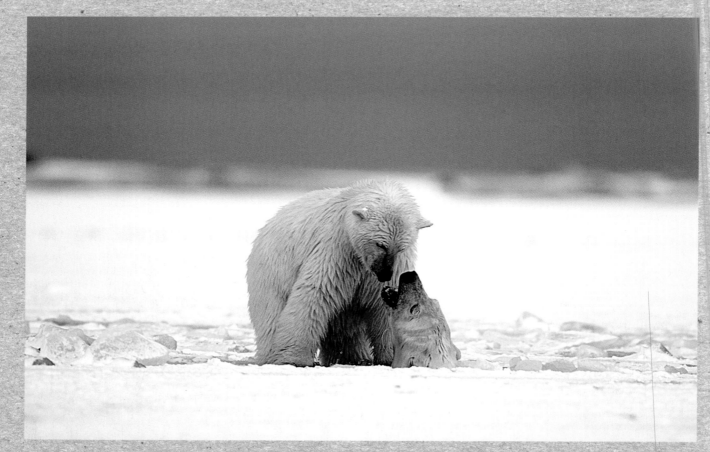

A spring cub with a playful glint in his eye wrestles with his mother through a hole in the ice. Polar bears are completely at home on the ice; in fact, without it they cannot survive.

bear cousins under the intensive pressure from their environment to select for traits geared toward hunting seals from the ice. If ever there was a specialist, this is it. It is ironic given the highly adaptable nature of their close cousin, the grizzly, that this specialization may have sealed their fate.

Their dependence on ice makes polar bears *the* climate change "canary in the coal mine." Predictions estimate we will lose two-thirds of the world's polar bears by the year 2050 due to the effects of climate change upon the arctic environment. That's a loss of around 16,000 bears in forty years, or an average of more than one bear every day. It is not exactly clear where the dwindling habitat of the world's remaining polar bears will be by that time, but it certainly will not be here in the Southern Beaufort Sea, where the amount of optimal sea ice habitat will decline by 6 percent per decade over the next forty-five years. More likely, this century's polar bears will retreat with the ice to the high arctic archipelago of Canada and northern Greenland, existing in much smaller numbers than they do today.

Arriving in Kaktovik in the fall, we immediately joined Art Smith, a filmmaker who has spent many years documenting the lives of the local polar bear population. His passion for these animals is clear, and it is born of countless hours of observations and many thousands of memory cards full of beautiful film footage. Art has come to know the bears as individuals with distinct personalities and characteristics. He has seen a curious mixture of polar bear behavior here. For example, as with most Alaskan polar bears, the majority of the Southern Beaufort Sea population is pelagic, meaning they remain with the sea ice year-round as its edge pulsates over the course of a year like a giant heart beating across the cap of the earth. Other bears jump ship, leaving the retreating ice each summer in preference for the land. They bide their time patiently awaiting the fall return of the sea ice and the platform upon which they depend for seal hunting.

In other places where polar bears are cast ashore for a period of time each year, like the Western Hudson Bay population in Canada, life is becoming increasingly difficult due to the earlier breakup of the ice in the spring and later freeze-up in the fall. Research there has shown a correlation between the weight of bears when they arrive onshore and the date of the sea-ice breakup; earlier breakup means lighter bears. At the other end of the ice-free period, more time on land extends the fasting period, and the bears return to the ice in dire need of a meal. So, more time on land means lighter bears, which means reduced reproductive success and cub survival.

It is a simple equation: First and foremost, polar bears need ice. Their lives have become intertwined so closely with the seasonal behavior of ice, and their main source of prey, the ringed seal, that they have become completely dependent on it.

In Kaktovik, the polar bears belong to one of the nineteen polar bear populations in the world, the Southern Beaufort Sea population. The bears here, as elsewhere, rely upon the rich waters that cover the continental shelf offshore and that are generally less than 300 meters deep. The continental shelf provides an upwelling of nutrients resulting in a copious supply of zooplankton. The zooplankton feed fish, which in turn are fed upon by seals, the favored prey of polar bears. It is a simple ecosystem,

which means that it is desperately vulnerable to collapse. Where will the seals be when the ice retreats farther north due to climate change and beyond the riches of the continental shelf? Once their populations plummet due to poor habitat, so will the number of polar bears.

October is freeze-up month in the Southern Beaufort Sea, and we spent our time in Kaktovik filming bears that were patiently waiting for the ice to return. The anticipation is heavy in the bears' faces. They nose the air frequently, searching for signs of changing weather, and despite their reputation as wanderers, we watch them do everything *except* wander as they wait for the ice to pave their way northward. It's an important distinction I suppose—yes, they are wanderers, but they are *ice* wanderers, and they have little interest or reason to roam the land when the world they rely upon is the Arctic Ocean.

One of these wanderers managed to approach us within one hundred yards as we were filming one day, and we were barely aware he was there. He nosed the air intensely and made a beeline for us at a fast walking pace. On a mission, with a target in sight. This was no grizzly or black bear—the entire focus and intent of this animal was different. As we scurried to the safety of our skiff, it reminded me of the polar bear's ability to stalk seals across the ice—a deft skill, especially considering that ringed seals have evolved as many ways to avoid polar bears as polar bears have evolved to catch seals.

We watched several polar bears during our two weeks in the fall on Kaktovik's beaches as they awaited the seasonal freeze-up of the ice. Much of the time they were in a patiently quiet, waiting mode. Conserving precious energy and trying to stay cool, hunkered down on any patch of snow that they could find until their icy home grew steadily out to sea.

The next stop on our search for polar bear stories was a springtime journey to Barrow, the northernmost city in the United States. Located at 71 degrees, 17 minutes north, it lies 320 miles north of the Arctic Circle and just 1,300 miles from the North Pole. Like Kaktovik, Barrow is home to the incredible native Iñupiat Eskimo people.

Here, we were to have one of our most fortunate encounters on the entire journey: a chance meeting with a person who captured our hearts immediately. Dale Brower is an Iñupiat whose welcome in the frigid spring temperatures of Barrow was heartwarming. He freely invited us into his community and showed us things that now seem out of a surreal and wonderful dream. The northern world he unveiled took us back in time to a place where community and family come first and where the tie to the land is as essential as the air people breathe.

Part of Dale's magic was his vibrant spirit and his total zest for life. He enjoyed snowboarding and adventure in exotic locations around the world, but still held true to his roots in every way. He was a wonderfully curious mix between the old and new. His knowledge of life in the wilderness was immense and had been passed down through generations before him. But as a young man, he was also a big fan of everything the modern world had to offer. He was nowhere more at home than in the Arctic, and he made the most of everything the land provided.

Despite his easygoing nature, when Dale set foot on the sea ice, he took on a serious, totally confident air that was eye-opening to me. Here he became 100 percent Iñupiat. Dale was com-

pletely at ease out here, but also mindful of the many dangers that could emerge, from thin ice to snowstorms and polar bears. He was keen to share the magic of this frozen world with us, and it is a privilege that will stay with me forever.

We spent much of our time with Dale searching for polar bears over many long, cold days, but he also invited us to join him for the annual subsistence whale hunt on the sea ice near Barrow. The hunt happens each spring with the return of the sun, and this special cultural event brings a glow to every person's mood. The bowhead whale hunt is hugely significant for this small community and continues a tradition that stems back thousands of years.

Dale arranged for us to join the whale camp around eight miles out onto the ice. This was a special privilege, and not one that we were expecting. Accessible only by snow machine, we maneuvered over miles of blinding ice and around massive pressure ridges sometimes two stories high. Like fault lines thrust skyward by tectonic forces, the ridges each told a story about current ice conditions, and Dale was reading every single clue. Including signs of polar bears of course. There were times when he would stop to quietly assess the conditions in every direction, and I would wonder what he was thinking. I never asked of course; he'd tell me in his own time.

Iñupiat Eskimo Dale Brower welcomes us to a camp about eight miles out on the ice near Barrow. This traditional subsistence whale-hunt camp was like a scene from the past, set amid giant ice ridges on the edge of an open water lead.

We passed several crews dragging their traditional umiak hunting boats toward a carefully selected spot on the ice edge. In the voices and faces of every person we encountered, we found eager excitement at the prospect of this special community event. However, seeing the boats made the potential dangers very clear to me. The beautiful vessels are made of animal skins (usually seal) stitched together with caribou sinew, and they are the perfect vessel for hunting, chosen in lieu of modern aluminum ones as they are significantly quieter and also easier to repair. Yet, they were no more than twenty feet in length, with a wooden frame—like a perfect relic from the past.

A bowhead whale, by comparison, may be more than sixty feet in length and can weigh more than sixty tons, or 120,000 pounds, second in size only to the blue whale. A tongue alone can weigh one ton—or the same as ten large men! Even a one-year-old calf can measure twenty-six feet long. So the feat of a successful hunt is monumental, and taken very seriously indeed.

Bowhead whales spend their entire lives in and around arctic waters. The whales that we saw near Barrow winter in the southwestern Bering Sea and then slowly migrate north and east each spring to feed in the Chukchi and Beaufort Seas. Thousands of them make this journey every year, and en route they pass Barrow. Following open leads (ice-free openings), they scoop up tons of copepods and amphipods, planktonic organisms that are filtered through a whale's baleen. It is during this annual migration that the Iñupiat from Barrow have traditionally hunted in a

The umiak, a traditional whale-hunting boat made of sealskin, is prepared at the edge of a lead, where the crew will patiently wait for a whale to emerge. They will share the meat and blubber with the entire community.

above Whale blubber sits in the ice after a successful hunt. Every part of the whale is utilized after the traditional subsistence hunt. The food is shared among the members of the crew, and then with the entire community back in town.

left Muktuk—the skin and blubber of a bowhead whale—is prized by the Iñupiat people. Their excitement grows in the spring as they anticipate the arrival of this annual food source.

carefully managed process that allows a harvest of up to twenty-two whales each year.

I wasn't sure how I was going to feel as I witnessed the whale hunt. I'm not opposed to hunting for food, but this whole setting was completely alien to me. For some people the hunt can be a difficult thing to accept. The conundrum of traditional hunting for people who love wildlife is a stimulating and ongoing debate. To me, there are different ways of loving wild animals, and respect as a source of food is among them. For the Alaskan Eskimo, in a land that offers little or nothing, bears, caribou, ducks, and whales are more than an essential part of life. It is difficult to describe just how deep the connection is between native people and the animals that they hunt. It is more than respect, love, honor, and need combined. It is as if there is no separation between the people and the animals, and whenever another living

The whale crew flies their flag proudly from their traditional hunting boat near the shore in Barrow as a sign of success. Each crew has its own unique flag, and takes huge pride in helping to provide food for many people.

being gives its life to provide food, it is thanked, praised, revered, and respected.

During my time at the hunting village on the ice, my experience was nothing short of intensely magical. I came away with a huge appreciation for the people, the respectful process, and the vitality of a culture that looks toward the sea for its survival. The excitement and anticipation during this event pulsate throughout the community of Barrow, not only because of the cultural significance of the hunt, but also because it represents a time of plentiful food for all to share. Even relatives who live in distant towns and cities receive gifts of carefully distributed meat and muktuk, pieces of skin and blubber that are highly cherished by the Iñupiat.

Back in town we were invited to join a "sharing," where the successful hunting crew divides up much of the whale meat and blubber for the entire community to enjoy. It was a fascinating and moving scene as a long line of people gathered at the front door and were greeted by the proud captain of the whale crew. Following a VHF radio announcement and prayer of thanks by one of the elders, it seemed as though the whole town filed through the house, gratefully accepting their preprepared baggie of muktuk, whale heart, and meat.

Out on the ice, just a few hundred yards from the home of the successful crew, sat the hunters' umiak, flag flying proudly in the midnight sun, a signal to the whole town that the hunters had been blessed with success.

As we headed back out to the sea ice in search of polar bears again that night, the whole significance of the ice as a critical home for the bear took on new meaning. It was just as much a home for the people here too.

Journal Entry, The Sea Ice

Our arrival in Barrow was intense and overwhelming. It has been a long journey to get here, and within an hour of my arrival I was layering up to head out onto the sea ice in search of bears.

We are traveling with Dale, an Iñupiat. He has a humble confidence born of his people's long history on the ice. For the Iñupiat, this icy world is home, and they have become as resilient as the bears around them. Nothing is half-done here. . . . It's all or nothing . . . black and white. Live or die. Eat or starve. Stay warm or freeze to death. Eat or be eaten.

It's a way of living that is raw and wild. It's rough in a way that is born of resilient people in an extreme world. It makes me feel so inadequate, so spoiled, and more vulnerable than in any other environment I've been in.

The Iñupiat are a proud people. They represent what is best about a way of life that demands fortitude, stamina, and determination. One Iñupiat man told me yesterday, "We've always been here, and we will always be here."

This is the Arctic of my childhood dreams. It is intact, alive, and thriving in a way that I really wasn't expecting. It pulsates with energy and makes you feel alive. It's intoxicating. This is not a place on the brink of extinction; it's a community that is stronger than any I've ever seen. In fact, it's the epitome of the

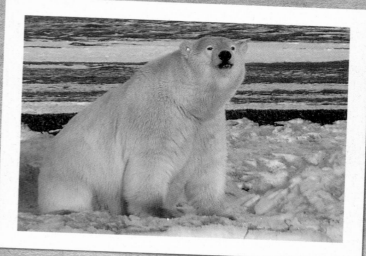

Young bears like this one are very curious. This species most likely had to be in order to evolve from brown bears in the first place. Curiosity leads to opportunities for finding food, which is a trait shared by all Alaska's bears.

Polar bear tracks on the tundra close to the shore.

word "community," where people band together to survive, share, and thrive. It makes me feel like the rest of us have lost our way.

I'm overwhelmed by the sense of generosity among these people toward one another. *Everything* is shared, in the way it always was. It is the way it *has* to be. Because you can't survive out here alone.

The whale hunt that we have been allowed to witness is a spiritual thing for the Iñupiat, but also an event that brings uncles, aunts, and cousins from all over the Arctic to take part in the annual bounty. The people are looking for nothing but the right to continue their traditional way of life here at the end of the earth.

Our long search for polar bears resumed in the cold today at midnight. Endless light during these late spring days make for a tiring schedule, and Dale is never keen to slow down. Joe is also in his element—like any filmmaker, he loves the perfect warm glow of light provided by sunrises and sunsets. Right now, it is one long sunrise, as the sun skirts the horizon in an endless arc. So our search becomes endless too. I'm constantly on the brink of collapse.

It's −6°F, −20 with the wind chill. We're covering a lot of ground on the snow machines and it is exhausting. The cold wears you down and makes even the simplest of tasks difficult. I constantly think of the polar bear thriving in conditions many times worse than this.

Then, a clue. Fresh polar bear tracks. Very fresh. In fact, some of them even crossed our snow machine tracks from an hour earlier. We clambered off our machines to take a closer look and to scan the horizon carefully with our binoculars for bears. But at that moment, a serious look came across Dale's face. "We need to leave," he said calmly. Without question I jumped on my machine and followed him gingerly

across the ice. I didn't waver an inch from his path as I had a feeling he was concerned about the thickness of the ice. As we left, he pointed out a giant hole where another snow machine had broken through earlier.

Our retreat was essential—the ice pan that we were standing on could have broken free at any moment and drifted far out to sea. It has happened before. I was amazed. To me, there was nothing different about this ice than any of the ice we had covered for hour upon hour for the entire week, but Dale simply saw things that we didn't. He reads the conditions of this white world like a city person reads downtown street signs.

We circumvented the treacherous sections of ice and managed to relocate the polar bear's tracks about a mile away. They were huge. Twice the width of my giant boots and pressed gently into the snow by a creature that had been here moments ago. I threw my shotgun over my shoulder and followed Dale toward the horizon, pausing at each giant track along the way. Joe had an air of intense anticipation, and camera at the ready. Our exhaustion was gone. Temporarily suspended for these moments among the footprints of something far more capable than any of us. Humility poured over me as I contemplated where I was, and what we were doing.

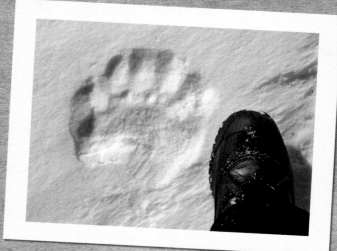

We scanned the horizon from the top of an icy pressure ridge, but the bear was nowhere to be seen. He may have been hiding behind any number of icy obstacles, melting into his environment, at one with this frightening place. Perhaps we'll find him tomorrow, which may have already begun.

I found this very fresh polar bear track while searching the ice with Dale and Joe. Perhaps the sound of our snow machines had spooked the bear just minutes before. He was nowhere to be seen but could have easily been hiding behind any number of nearby ice ridges and snowdrifts. To give you some sense of scale, I wear a size 13 boot.

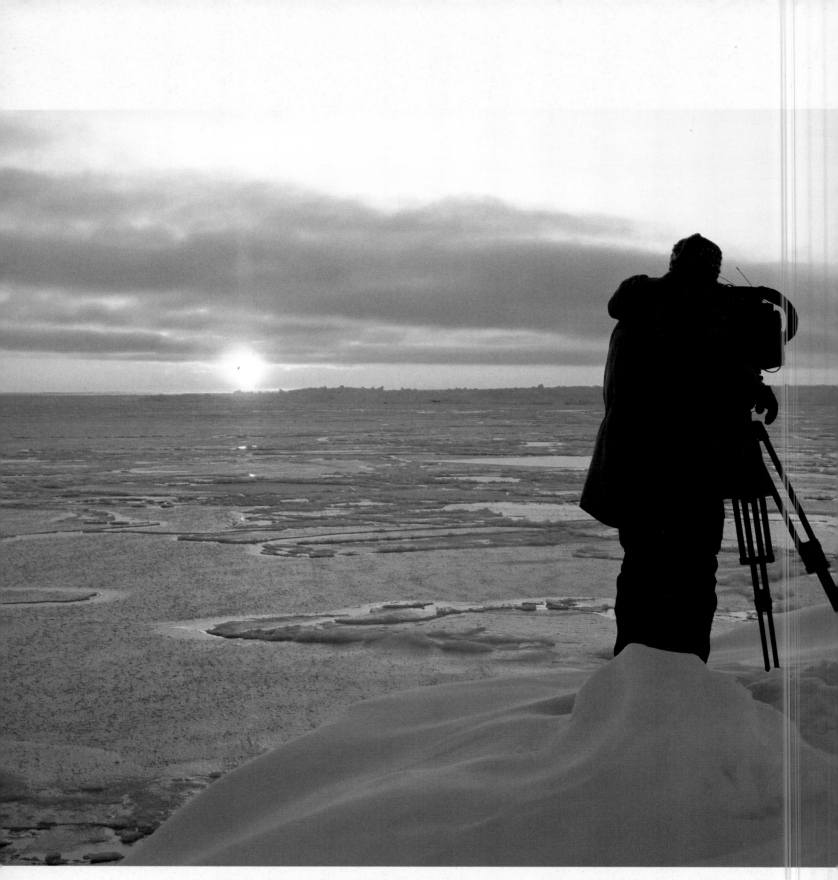

Joe had to work hard just to keep equipment from freezing up, but unbelievably, the camera remained intact in these inhospitable arctic conditions.

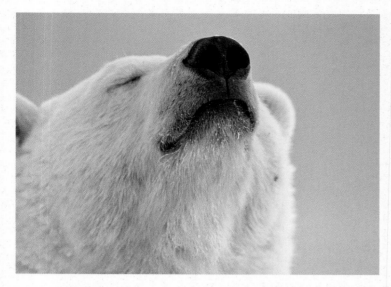

A polar bear's sense of smell is unparalleled. It has to be. In order to survive, a polar bear must find and kill seals by stalking them across the ice, waiting for them to emerge from a breathing hole or pouncing through an ice-enclosed nursery den. These bears can smell a seal from miles away, practically "seeing" their environment with their noses.

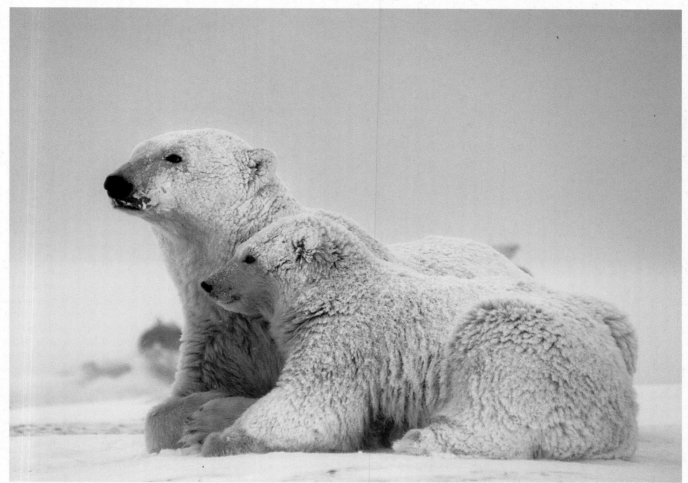

As with all bear species, the bond between polar bear mothers and cubs is extremely tight. I've witnessed even large males retreating from mothers much smaller than they are, as the males are well aware of mother bears' defensive prowess.

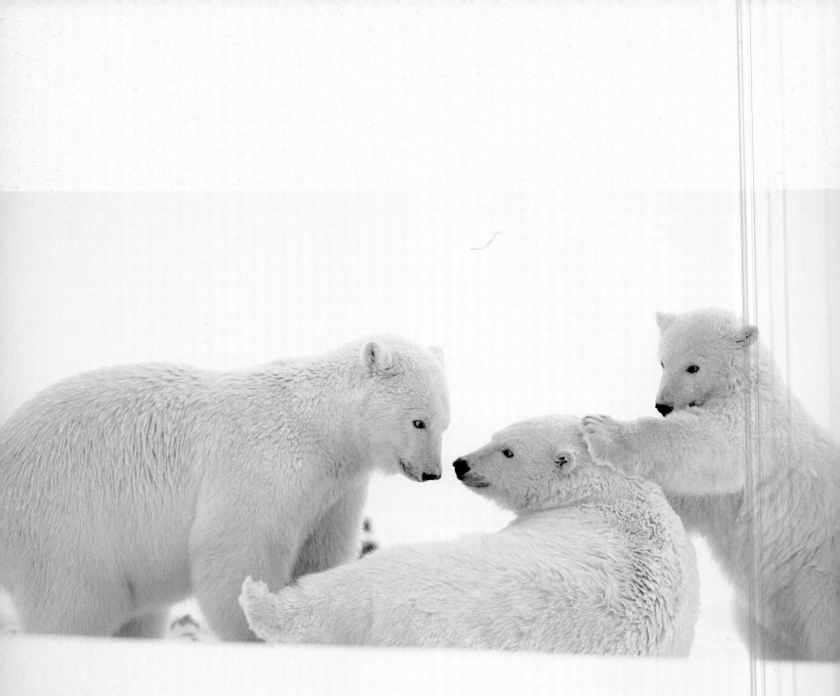

Bears are incredibly playful. The mischievous eyes on each member of this polar bear family say it all.

opposite Fresh polar bear tracks head out across the pack ice. There were times when we missed seeing polar bears by just minutes. Polar bears most often head toward open ice-free leads to hunt for seals. Dale explained to me that dark strips of cloud indicate open water below—knowledge that has been passed down through generations of Iñupiat people. I wondered if polar bears knew the same thing.

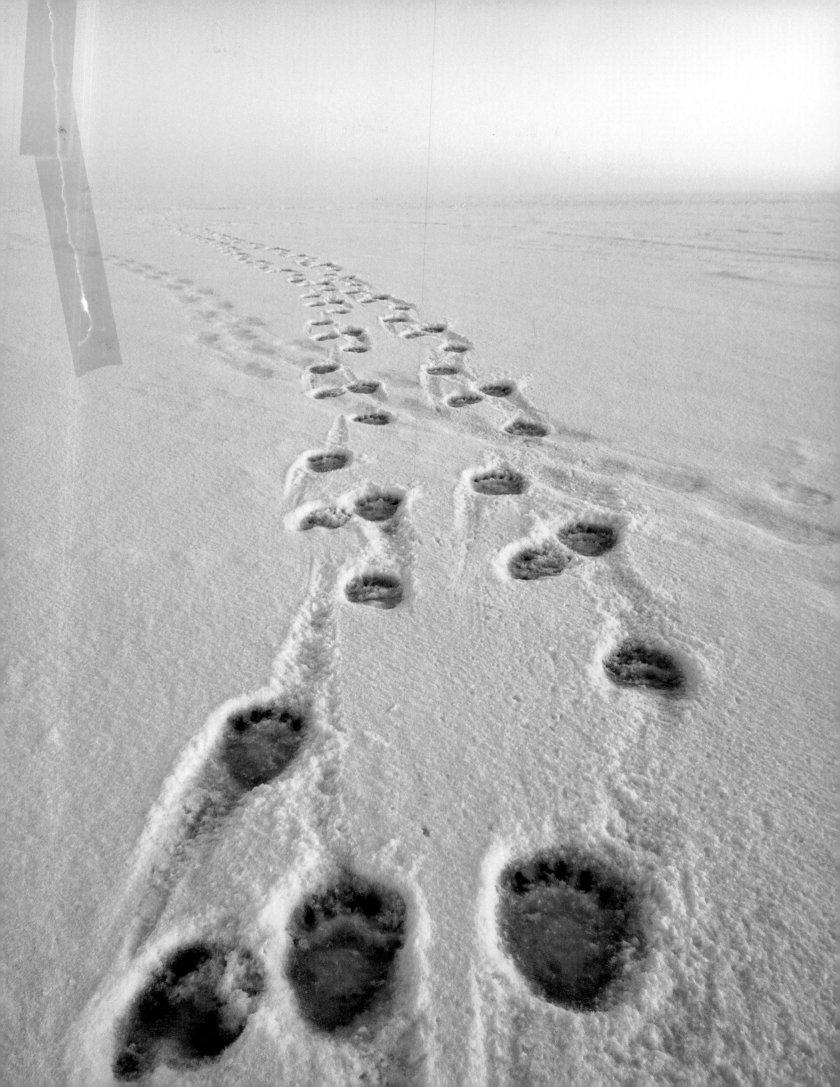

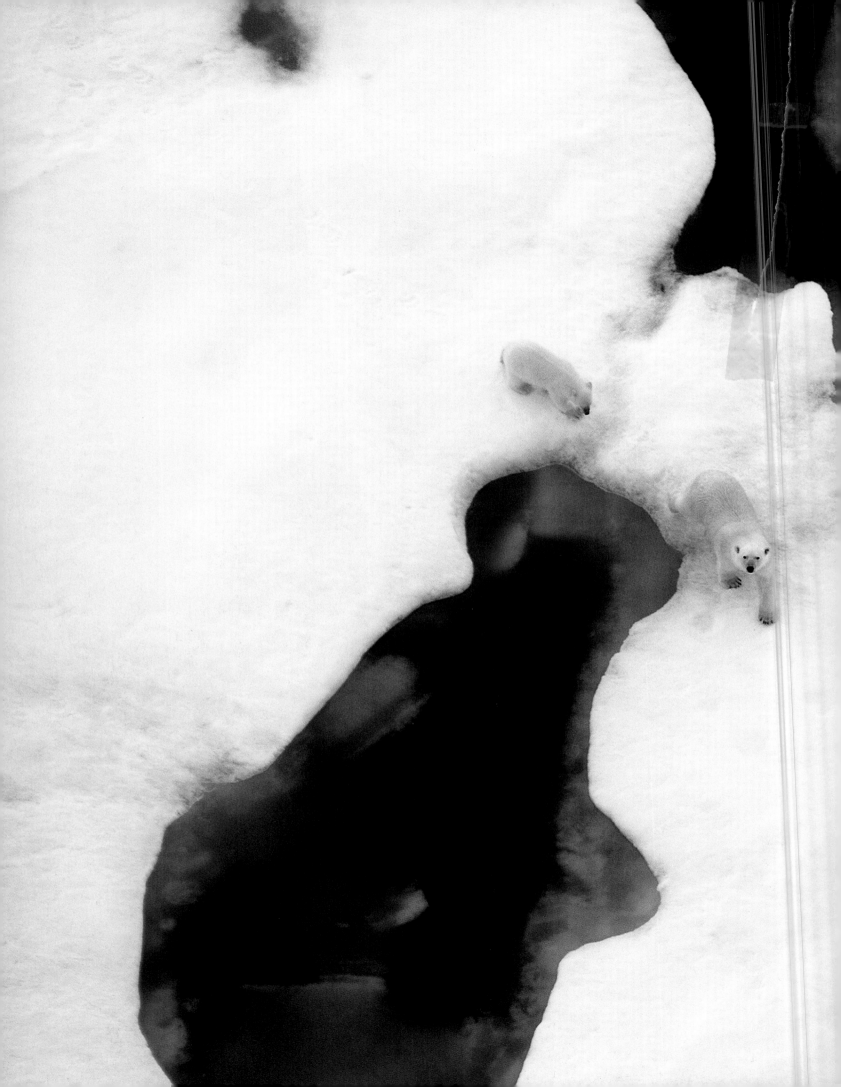

The connection between polar bears and their icy habitat is so strong that if ice conditions decline, so does the health of the bears. Bears need ice because their prey need ice. Their almost exclusive dependence on seals means that conditions have to be just right for hunting. For example, bears need more than 50 percent ice cover to hunt and travel efficiently. Research has shown that a reduction in ice cover leads to thinner bears, fewer young, and lower survival rates. Climate change means that the spring thaw comes earlier and the fall freeze-up later, giving the bears less time to hunt.

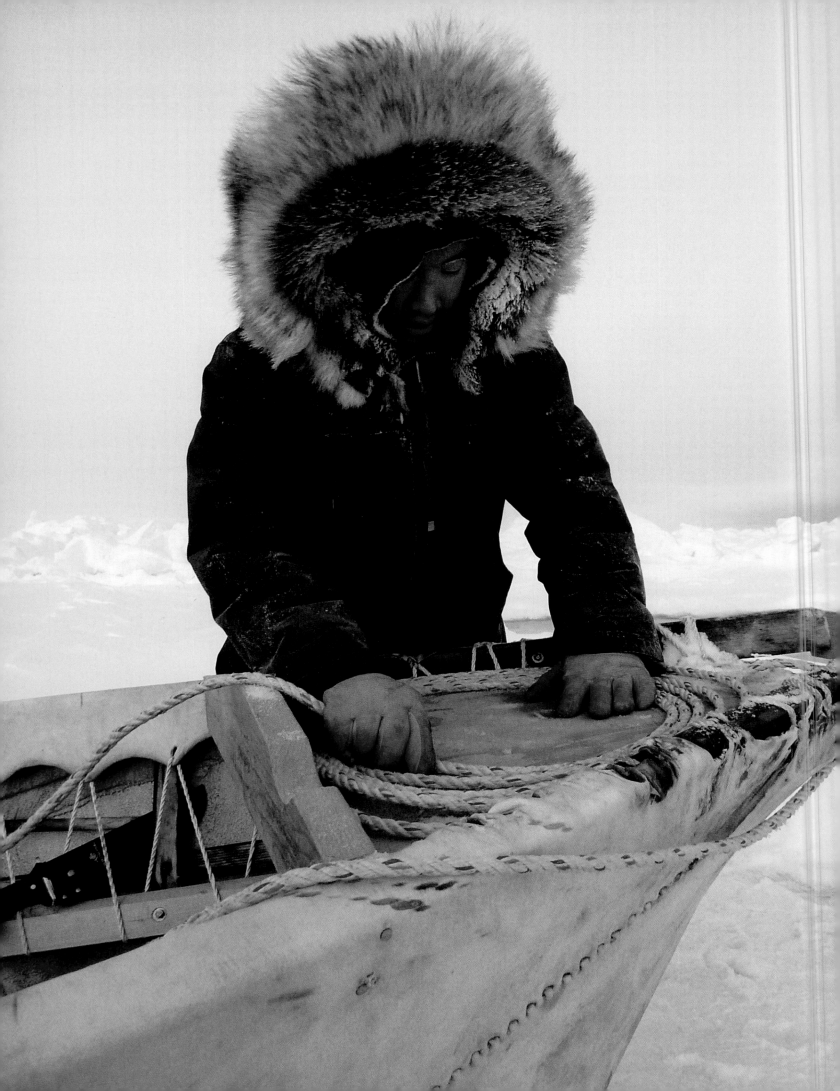

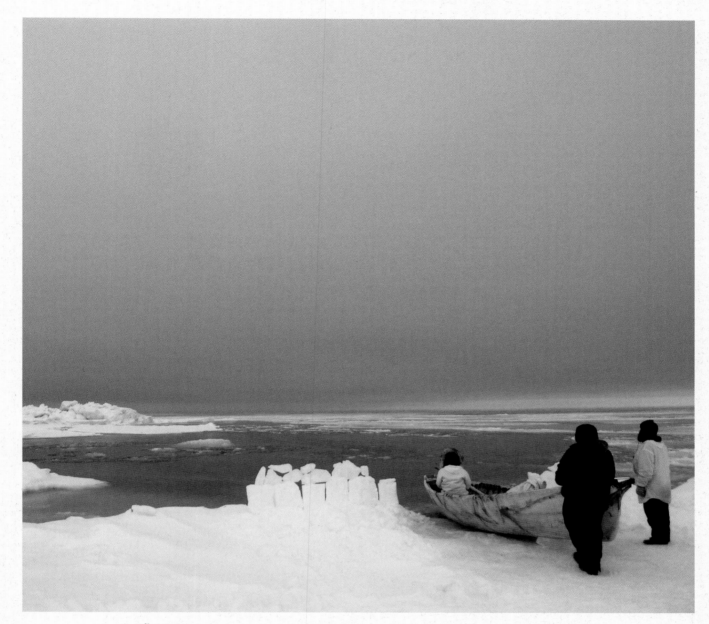

An Iñupiat hunt crew waits motionless in search of a whale. The blocks of ice to the left are placed to help conceal their position at the edge of an open lead.

opposite The umiak, a traditional whale hunting boat made of seal skin, is prepared at the edge of a lead where the crew will patiently wait for a whale to emerge. They will share the meat and blubber with the entire community.

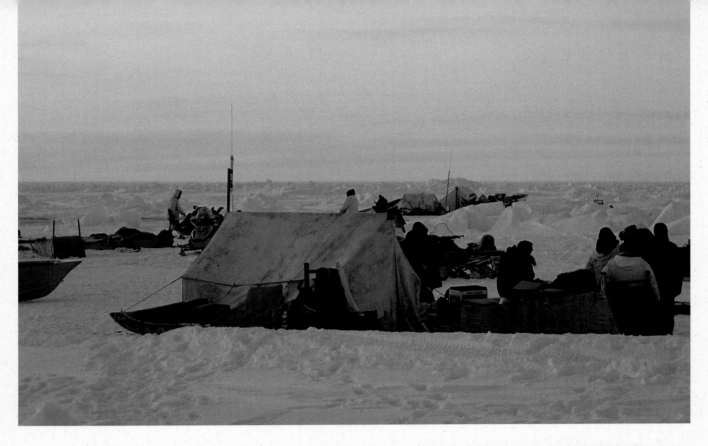

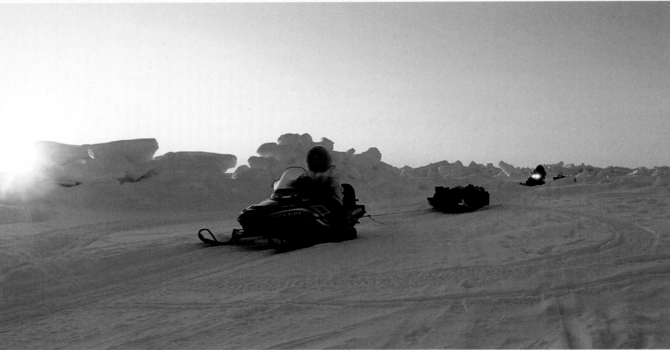

Heading across the pack ice in search of polar bears behind Dale Brower. Constant daylight made for long but very rewarding days in this beautifully surreal setting.

top It was a surreal privilege to spend time at the Iñupiat hunting camp on the ice. It is a place that brings friends, family, and community together in a very moving way.

opposite The remains of a successful subsistence whale hunt bring welcome rewards for bears and birds.

An Iñupiat hunter waits for a bowhead whale to appear. Sometimes the wait can last for hours or even days. The umiak boat is perched on a piece of ice to allow the crew to slip it into the water quickly and quietly as the pursuit begins.

A long way from anywhere in Barrow, Alaska. Amazingly, my old home of London and my current home (near) Seattle were both featured on this signpost in town.

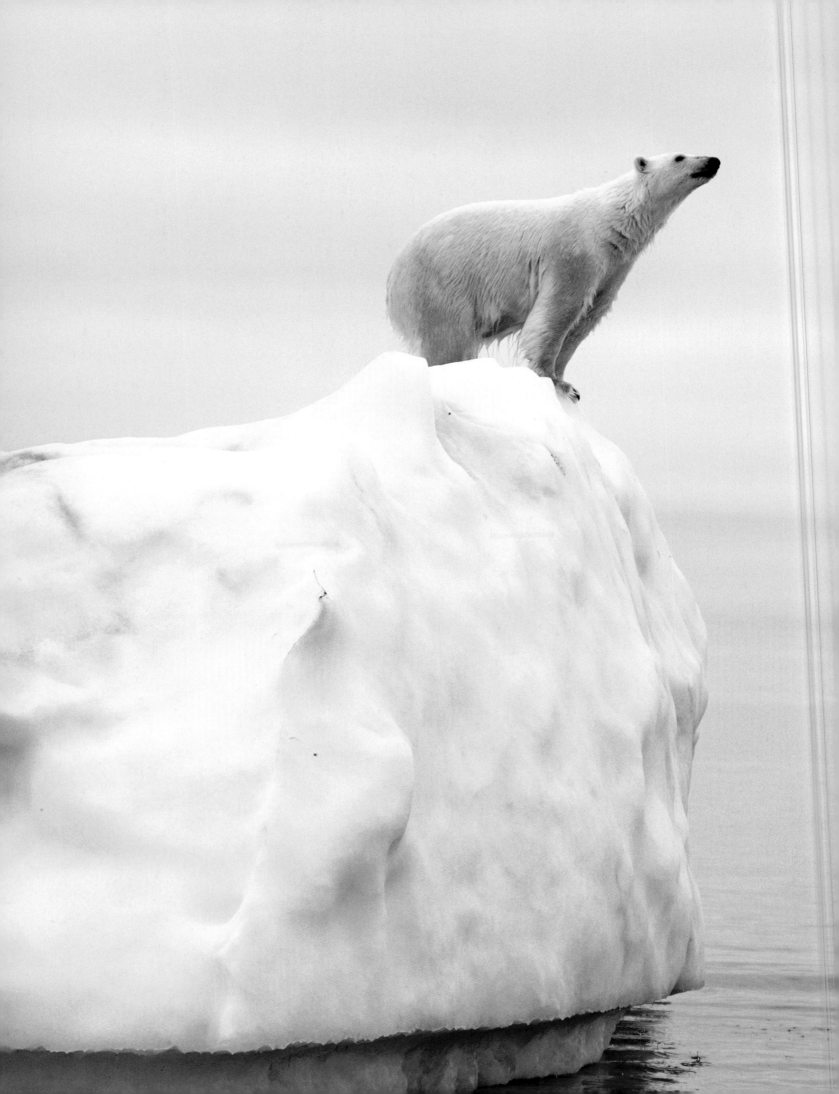

I feel very fortunate to have watched many polar bears over the years, and one thing that stands out and surprises a lot of people is how individual their personalities are. Bears are incredibly intelligent animals with huge variation in character—just like people. We can tend to forget this personal side of bears as we talk of "populations" in distant places, but these populations are made up of individuals, each living their lives with a range of habits and traits, some learned, some passed down from generations before.

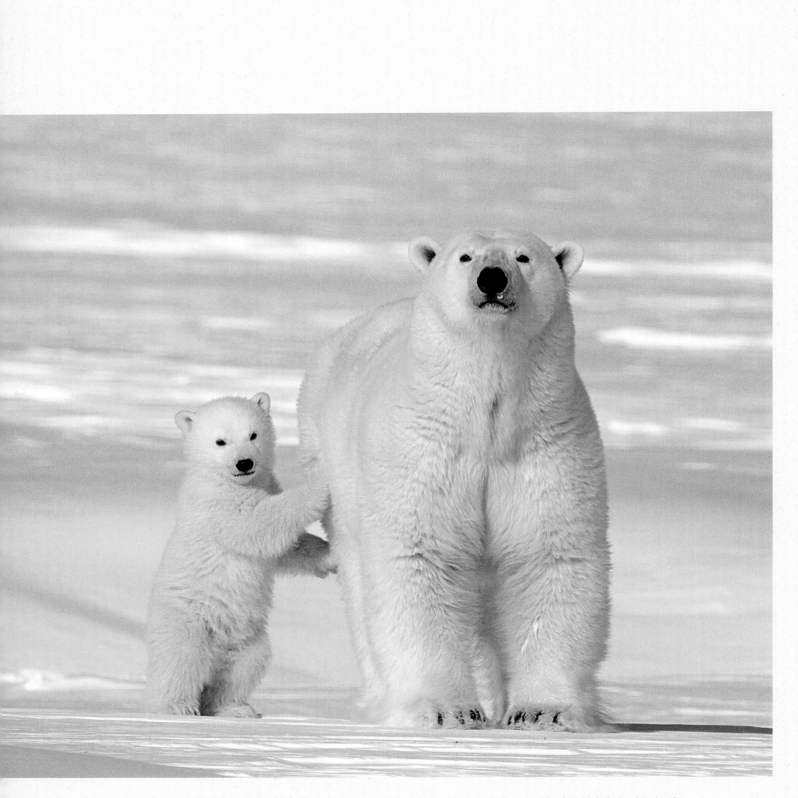

Newborn polar bear cubs weigh only one pound, but due to the high fat content of their mother's milk, they can weigh 100 pounds just a year later. The cub in this picture is around four or five months old and still follows her mother's every move during the first weeks and months after emerging from the den into her new world. The North Slope of Alaska provides some critical denning habitat for polar bears, especially given a documented shift over the last 20 years from females denning more frequently on ice to more frequently on land, perhaps in response to unstable ice conditions.

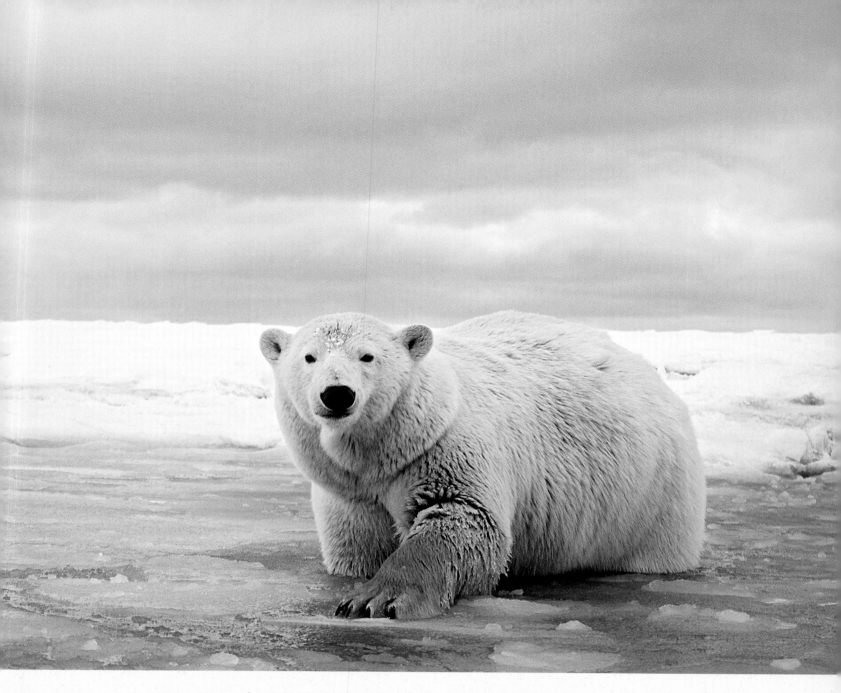

The polar bear's world is literally melting around them. This species diverged from brown bears only about 150,000 years ago, making them the youngest of the eight bear species. We stand to lose two-thirds of the world's population over the next 40 years—an average of one bear per day. This is one of many poignant images taken by photographer Steven Kazlowski. Much of Steve's work revolves around documenting the lives of polar bears in northern Alaska during a time when climate change is having a very noticeable effect on this species.

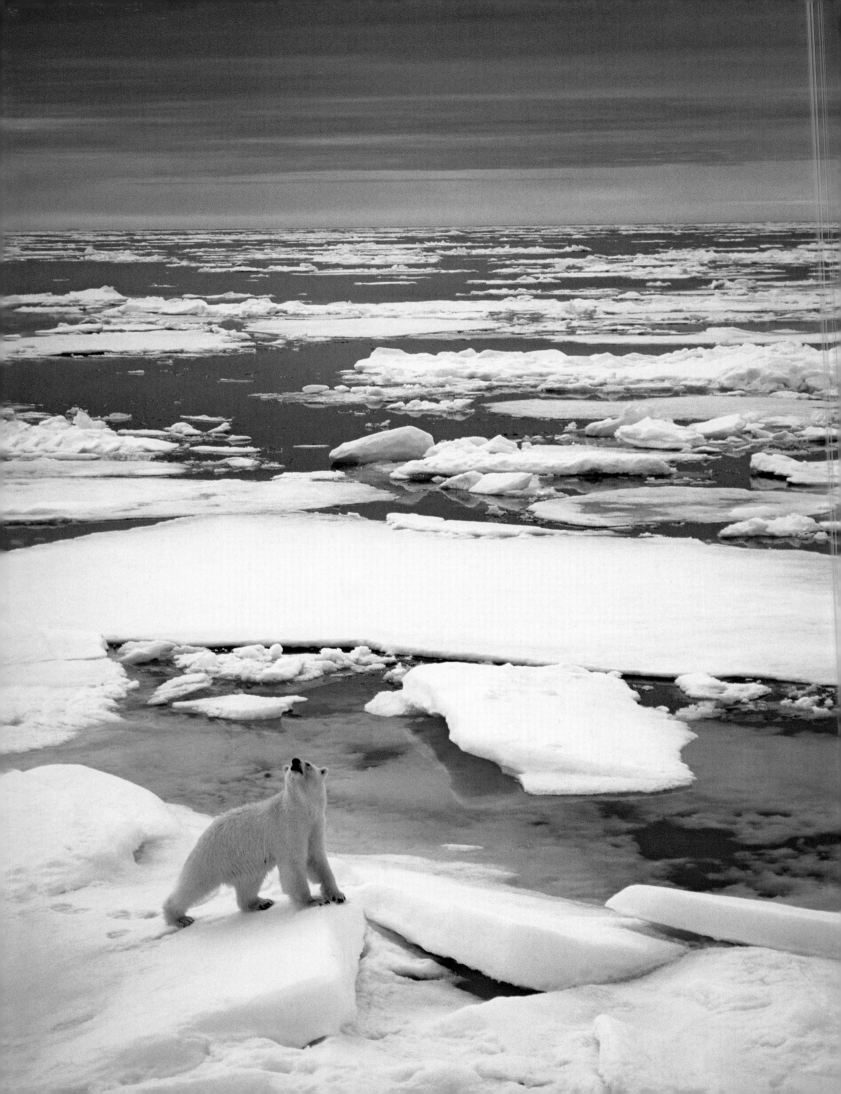

Ringed seals are the mainstay of a polar bear's diet. Seals depend upon ice, and so, in turn, do polar bears. In fact, the two species are so closely tied that the number of seals regulates the number of bears and vice versa, rather like the relationship of the lynx and snowshoe hare. It is even possible to estimate the number of seals from knowing the number of polar bears in a population.

opposite When a bear catches the scent of a bearded or ringed seal, it might follow it for several miles across the ice before stalking the seal and making a dash toward it over the last 20 to 30 yards. More commonly, though, a polar bear will wait at a seal's breathing hole, sometimes for hours at a time, for the seal to emerge. When the seal does, the bear grabs it by the head and effortlessly drags it through the hole onto the ice. (No small feat considering that ringed seals weigh roughly 150 pounds, and bearded seals much more.) The polar bear consumes the seal rapidly out of fear of competition, starting with the blubber, which it "vacuums" off, assimilating 97 percent of the fat.

Arctic ocean sunrise.

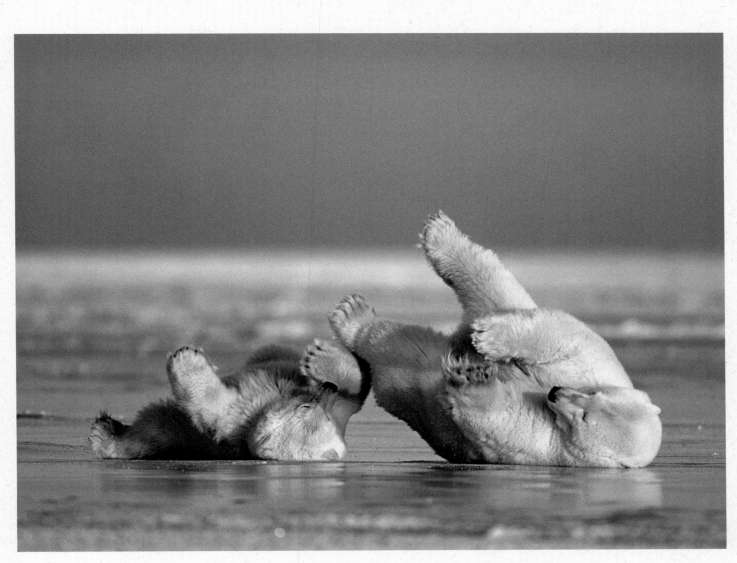

Never before have I seen an animal so at home in such a painfully cold environ-
ment. The polar bears don't just put up with the cold, they relish, crave, and seek it
out. Even the adults become playful with the onset of the fall ice as they antici-
pate the return of the world that they know, the world that they love.

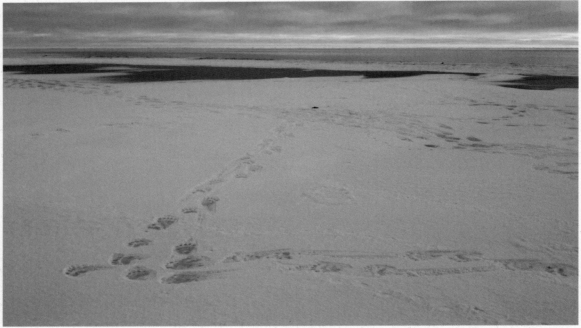

I found these polar bear tracks near Kaktovik, and they tell a story. The bear that left the tracks in the foreground came to an abrupt halt before taking a right turn directly toward a fresh scat (droppings) left behind by an earlier bear. Bears "see" the world through their nose and are able to obtain much information about other bears from the scents that they leave behind.

top A huge fresh polar bear track in Kaktovik showing the five toes of the front paw very clearly.

opposite Polar bears are wanderers that seem to cover ground effortlessly in their endless search for prey. Most of their activity centers around open leads, where the ice reveals productive waters and seals can be found. Research on the Beaufort Sea population over the last several decades has revealed that it is not uncommon for satellite-collared polar bears to travel over 30 miles per day, and have annual activity areas of up to 230,000 square miles. Bears have been clocked at advancing 9 miles per day even when sea ice is moving faster than that in the opposite direction!

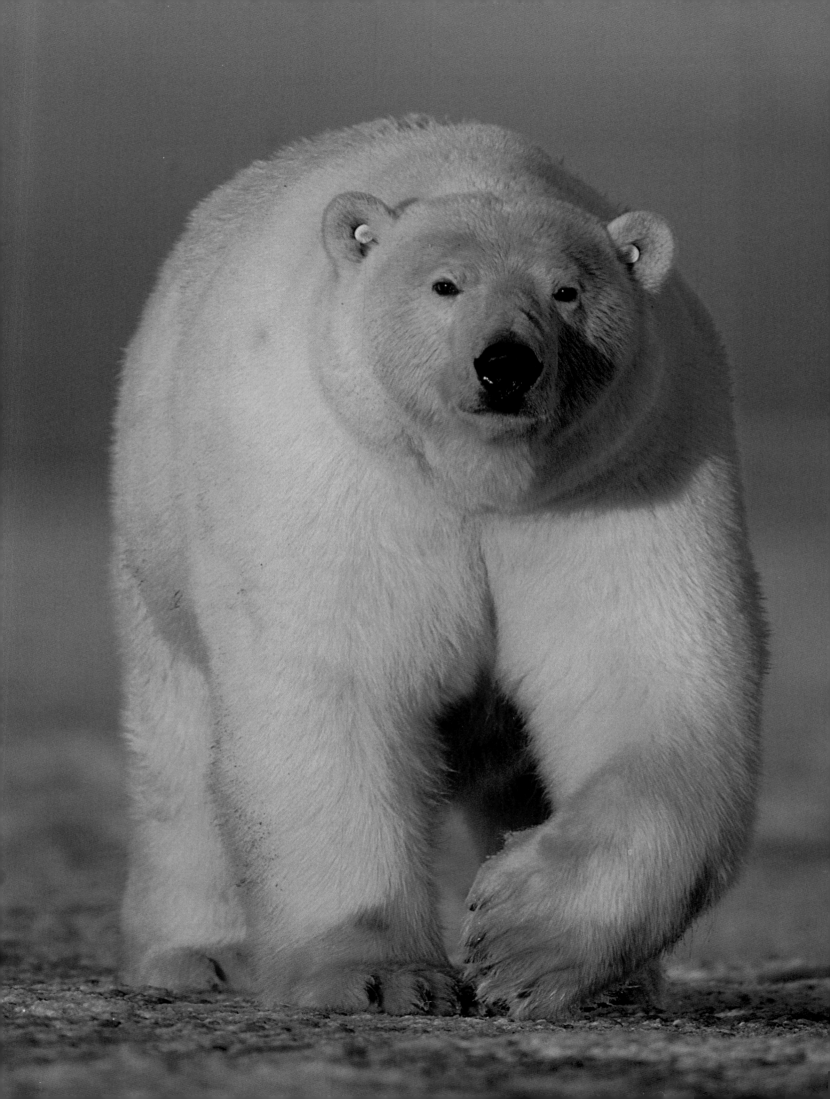

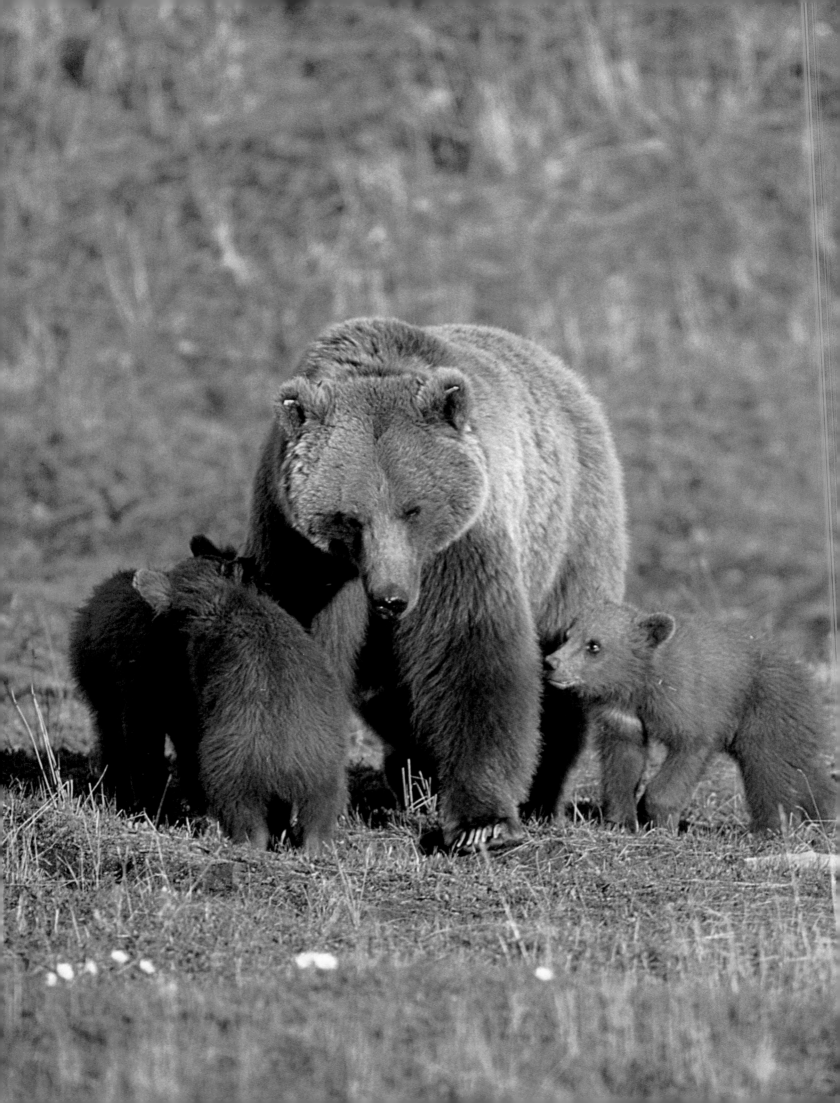

ARCTIC GRIZZLIES

The Brooks Range and Western Arctic— The Unknown Jewel

"Love at first sight" were the words I entered in my journal after seeing the western Brooks Range for the very first time in the spring, and they stir the same emotions now as they did then. I don't remember anywhere else on earth having such a profound, immediate, and deep effect on me, and it's an area I will always long to return to.

This incredible mountain range is the northernmost mountain chain in the world and represents one of the most impressively wild regions of Alaska. West to east, the Brooks Range stretches for nearly 700 miles into Canada's Yukon Territory, bisecting the giant state of Alaska like a convenient wall designed to separate the Arctic from the

rest of America. Water north of the range crosses the tundra of the North Slope, before spilling into the Arctic Ocean, while rivers south of the range flow through the boreal forests to the mighty Yukon, or west to the Chukchi Sea.

We were to spend time in several separate locations in the Brooks Range, in search as always for the great bear. But in this case we were also seeking another treasure: This unknown corner of Alaska is home to the colossal Western Arctic caribou herd and central to the ecology of the grizzly bear.

In early June, I was whisked by helicopter 120 miles northeast from the western coastal town of Kotzebue (located 340 miles southwest of Barrow). The flight took me across the foothills and forests of the beautiful Noatak National Preserve to begin a search that I won't soon forget. From our aerial vantage point, giant rivers looked like endless meandering creeks, trickling from every direction, meeting each other to create even mightier rivers that flow through hundreds of miles of endless wilderness. There is not a person in sight. The scale was deceptive from the start.

Joe was already at Brooks Base Camp 1, situated in the DeLong Mountains, one of several smaller mountain chains within the Brooks Range. It was a surreal sight as we swooped in to join him since I couldn't even see his tent or any sign of the camp until the last moment when my eyes adjusted to the scale. Joe had been scouting the area in search of the caribou that aggregate at this time of year in the western Arctic—or so we had been told. He had yet to find a single caribou, which might not be surprising given the vastness of the mountains and tundra in this part of Alaska—that is, until you re-

alize that the Western Arctic caribou herd numbers some 400,000 animals. How hard could it be to spot them?

We were just inside the colossal National Petroleum Reserve, Alaska (NPRA), a giant, federally owned piece of land on the North Slope that is larger than many countries. It covers some 23 million acres, or 37,000 square miles—an area the size of Indiana—and stretches from the Brooks Range to the far north of Alaska and the area around Barrow. By comparison, the Arctic National Wildlife Refuge is only 19 million acres in size. The NPRA is the largest tract of undisturbed public land in the United States, yet most people have never even heard of it. Its immensity dwarves even the colossal national parks of Alaska, including Gates of the Arctic and Denali. Not to belabor the point, but if you so were inclined, you could fit ten Yellowstone National Parks inside the NPRA. So yes, the place is large.

Its reputation for wildlife is also impressive as it is home to perhaps the highest concentration of grizzly bears in the Alaskan Arctic, which along with wolves and wolverines benefit from the estimated 125 million pounds of caribou meat that traverse this area. Around forty communities and 13,000 people are also found within the range of the Western Arctic herd. The caribou are a vital cultural element of native life, and just as important, a critical source of food and clothing. Mittens, parkas, pants, mukluks (boots), dresses, and hats are still created from caribou skins, and for good reason. I would never have understood the warming qualities of a caribou hide before I lay on them on the pack ice in our tent near Barrow a few months earlier. I was astounded at how immediately and effec

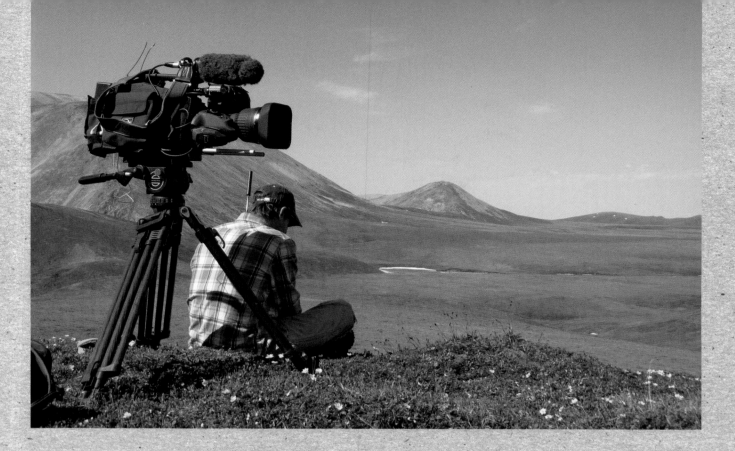

tively they insulated my body, almost as if they were *themselves* generating heat.

Like so many places in Alaska, the NPRA is all at once spectacularly wild, but also vulnerable. It has been estimated that nearly three trillion tons of coal deposits and huge quantities of oil lie beneath the surface of the reserve, so what the future holds for this great land is uncertain. Flying over the area and hiking through its valleys, I was filled with a sense of remorse that this jewel of North America was named a "petroleum reserve." Where did we go so wrong?

The caribou herd wanders an area of 140,000 square miles, or the size of Montana, so they are tough to keep up with. What makes matters worse is that they appear to move completely randomly at times, making their whereabouts totally unpredictable from one day to the next. This became clear after many days of searching. Even with a small plane, a helicopter, and plentiful local knowledge at our disposal, the herd was almost impossible for us to

above Joe and I were dropped off by helicopter and bush plane in some very isolated parts of northern Alaska as we searched for bears and caribou. Here, Joe orchestrates the next move using his trusty satellite phone.

page 156 A family of arctic grizzly bears. In this case the female has three cubs, which is quite the accomplishment in the harsh environment of Alaska's north. I embarked upon our exploration of the Brooks Range with optimism and the hope that we would be able to see and film grizzly bears, but I knew that the odds were stacked against us. The Arctic is certainly no Alaska Peninsula. Grizzly bears here are thin on the ground and difficult to see, but patience and determination ultimately paid off.

find. As the native saying goes, "No one knows the way of the wind and the caribou." I found myself chanting this in delirium as the light of the long arctic nights revealed nothing but an empty landscape day after day after day.

Caribou migrate long distances between winter and summer ranges every year. During the summer they seek rich feeding grounds to fatten up for winter and strengthen calves born in the spring, and during the winter they retreat from these places as the land becomes harsh, windswept, and desolate. Their movement patterns depend upon a number of factors, including the thick swarms of aggressive mosquitoes that emerge to torture the caribou each summer. At the top of the list though is locating an adequate food supply. Whether feeding on caribou lichen and sedge in the winter or willow and dwarf birch in the summer, the herd's constant movement helps to prevent overgrazing, giving areas time to recover for future use by caribou.

I was completely moved by the majesty of the scenery around Brooks Base Camp 1. I took regular hikes through the mountains to discover this arctic world from the ground, while Joe and Daniel Zatz, the helicopter owner and Cineflex camera operator, pored over maps to devise a plan. So far, there were no caribou, but I was wildly happy just looking.

Our daily searches of the area from the air yielded only a small handful of caribou that calmly walked the riverbank below our camp one day. In fact, the scene was eerily devoid of caribou, but in every direction there were unmistakable clues that they had been here before—lots of them.

Entire mountainsides were scratched with trails in every direction, as if a stampede of

The Western Arctic Brooks Range is home to one of the most incredible wildlife spectacles on earth: the aggregation of the Western Arctic caribou herd, which is some 400,000 animals strong. But we had to work hard for the reward, following clues like these fresh trails that line riverbanks in every direction.

As if a giant comb has been drawn across the landscape, the lines of caribou trails stretch across every mountain and valley. It's almost eerie, as if they were once here, but are no more.

crazed animals had thundered their way through the valleys. During my hikes I discovered trail after trail of fresh caribou tracks, in some cases followed by wolf and grizzly bear tracks. But the giant herd we were seeking somehow managed to conceal itself from discovery. I found it strangely heartening that such a huge number of animals could outwit a group of determined humans in a landscape that they were clearly far more familiar with than we were.

Several days into our trip as I topped a ridge, my eye caught a glimpse of some caribou in the valley below. My heart raced in anticipation, hoping that they were merely the leaders of a much bigger herd, but it wasn't to be. Eleven caribou trotted by, pausing every so often to graze, with no intention of giving away their intended meeting place with the rest of the herd. I was tempted to follow them to the prize, but might have had a long hike ahead. I later discovered that these animals were probably headed 110 miles eastward.

As I watched the small group of caribou from my mountain perch, the significance of this fascinating animal struck me. They are an ancient species, completely at home on this northern landscape. The earliest fossil records were found in the Yukon Territory and date back 1.5 million years. They have shared this landscape with woolly mammoths, steppe bison, camels, and giant beavers measuring eight feet long and weighing two hundred pounds. Moose, musk ox, and grizzly bears survived alongside the caribou and, to this day, also call this place home. The caribou have become an essential component of the ecosystems here, aerating soils, providing nutrients in the form of thousands of tons of droppings, and even contributing insulating lining materials for the nests of lemmings and birds.

The caribou's longevity stems in part from its infinitely well-adapted physiology and behavior. These animals are made for the cold. Their short, compact bodies are covered with thick woolly hair under an outer layer of guard hairs that are hollow to aid insulation and flotation in water. Their large muzzles regulate air temperature to ease breathing, and their hooves perform seasonal miracles by hardening in winter months to break through ice in search of vegetation. They are the only deer species for which both sexes have antlers—which can

grow an inch per day in the summer months! Although the bulls shed their antlers after the breeding season in the fall, the females retain theirs until after calving, perhaps as a defense against predators.

Such a long history of living among predators has led to additional evolutionary adaptations that have helped the caribou succeed, including their habit of gathering for safety in numbers and the facts that calves are able to take their first steps one hour after birth and are able to run after one day. They were also, it seemed, good at avoiding people.

Our search took us well beyond the NPRA toward the Lisburne Peninsula at the far western edge of Alaska. But still, for so many days it was fruitless, and even comical at times. Between stints of our seemingly endless pursuits across the tundra by foot and helicopter, Joe and I would take catnaps under the midnight sun, stretched out in our sleeping bags like giant grubs on an immense playing field. On one occasion I lifted my head to see a lone caribou walking by just fifty feet away. I was completely convinced that I was still sleeping. After all, it's what I had been doing for days—dreaming of

When we finally found a large part of the herd, probably numbering some 150,000 caribou, we were only allowed a fleeting glimpse before fog blanketed the valley.

huge herds of caribou trotting across the landscape right under our noses.

With one day blending seamlessly into the next, I'd find myself shaking my head in disbelief. Nearly half a million animals? How could this be? We began to wonder if they were just mythical creatures to be found only in local folklore. But one clue comforted us: A lone grizzly bear crossed the slope about a mile away one day, nose buried in the ground, following the scent of a fresh herd.

And then it happened. It is something that makes the hairs stand up on my arms and tears come to my eyes even as I write about it. Daniel called Joe and me on the satellite phone at one o'clock in the morning, panting with excitement—they had found the herd some 110 miles to the east of our original base camp, in a place near the Lisburne Hills overlooking the Chukchi Sea.

John Spencer, the helicopter pilot, swept in to collect us, and as we landed on a rocky mountaintop my heart pounded with anticipation. Below me in the silent valley appeared an endless stream of grazing caribou, including thousands of calves, gently moving in unison northward like a vast mammalian river. We could not contain our excitement. It was 120 seconds I will never forget. But then, as in the closing moments of a theatrical performance, a curtain of fog crept over the valley, hiding the caribou from view.

Our quiet patience and long days began to pay off, with seemingly endless rewards toward the end of our stay, starting with several unforgettable days spent with an immense part of the herd, hundreds of thousands of animals strong as they flowed across the valley floor beneath our

camp from one horizon to another. But the real impact really struck me as we flew over the caribou herd to capture some beautiful aerial footage from Daniel's helicopter. We spotted six grizzly bears, the first of which was making its way very purposefully toward the valley where the caribou were grouped en masse. The bear was a dot on the landscape, tracking the caribou down a single trail that was paralleled by a hundred others just like it. He motored on with supreme confidence and an air of expectation, as if unaware of our presence in the helicopter high above him. His serious determination said everything.

In that moment, I somehow understood how the bear felt. Determination and focus had brought us all here. Like us, he had almost certainly covered a lot of ground to find his prize, but for him, and the other bears that were busy patrolling the periphery of the herd, this was not a luxury, but a necessary opportunity for a seasonal feast. I thought about the caribou's importance, and their essential role for the health and vitality of this otherwise overwhelmingly hostile environment. The bears knew, and I was beginning to understand even more clearly, that the caribou represent an irreplaceable element of this grand ecosystem—an ecosystem that would function very differently without them.

My most lasting image is of the moment I dropped down into the herd and simply lay among the passing caribou, realizing a lifetime dream to be amid this ancient scene from the past. Caribou after caribou walked within a few feet of me. Some were so close I feared they would hear my heart pounding with exhilaration. Every one of them was heading in the same single-minded direction, and for a moment I felt like the new guy who wasn't in on the plan.

Journal Entry, Brooks Range

Part One: Searching for caribou in the Western Arctic Brooks Range

Love at first sight. I have fallen for this place, deeply and immediately. I feel so lucky to be here, about to experience this land, the animals, the pace, the endless silence, and the purity of a place in a world that has not been touched by man.

I departed Kotzebue by helicopter today and headed toward base camp as our search for bears and the mighty Western Arctic caribou herd begins. We swept over the tree line into a truly arctic environment. There is a vastness to this gorgeous landscape, a limitless feeling like very few places I have been to. The rolling mountains seem to stretch even farther to the horizon than the sea ice did on the coast at Barrow.

Toward the end of our 120-mile flight I spotted my first Brooks Range grizzly bears—three of them in total. A thrilling moment. Seeing them gave me incredible hope. One bear was completely blond—a tiny dot walking across a giant mountain shoulder, fixing the majestic scale in my mind in the most appropriate way.

My sense of respect for bears soars here. If I didn't know that this place could be at times packed with meat, I'd be seriously looking at it from a bear's perspective and saying, "No way, I'm off to the coast." After waking from a long winter sleep of fasting, the bears are ravenous but have to be content with flowers, roots, sedges, and ground squirrels until the caribou flow across the land like life-giving blood during the calving season. Then, the feast begins.

Our location at Base Camp 1 feels like a place where people don't belong, where we are very out of place and at the mercy of so much. It is a scene from the Pleistocene, but so far the wildlife is scarce. It's

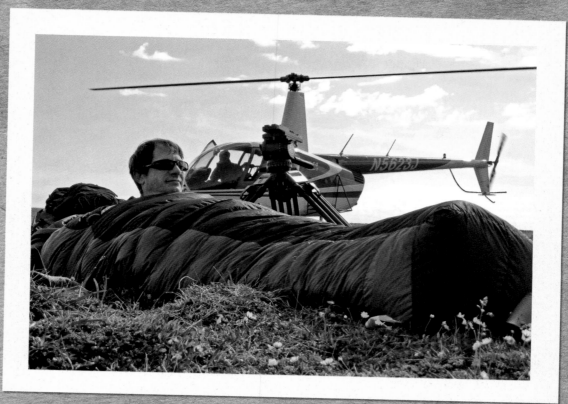

Joe wakes from a catnap as the helicopter arrives to move us to another location. The search for wildlife in the endless western arctic can be exhausting, especially during the summer when your mind fools your body into thinking that it can stay active as long as it is light. The problem is, it never gets dark.

what I would expect from a harsh landscape like this, and it is difficult to believe that nearly half a million caribou hide somewhere—there may be 50,000 of them around the next bend, and the idea of that and the anticipation of coming face-to-face with a bear or a wolf energize me beyond reason. I'm pondering why that is.

Sitting on top of a mountain peak at 3,200 feet after a rigorous climb from camp to scan the horizon for caribou really brings the scale into focus. The helicopter and our tents at camp are meaningless dots, and that's how I feel too. It is becoming easier to comprehend how the caribou are evading us. I think that part of my love for this place stems from a certain familiarity. It's like a hundred Scottish Highlands laid down side by side.

Despite the size and grandeur of these mountains though, the area seems vulnerably delicate. One-hundred-year-old lichens stretch painfully across an inch of rock. I feel terrible stepping on even a single plant.

On the way to the peak today I found wolf tracks from a young animal, and then much larger ones six inches wide. There must be a

Flowers hug the ground, having adapted to withstand the short season and cool temperatures. This wooly lousewort dons a thick "coat" of fine hairs for insulation.

den close to here. It takes me forever to get anywhere on foot—always looking, glancing at every slope and mountaintop, searching, and stopping to see the tundra world in miniature beneath my feet. It's like I've stepped back in time. I feel as likely to spot a woolly mammoth or a saber-toothed cat as I do a band of caribou. It is ancient here. I can't help but be constantly reminded of the power of nature, the history of this planet, and how incredibly insignificant our species is in the vastness of time that this land represents.

It is becoming very difficult to differentiate one day from the next. Time has lost significance here. A single night can seem like three when we are only sleeping for two or three hours at a time. The endless light also plays with your mind, and it is too easy to lose track of where you are and when you are. Right now for example, it is 3 a.m., and we are about to begin filming.

Although the caribou are scarce, the landscape gives away the fact that they have been here—thousands of them. Trails wind up every mountainside in a seemingly random zigzig of parallel lines.

For the caribou, it's about safety in numbers. A landscape this big needs a herd of nearly half a million animals roaming across it.

Anything less just wouldn't be Alaska. But for now it is the calm before the storm. If it weren't for the scarred trails across the landscape in every direction, I wouldn't believe there were any caribou here at all. I close my eyes and imagine a tide of them washing over the hills, as if from nowhere—wave after wave of them in an intense drive for food and to escape from the marauding mosquitoes.

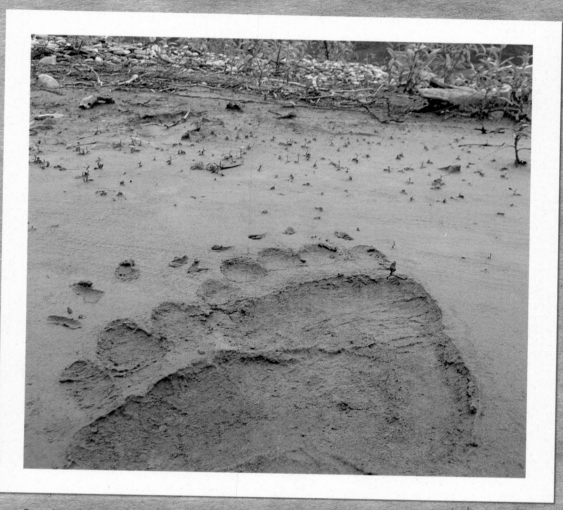

One step closer: fresh grizzly bear tracks on the muddy riverbank near camp. I was afraid that our arrival may have spooked the bears that we had come so far to find, so the tracks provided hope. The track on the left is from the front right paw (note the long claws), while the longer track on the right is from the rear right paw.

Our final leg of the Brooks Range adventure began with spontaneity, and a return to our focus on grizzly bears. Our dream was to find and film a very rare event that was rumored to occur in the Gates of the Arctic National Park, some 300 miles east of our location with the caribou directly along the spine of the Brooks Range. This giant park covers an area the size of Massachusetts and Connecticut combined. From here flow four mighty rivers: the Colville, the Noatak, the Kobuk, and the Koyukuk.

Access to the park was from the tiny, but colorful town of Bettles near the Dalton Highway. We were hoping for a scene that was completely familiar to us, but in a setting that was almost unbelievable: arctic grizzly bears eating salmon, at least 200 air miles from the coast, and an estimated 375 "fish miles" up the mighty, painfully meandering Noatak River. That any fish could make it this far in such an extreme environment was difficult enough to believe, but that bears were able to find them? This, I had to see.

After the most stunning floatplane flight I have ever taken, clear across the highest peaks of the national park (Mount Igikpak at 8,510 feet), Tyler Klaes, our pilot delivered us safely, in his classic 1943 Beaver, to one of the many small lakes near the Noatak River. Here we established base camp—home for the next eight days. With us on this leg of the trip was Max Hanft, the type of colorful, entertaining character whom every base camp needs. He was also familiar with just about every river valley in this region, having guided here for years in all seasons.

Our search began in earnest, and the results of our first day are best described by the words from my journal:

Our bush plane flight from Bettles over the Brooks Range into Gates of the Arctic National Park was without a doubt the most spectacular flight I have ever been on. It is easy to feel insignificant here. The truth is, you are.

Journal Entry, Arctic National Park

Part Two: Arctic grizzly bears fishing for salmon, Gates of the Arctic National Park

After selecting a suitable location for our base camp by a small lake, we rafted three loads of gear from the floatplane to shore. It is a stunningly beautiful location made up of rolling tundra, willow shrubs, and giant gray mountains. We set up tents and electric fences, established our kitchen a safe distance away, and enjoyed a quick brew. Anticipation is high. None of us can quite believe that there may be grizzly bears gorging on huge salmon here. It certainly doesn't feel like the salmon country we got to know so well on the Alaska Peninsula. I have to remind myself that these are the same species as those close cousins nearly 700 miles due south.

We hiked a mile to the river, and after walking downstream for no more than an hour, at 9 p.m., bingo. Four bears walking right toward us. I couldn't believe my eyes. A female with no fewer than three two-year-old cubs. At first she seemed completely unaware of us. I knew that we were upwind of her so we had to be very careful not to surprise her. I checked to make sure that my bear pepper spray was still in its holster just in case. The rain was pouring down, and the gray skies were ominous and moody. Then I noticed that one of the cubs was carrying something. Maybe a fish? They spotted us and immediately all four noses were up in the air, trying to catch our scent. These were not bears that had seen many people before. They slowly disappeared into a willow thicket on the riverbank, and Joe, Max, and I turned to each other with excited grins.

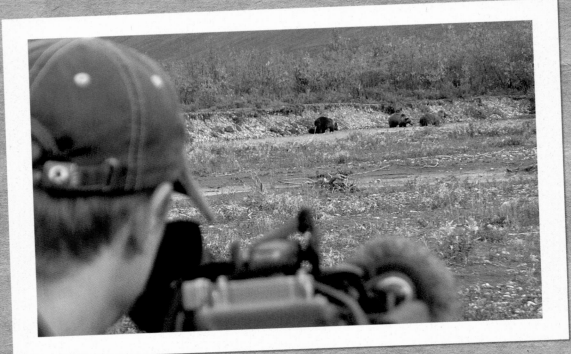

Our patience pays off as a family of grizzly bears emerges to start fishing on a river in Gates of the Arctic National Park. To witness and film this event is incredibly rare as arctic grizzly bears occur in low densities across huge areas. Impressively, in order to spawn, the chum salmon had made their way upriver from the coast, some 400 river miles to the west.

It wasn't safe to follow them so we gave them a wide berth and continued downriver to look for more clues. The jackpot would be a salmon carcass on the bank, but we found nothing.

Thirty minutes later very heavy rain turned us back empty-handed, but on the way to camp we decided to scout the area where we had last seen the bear family. Making plenty of noise between us, we clambered up the riverbank; I was determined to find the object that the cub had been carrying. It didn't take long: Right where we had seen the cub lay the remains of a giant chum salmon—the proof we needed, and relief beyond imagination. It looked like our trip might not be in vain. But the bears were nowhere to be seen. I wonder if they will return.

Hiked back to camp, very wet but very happy. Bed at midnight. High wind and heavy rain until 4 a.m. Then deep sleep.

So, as unbelievable as it may sound, we were able to find four grizzly bears a lot more quickly than nearly half a million caribou. It's certainly not what we were expecting. However, despite our surprising immediate success, we were not sure that we would ever see the bears again, never mind have an opportunity to film them. I had initially doubted that we would see any bears at all and so was overwhelmed about the fact that within hours we had not only found a family of four, but we had discovered evidence of them fishing too.

My doubts were based on the fact that arctic grizzly bears are thin on the ground due to the nature of a habitat that does not offer the plentiful supply of food that that bears enjoy on the Alaska Peninsula. So bears are smaller, and populations are less dense. You could hike for days without seeing a bear. Here, a mature male grizzly bear might have a home range size of a thousand square miles while their coastal cousins need wander no farther than perhaps 200 square miles, with much of their focus in a considerably smaller area.

But fortunately for us we had found the right family. The next day we staked out the most likely fishing hole on the river and waited. The anticipation was almost unbearable. After three hours, the four bears emerged from the willows, casually looked upriver, then downriver, and began to fish. The scene that unfolded was unbelievable: They spent the next forty-five minutes fishing within 100 yards of where we sat on a gravel bar. Their mood was slightly cautious, but far less so than I had expected. They splashed and fished, took breaks to feed on blueberries and

hedysarum roots, and slowly began to forget that we were even there.

For the next seven days we returned to the tributary, and on every occasion, just like clockwork, they joined us at the river and allowed us to observe, film, and marvel. There were moments when our minds were right back on the Alaska Peninsula, where we were often surrounded by bears thundering in every direction in pursuit of salmon.

These arctic grizzly bears were not the ornery animals that had been described to me by countless northern adventurers. These bears were tolerant, patient, and completely nonaggressive toward us. On one occasion one of the cubs couldn't take it any longer and *had* to break off from the rest of his family to get a closer look at us. But even he was easy to deter with a firm voice and a bluffed sense of confidence. I thought a lot about how misunderstood these animals are, and how they each exhibit distinct personality traits. Two bears are as different as any two people. Knowing that helps us treat them with the respect and understanding that they deserve.

It was surreal and magical to watch them key in to this bountiful supply of calories in a landscape that offers only sporadic opportunities to gain weight. And it was equally impressive to imagine the gruesome journey that the chum salmon had made from the coast far to the west. They had run the gauntlet along North America's wildest river, and with the help of the great bear, now nourished the land with nutrients from the Pacific Ocean nearly 400 miles away.

Wrap up

Alaska is nine times bigger than my home state of Washington, and thirteen times bigger than England, where I grew up. So traveling across it was an intimidating prospect. But I have come to know it well, and it has gripped me. Its vastness always gave me the impression that Alaska is so wild that it is indestructible. But of course it is not. It is a delicate, vulnerable place, and it is at our mercy.

Even the bears, among the most powerful creatures on earth and ruling this wild landscape, live a delicate balance. I have been privileged to see their world with my own eyes over the course of this journey, and I have come to understand them more than I ever thought I would.

Some people speak of Alaska's north as if it is a barren wasteland. Perhaps they have never been there. The land, the animals, and the people are more alive and vibrant than anywhere I know. As humans, we need the wildness that only places like Alaska still offer to keep us sane, humble, and cognizant of the world from which we came. And despite its ruggedness, Alaska's wild places are at our mercy, and at the whim of politics and perception. We cannot be complacent, because we all need this place, whether you are blessed enough to taste it in the flesh, or just happy to know it still exists.

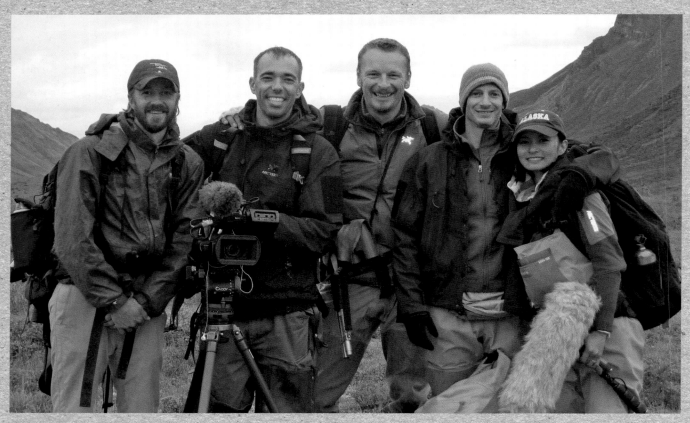

Smiling faces after our discovery of a rare find: a family of arctic grizzly bears fishing for salmon some 400 river miles from the coast where the grueling journey for the fish began. Left to right, the Gates of the Arctic crew: Max Hanft (Brooks Range guide), Dean Cannon (associate producer/second camera), me, Joe Pontecorvo (producer, director of photography), Nimmida Pontecorvo (sound).

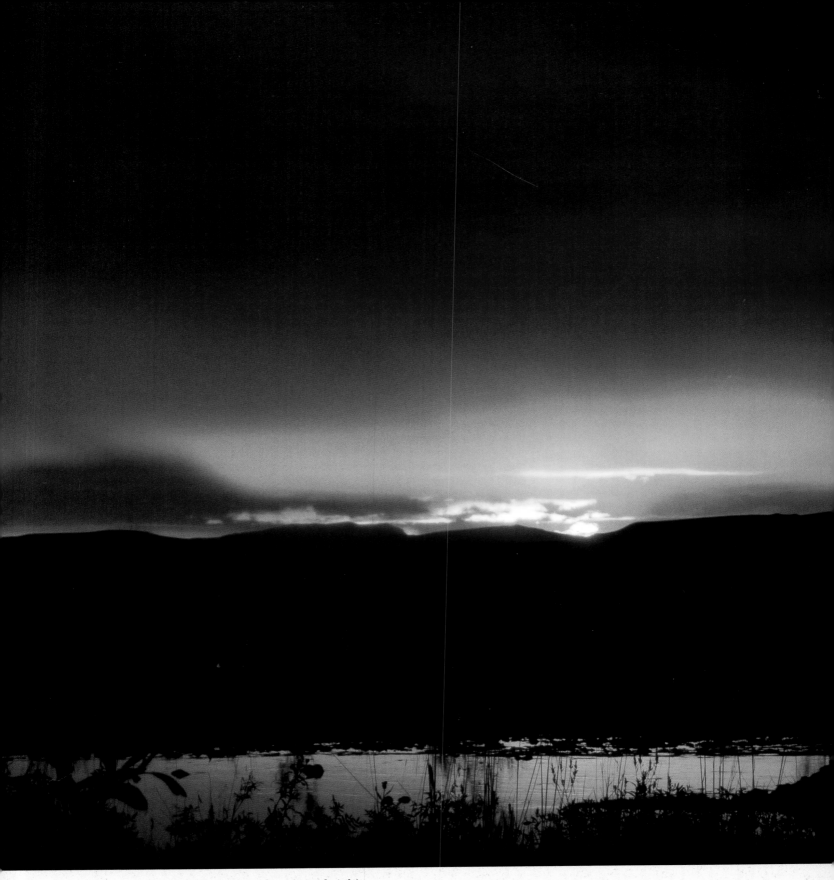

June sunset at close to midnight.

A dot on the giant landscape is a grizzly bear following one of hundreds of parallel caribou trails toward a valley where thousands of caribou were gathered. The bear was moving at a fast pace, eager to reach the rich source of seasonal food provided during the calving season.

opposite Late in the evening on our first night on the Noatak River, we found a scene that was beyond our dreams: a river full of chum salmon, and a female grizzly bear with three two-and-a-half-year-old cubs. She must have been an experienced mother to have successfully raised this many cubs in the unforgiving arctic ecosystem, and I'm sure her knowledge of the chum salmon run was a huge factor.

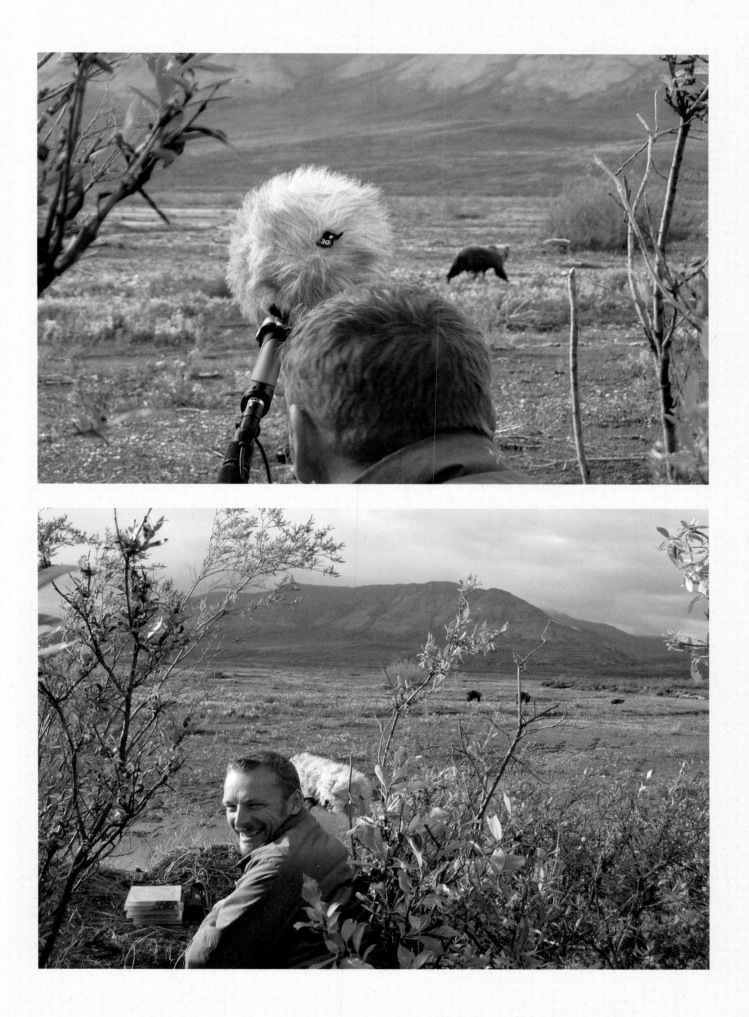

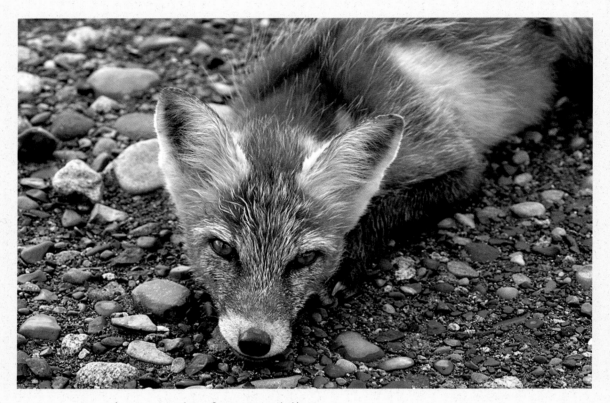

An ever-curious fox pays a visit.

opposite The wolf trotted effortlessly down the mountain side, stopping every few moments to scan the horizon. I sat motionless, knowing that he would lock on to the slightest movement, even from a mile away. Dropping down into the riverbed I thought I would never see him again, but four minutes later he rose over the ridge into full view. Only 100 yards away. He is beautiful—healthy and proud, and suspiciously well fed. His focus is absolute, and he seems to glide through this environment with a fluid movement of supreme confidence and familiarity. He is on the prowl, taking in every sound, every smell, and every tiny thing out of place. Including me. He's seen me. Suddenly we are dead still. Motionless. Not a blink. His eyes lock onto mine. Like I'm the first person he has ever seen. And maybe I am. The stare lasts forever and feels as wild as the earth. It is an ancient connection that pounds my heart. The wolf is in complete control and calmly turns his nose to take another route. One that will take him directly downwind from me. I have become part of his sensory assessment of the place, and I feel like he will be able to read my soul once the breeze carries my scent to him. Then he is gone. Pouring over a ridge to a valley beyond in search of whatever he will find.

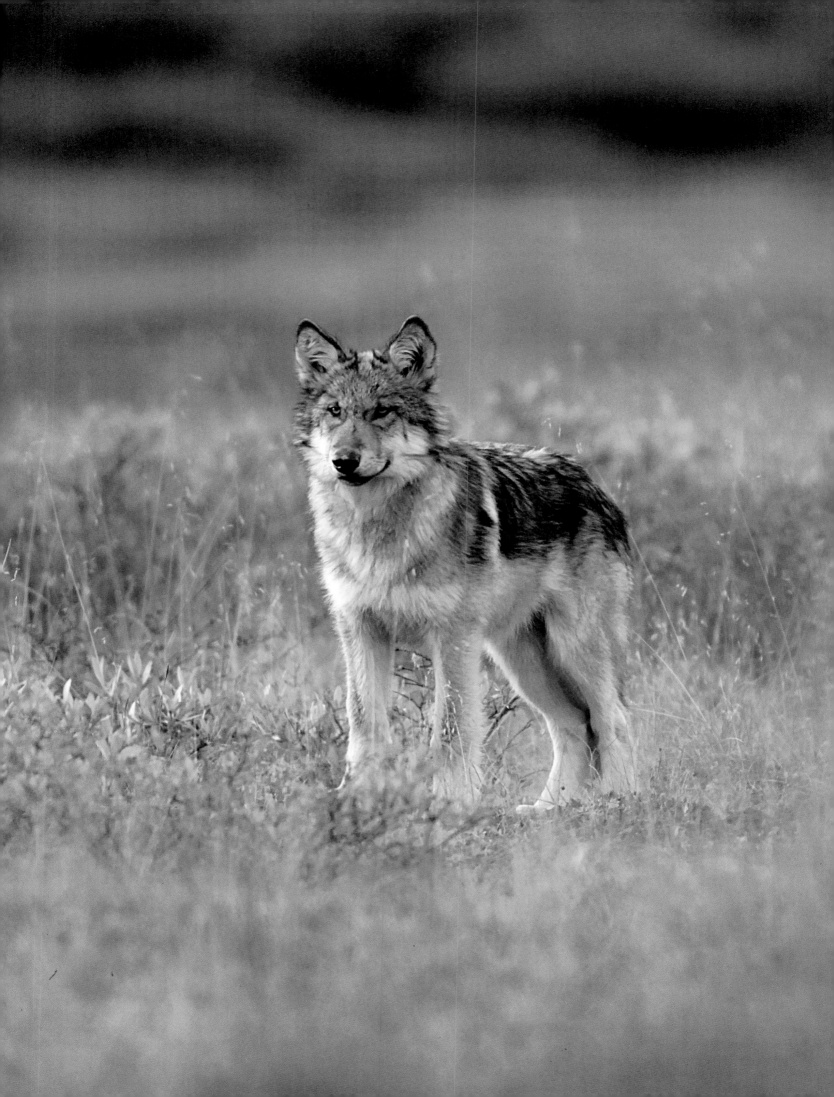

Flying by helicopter over the Noatak National Preserve on the way to the National Petroleum Reserve, Alaska. The preserve covers six and a half million acres, a little larger than Denali National Park, and was established to protect the Noatak River basin, the entire length of which runs north of the Arctic Circle. This is considered to be the last remaining complete river system in the United States that has not been altered by human activity, and it is internationally recognized by the United Nations as a Biosphere Reserve. The area's ecology and genetic components are carefully studied to provide baseline, benchmark data that helps measure changes in other ecosystems worldwide.

Joe at base camp in the Brooks Range.

The meandering rivers and rolling hills of the western Brooks Range are endless and beautiful. Our Brooks Base Camp 1 can be seen in the center right of this photograph—a dot in the vast landscape.

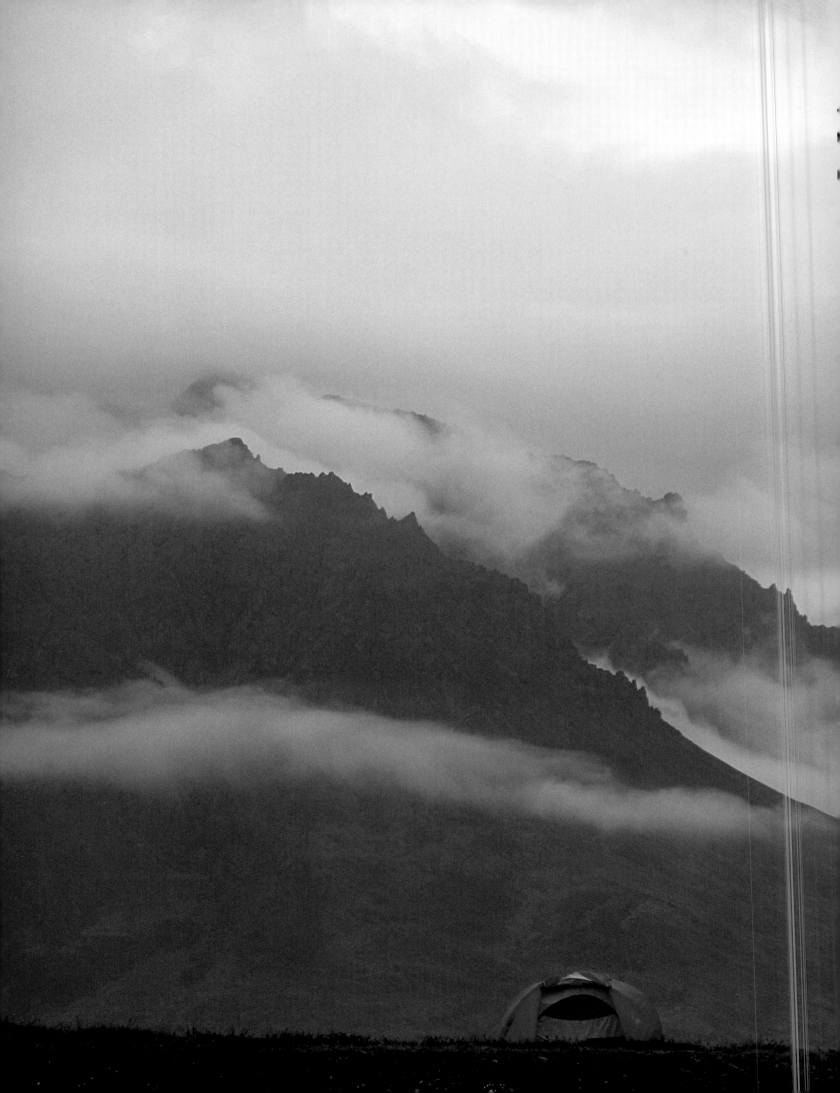

The fog clears and begins to reveal a line of caribou joining the main herd.

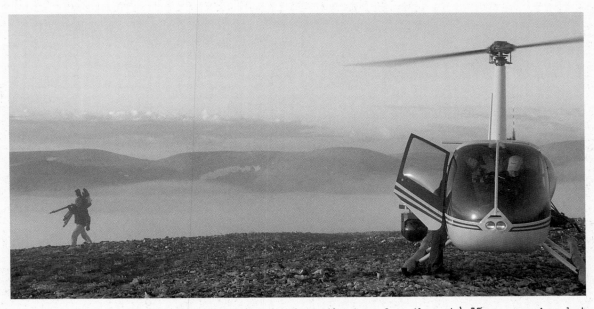

After a long search, we discovered our first major gathering of caribou at 4:15 one morning, but then fog immediately crept up the valley, concealing everything below. As we looked out to the Arctic Ocean, it was evident that the fog was getting thicker very quickly, which forced a helicopter evacuation.

opposite The weather in these Arctic mountains could turn in an instant. At times it became the most foreboding, ominous environment and it made me constantly wonder how the wild animals here survived the much harsher winter conditions which were several months away.

overleaf and pages 186-187 How little the caribou realize their importance. Their role in this ecosystem is as essential as the sun and the soil. They are the life force of this wild place: They flow through it like blood vessels feeding the land. They nourish the land with nutrients, recycling energy that would otherwise halt with the growth of a plant or lichen. They churn the earth, aerating it to bring it to life. Even the birds and lemmings benefit, lining their nests with warm caribou hair. But that is just the beginning, of course. For bears and wolves, caribou are the difference between being here, and not.

I was amazed at the sheer determination of the caribou we saw in the western arctic. They were on a synchronized mission westward, and it seemed as though nothing would stop them. Their hollow hairs make for not only highly effective insulation, but also help with buoyancy when swimming.

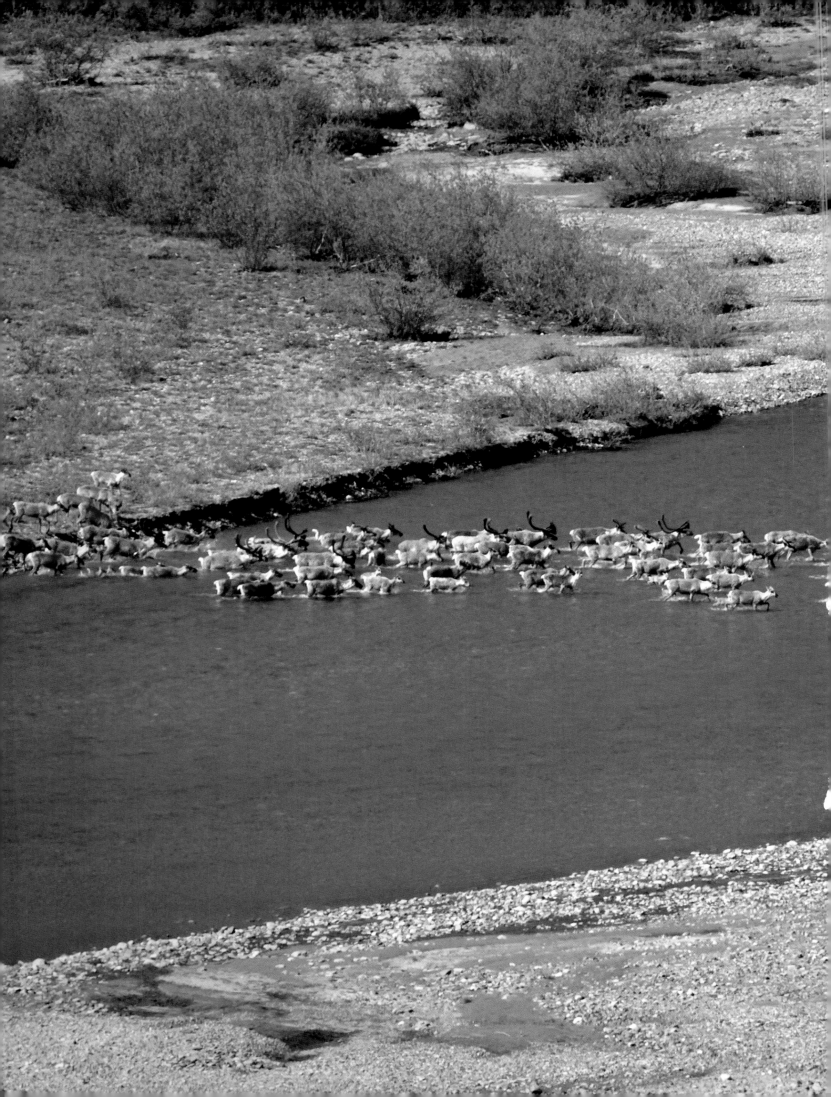

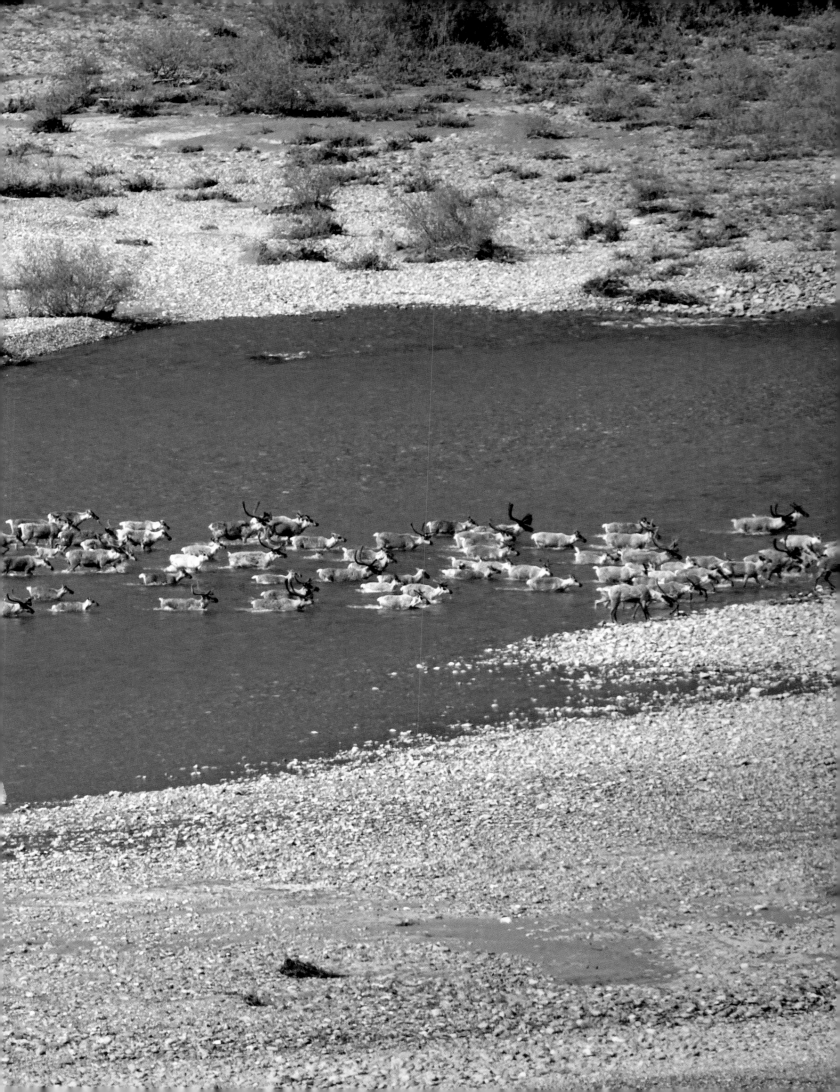

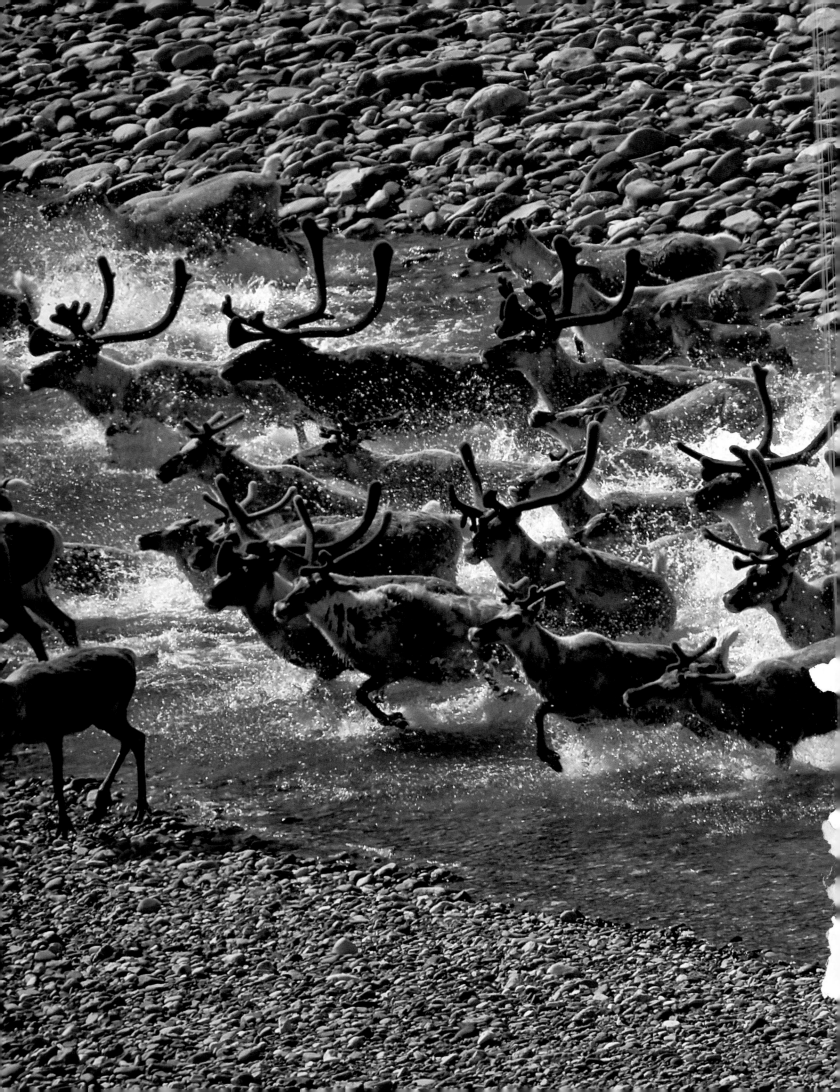

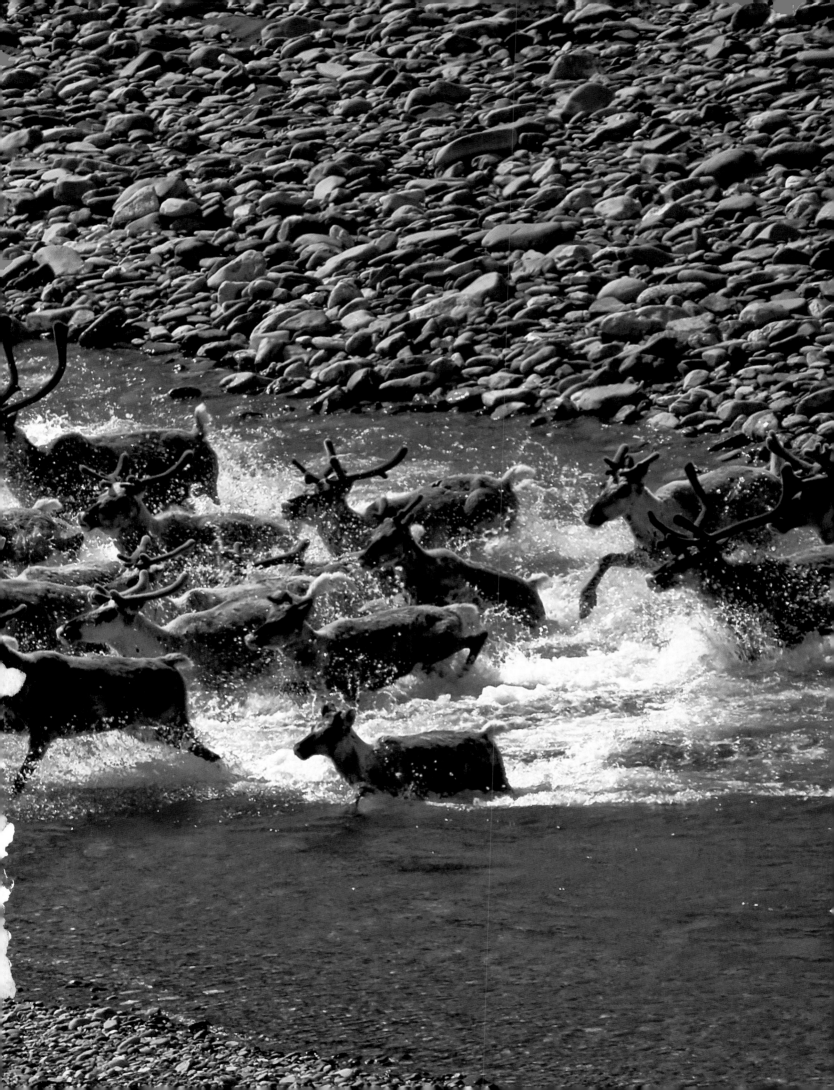

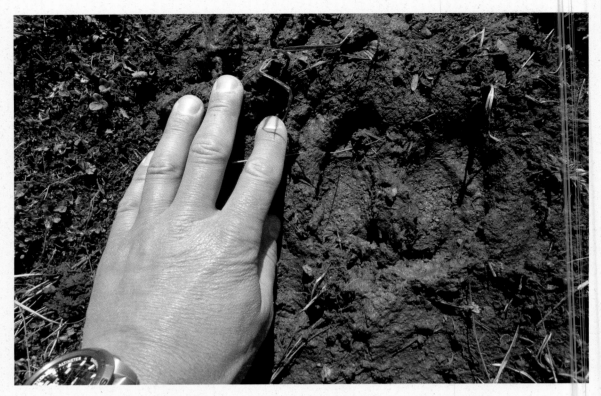

It seemed that there was sign of caribou in every direction, but not a single animal happened by for many days. An entry from my journal reads: "The bears are waiting, the wolves are waiting, we are waiting. But as the native saying goes, 'No one knows the way of the wind and the caribou.'"

Life is hard for a flowering plant in the Arctic. On the left, the eight-petal mountain avens is insulated by downy hair. The Siberian phlox on the right hugs the ground, where temperatures are a little warmer on average.

I easily collected this handful of lichen from just a few square feet of tundra. More than 1,000 species of lichen can be found in the North American Arctic, and several of them are essential to the survival of caribou.

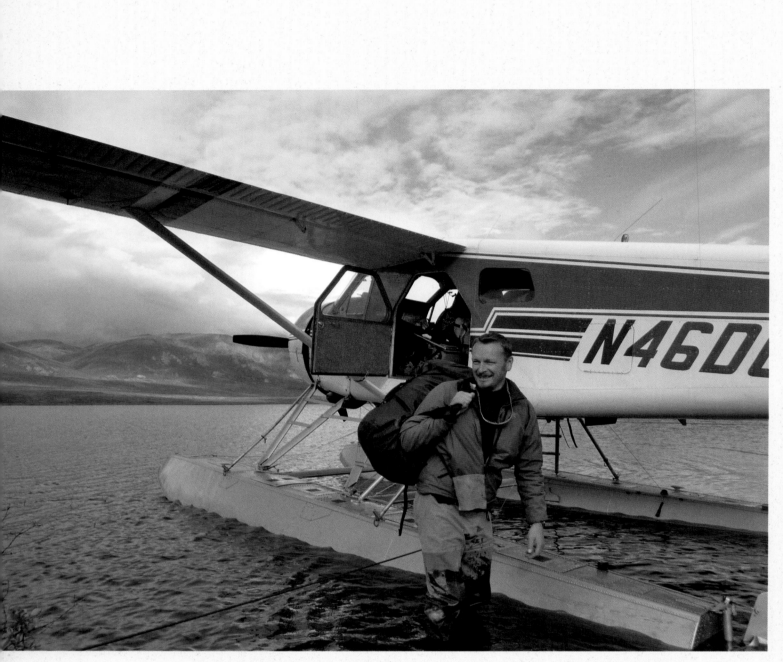

Our reluctant departure from base camp on the Noatak River. Fulfilled, inspired, and humbled by this majestic landscape and the wildlife that calls it home, I knew as I boarded the floatplane that this would not be my last visit.

opposite, top Joe prepares to film me at camp from the ground while the helicopter captures aerial shots with a specially designed Cineflex camera that acquires rock-steady, level shots thanks to its gyroscopic mount.

opposite, bottom Joe (right) discusses filming plans with Daniel Zatz (left) and John Spencer (center).

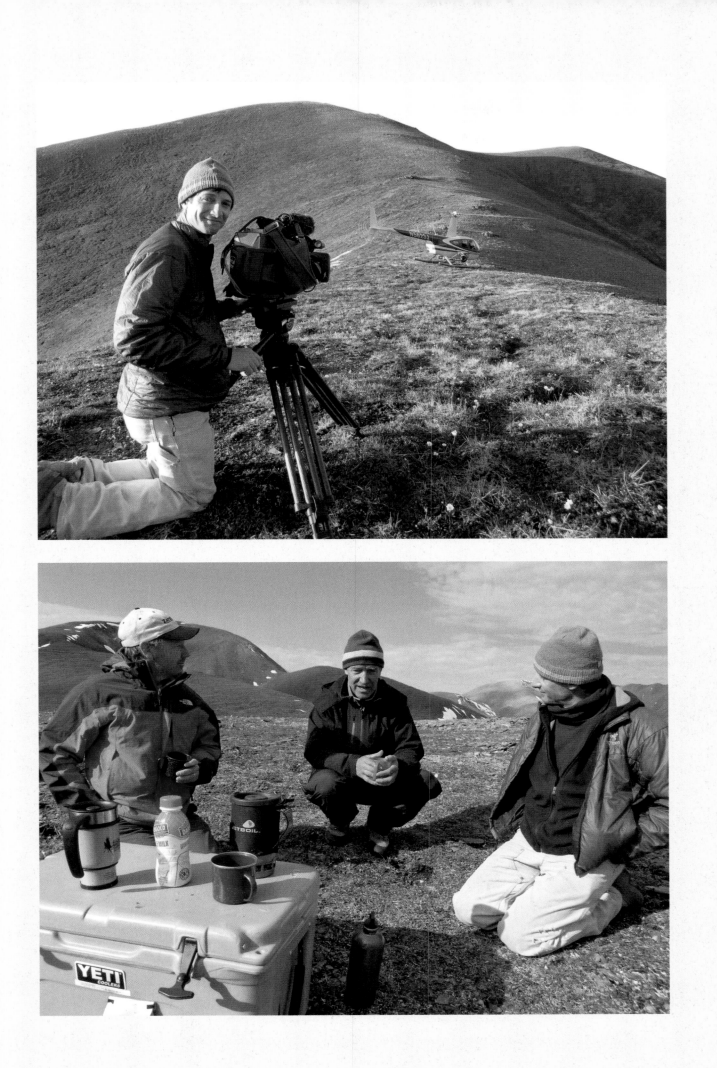

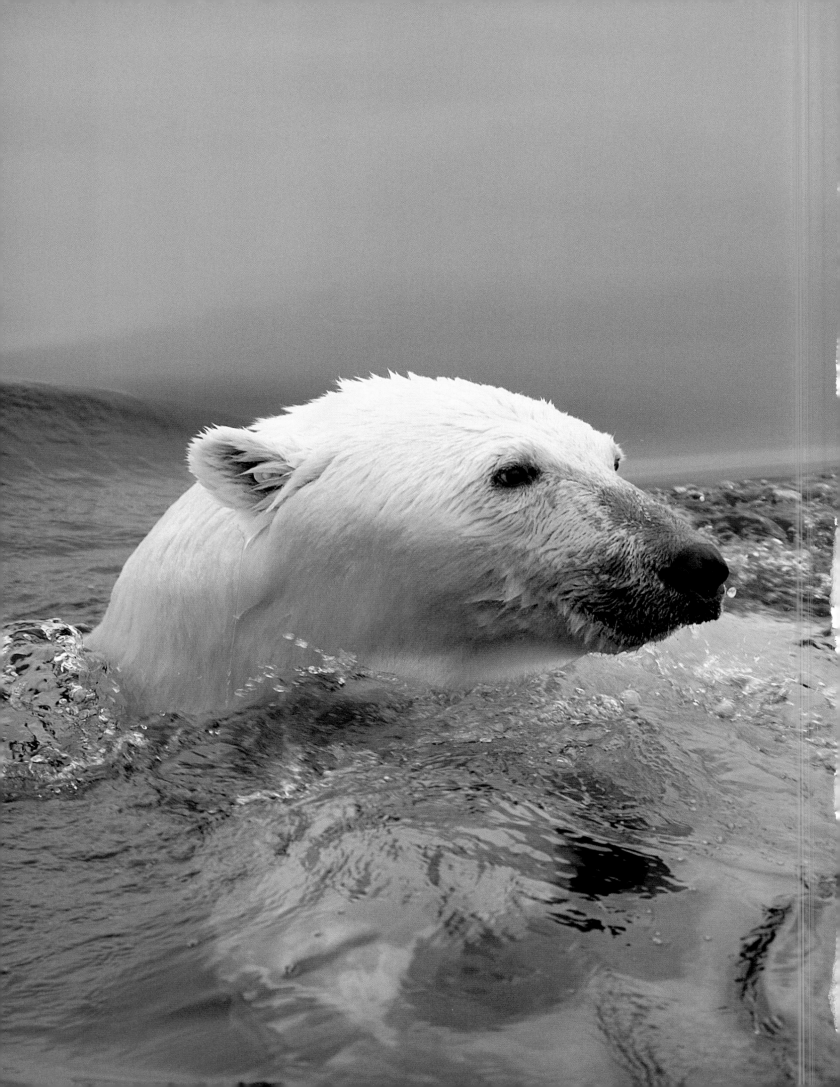

CONSERVATION

Hope for the Future
of Bears and Their Habitats

If you overlay a map of the Northern Hemisphere with brown bear distribution, some of the world's wildest places will emerge. *That* is the beauty of bears as charismatic representatives for conservation. For me, and many of my wildlife colleagues, bears represent the vast, untamed areas that need our attention, but for many such areas that used to harbor brown bears it is already too late.

My native Britain is one of those places. The last brown bear there was killed almost one thousand years ago, at which point the landscape had become too civilized and the people too intolerant to allow a future that would include the great bear. The same pattern occurred throughout Europe—a continent that until the late sixteenth century had a healthy contiguous brown bear population that spanned from Portugal through Spain, France, and modern-day Germany,

Italy, and Austria, into Eastern Europe and beyond to Asia. Now, only small, remnant populations can be found across this former range, and there is something missing.

As someone who spent the first twenty-seven years of my life in Europe before moving to the United States, I have a worrying perspective on things to come for North America's wild places. It's what fuels much of my work, especially in the case of grizzly bears—a species that I have focused much of my conservation efforts upon.

The lower forty-eight states have followed a pattern similar to Europe's in many ways. With the arrival of European settlers came the simultaneous persecution of bears and their northward retreat into the remaining wilderness. I've likened this dramatic reduction in grizzly bear distribution to water evaporating from a tabletop.

From what was an expansive pool of grizzlies that covered the entire western half of the country, retreating fingers emerged, leaving drops behind, which in turn became isolated and eventually dried up. Several of these populations, including those of the North Cascades and Yellowstone, persist as islands, separated from larger populations of bears to the north. Two hundred years ago grizzly bears numbered in the range of 50,000 to 100,000 in the Lower 48, while today there are only around 1,400 remaining in the four states and five distinct ecosystems that are wild enough to sustain them. Connectivity with Canada provides hope for some of them, but only if conservation measures there are also adequate.

Alaska is different—for now. Here, the human population density is around one person per square mile. The same space in New Jersey supports more than 1,000 people, and even a state the size of California stands at 217 people per square mile. The closest density to be found is in Wyoming at 5.1 people per square mile. Clearly Alaska is a place where conservation efforts that have become impossible elsewhere are still an option. By its very essence in this rapidly changing world, Alaska cannot be treated in the same way as a European country or the rest of the United States. It is *far* too precious.

In a world that faces an increasing loss of wildness, Alaska provides a special place for bears. Almost every corner of the state from sea level to close to 5,000 feet above is bear country, from the impenetrable coastal forests of the southeast to the pack ice of the Arctic. Looking at a map of global bear distribution, Alaska stands out as a bastion of hope for these majestic creatures.

Alaska has the largest brown/grizzly bear population (around 30,000) of any state or province in North America. Internationally, only Russia has a larger one. Of North America's 900,000 black bears, one-fifth are in Alaska. And of the world's estimated 25,000 polar bears, Alaska shares populations with Russia and Canada numbering some 3,000 to 4,000 individuals.

Over the millennia, Alaska has often provided a safe haven for some of the world's most spectacular animals. Thousands of years ago, during the late Pleistocene, when a significant proportion of the world's oceans were locked up in continent-size glaciers, a whole array of species enjoyed the ice-free refugium that the Alaskan interior provided. At that time, the surrounding mountains attracted most of the precipitation, which meant that no permanent layer

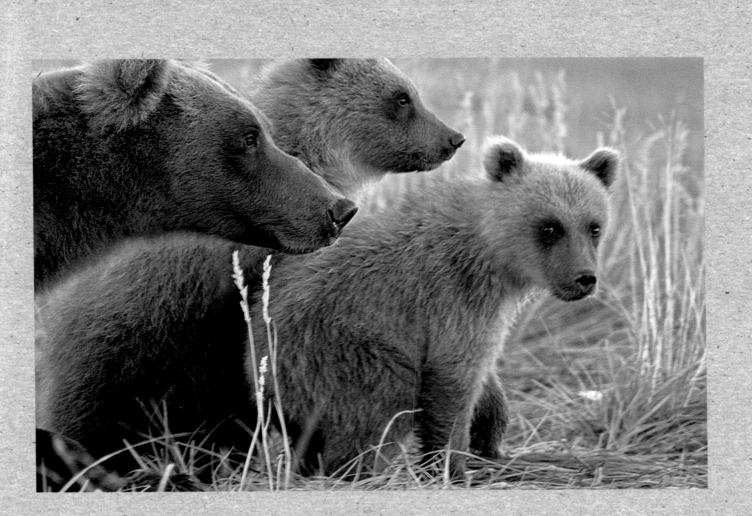

of snow and ice was able to accumulate in the central lowland. Species included the bison, the giant short-faced bear, the woolly mammoth, and the saber-toothed cat. With the retreat of these glaciers, new habitats emerged, but still the isolation, scale, and sheer ruggedness of Alaska continues to underscore its crucial role in the realm of globally significant wild places.

A variety of mammals have been here since the Pleistocene and continues to thrive in many parts of Alaska. It's like a living museum from the past. Moose, Dall sheep, beavers, lemmings, wolves, lynx, wolverines, red foxes, arctic foxes, arctic ground squirrels, and grizzly bears have seen glaciers come and go, and indeed entire species come and go. But they are still here, representing an ancient line that once called much larger areas of North America home.

Grizzly bears are a type of brown bear. Historically they lived over much of the northern hemisphere, but human encroachment, habitat loss, poaching, and a simple lack of space have seen many populations around the world decline dramatically.

page 190 Polar bears are completely at home in the water, and can swim many miles between ice floes. Long necks, hollow hair, and giant paddlelike paws have evolved for this very reason. But in the Southern Beaufort Sea where pregnant females head from the ice back to land to den and give birth, distances are becoming unmanageable with increasing sea ice retreat. Increasing numbers of bears are drowning on the way.

Distribution of the eight bear species of the world

- Polar bear (25,000)
- Brown bear (180,000)
- American black bear (900,000)
- Spectacled bear (20,000)
- Giant panda (1,600)
- Asiatic black bear (50,000)
- Sloth bear (20,000)
- Sun bear (population unknown)

Approximate distributions and populations listed

It is places like Alaska that provide something that is becoming very rare in today's world: large-enough landscapes to provide fully functioning ecosystems not impacted by man. The Noatak River system in the western Brooks Range is a perfect example of such an ecosystem. It is quite possibly the last complete river system in the United States that has not been somehow altered by human activity. It is an indescribable feeling to fly over this area with that in mind. A place as wild and undisturbed as this can still function the way that it is supposed to, with the natural balances that allow for ecosystems to change and evolve, along with the species that are a part of those systems.

The key to protecting large carnivores and the many species that fall under their umbrella is connectivity. The conservation of countless wild areas around the world currently depends upon a scramble to reconnect habitat islands that have become disjointed and fragmented.

The sheer size of Alaska gives us the opportunity to keep that from happening in the first place—and on a massive scale. After all, it is far easier to protect wildness than restore it.

My appreciation of this scale was something that I thought long and hard about many times during my journey through Alaska. It helped to put a lot into perspective and made me wonder about things to come for this grand state from the past.

In some ways, Alaska seems to be a microcosm of the conservation circumstances that face many parts of the world. Alaska is on the front line of the relationship between humans and wilderness, people and wildlife, industry and conservation. But is also one of the few places to still offer untouched relics of our world's distant, wild past.

When the United States purchased Alaska from Russia in 1867 for a mere $7.2 million (2.3 cents per acre), no one could have possibly com-

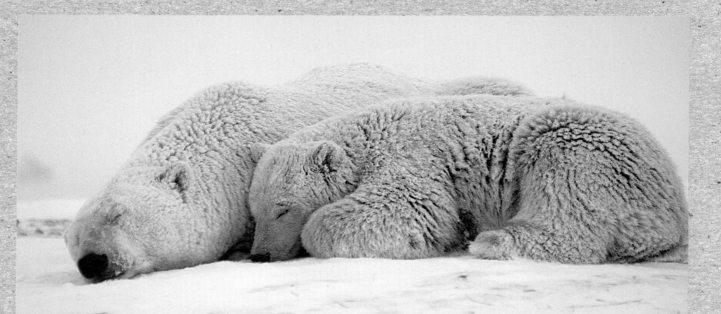

A female polar bear and cub await freeze-up. Throughout much of the polar bears' range, it is happening later each year, and spring ice breakup comes sooner. This means that hunting conditions are not what they used to be.

prehended what the state and its incredible natural resources would later be worth. I could not hike through a place like the NPRA in the Arctic without being overwhelmed by the sheer magnitude of this untouched area. But size does not translate to security for a place like the NPRA, and its precariousness is something that also haunted me. Here, beneath the feet of the Western Arctic caribou herd are thought to lie 2.75 trillion tons of coal. Until recently, the NPRA was also thought to hide 10.6 billion barrels of oil, but new research shows much less—perhaps only 10 percent of that. In our oil-hungry world, this is more than good news. As my friend Tom Campion of the Alaska Wilderness League says, "This place needs a name change!" But before the celebrations begin, we need to remember that there are still around 53 trillion cubic feet of natural gas there too. The dollar value of this modern-day gold mine could change this unknown corner of Alaska forever—and with it, the complex web of life that caribou and grizzly bears share there.

Throughout my journey, I was reminded so often that our perspective of this world is such a fleeting one. Unfortunately people have a tendency to think of the human race as a permanent fixture on this planet. There's a sense of entitlement that comes from behaving as though we have always been around and always will be. Alaska has a tendency to make you dwell on the fact that nothing could be further from the truth. If the planet's 4.6-billion-year history were condensed into a more comprehensible forty-six-year period, modern man has been around for four hours, and the Industrial Revolution happened sixty seconds ago.

And from my experience traveling through this beautiful land, my sense is that no one wants to see Alaska go the same way. Here, the window of opportunity for conservation is still open, but it could close in the blink of an eye. Yes, Alaska is big, and most of it very wild, but conservation complacency should be our biggest fear.

Alaska's bears face threats ranging from human encroachment into bear habitat; increased access to wild areas, which can lead to poaching; habitat disturbance associated with oil, coal, and other extraction industries; and of course the invisible threat of climate change.

Polar bears in Alaska face perhaps the bluntest challenges of climate change imaginable. The very ice they depend upon is melting around them. Long-term studies of the Western Hudson Bay population in Canada have shown that polar bears are affected dramatically by a spring thaw that comes earlier than it used to. The bears there have traditionally spent time ashore each summer when their icy habitat melts seasonally. But now, breakup occurs three weeks sooner on average than it did, and fall ice appears later, which translates directly into a shorter hunting season for bears (the ice-loving ringed seals they prey upon are the reason for the polar bears' dependence on this habitat). Dr. Ian Stirling and Dr. Nick Lunn have shown a very clear correlation between the breakup of the sea ice and the condition of the bears when they arrive on shore. Bears there are now lighter, reproducing less successfully, and facing reduced survival. In addition, the population has declined significantly.

Sadly, the same pattern seems to be emerging for the very bears we were watching in the Beaufort Sea of northern Alaska. Here, work headed by Dr. Steven Amstrup has revealed additional disturbing impacts of climate change.

In October or November each year, pregnant female polar bears jump ship from the ice and walk or swim to the coast to dig a den on land, in order to give birth during winter before emerging with cubs in the spring. Those females are now having to swim much longer distances as the ice is retreating much farther than it used to each summer. The sea can be treacherous, and of course wider expanses of ice-free water only make conditions worse. Tragically, some bears are drowning.

On top of that, the greater ice retreat carries the bears to waters beyond the continental shelf that are less productive for fish, and subsequently seals and bears. And unfortunately it doesn't end there. The state of sea ice, as a platform from which bears hunt seals and an essential part of the polar bear's world, has other ramifications. Polar bear biologist Dr. Andrew Derocher and his colleagues have predicted that an increase in the amount of open water will mean that seals will have to rely less upon breathing holes in the ice. And these are the exact locations where polar bears conduct most of their successful hunts as they lie in wait for a surfacing seal.

There may even be an increase in the potential for conflicts between polar bears and people as more bears begin to spend extended periods of time on land only to watch their sea ice platform shrink more and become less dependable for hunting. Off-shore drilling in the Beaufort and Chukchi Seas could also spell disaster for bears, seals, and whales, not to mention the local Iñupiat peoples who depend upon the sea as their "garden." And as ice melts, shipping activity increases, which will change the face of this whole environment for the great

white bear. Unfortunately, the odds seem to be stacked against this majestic creature in northern Alaska.

But there is hope. Like no other species, bears represent the wild, open spaces around the world that humans have not yet been able to completely dominate. It is a bonus for conservation that bears seem to have a knack for living in places that are as beautifully dramatic as the animals themselves. Bears help us to push the limits of our imagination and keep us humble as we find ways to share space with them. In addition to the three species found in Alaska, five other bear species represent frontiers around the world, revealing opportunities to preserve animal and place in every instance.

These frontiers range from the mountainous realm of the giant panda in China to the incredibly rich rain forests of the Malayan sun bear, the smallest and only truly tropical bear species in the world. South America hosts the Andean or spectacled bear, which roams from coastal mountains through dense cloud forests up to high elevation *paramo* grasslands at the bases of giant volcanoes. Sloth bears are scattered throughout island populations across India, Bangladesh, Bhutan, and Sri Lanka, and the little-known Asiatic black bear spans the mountains of Afghanistan to the forests of Southeast Asia, as well as Japan and Taiwan. Some of the busiest and most populated countries in the world still have space for bears. Amazingly, India has four species, and Japan is home to brown bears as big as Alaska's giants. There is room and time enough for us to do right by bears, and nowhere more so than in Alaska. Here, and in other places around the world,

many good people are doing incredible work for the wild places that bears and countless other species need.

To me, conservation is about hope, determination, optimism, and passion for a cause that is good for everyone. My journey through Alaska brought me into contact with so many wonderful people whose love for the land and the animals it supports unites them in a way that transcends politics, race, or social status. Alaska seems to ground people in the things that are truly important. If that's not reason for optimism in today's world, then I don't know what is.

Alaska, like its people, is resilient and strong. But despite its outwardly rugged appearance, it is also vulnerable and fragile. And it is one place on earth where pride, heritage, and fortitude can prevail to see that this wilderness *stays* wild for future generations, of both people *and* bears.

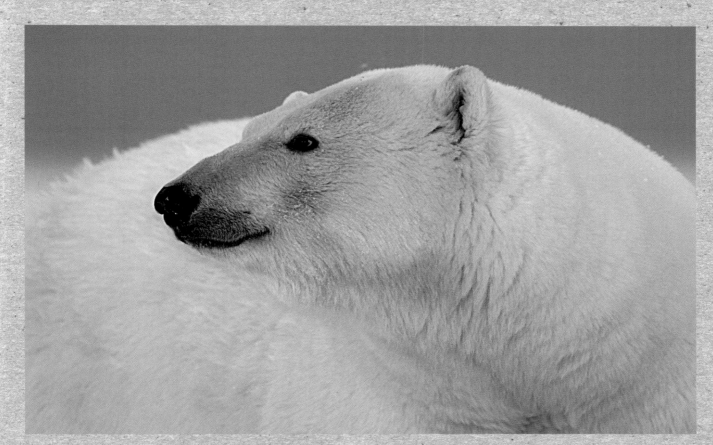

Polar bears face perhaps one of the most uncertain futures of all bears. Since their split from the brown bear around 150,000 years ago, they have become incredibly well adapted to their icy environment and depend upon it for hunting seals. Sadly, their impressive adaptations have locked them into a way of life that is threatened by climate change, as warming melts their environment.

overleaf A brown bear on the Alaska Peninsula selects a suitable fishing hole in prime habitat. In many other parts of the world, brown bears don't have it so good. This incredibly adaptable species occurs in a surprisingly wide range of different habitats from Siberia to the Gobi Desert to the Alps.

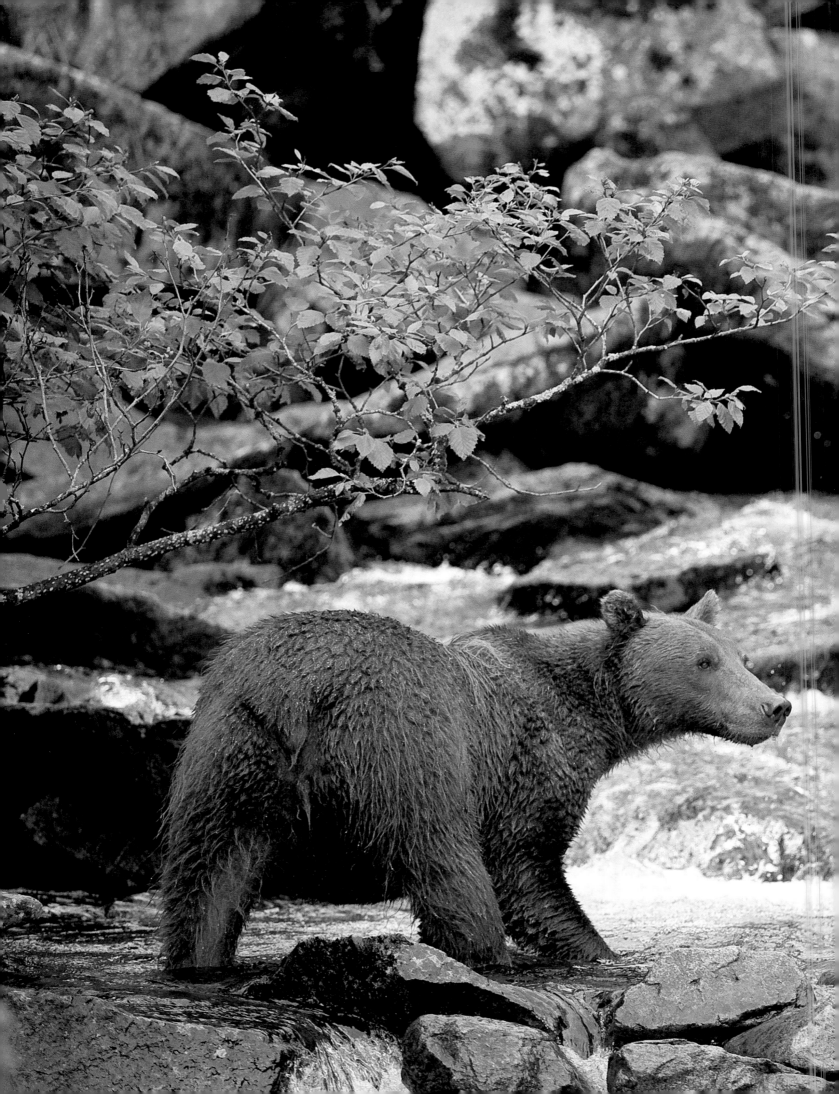

A brown bear thunders through the water in pursuit of a salmon. The ancient connection between salmon and bears is readily apparent during the spawning season as bears anticipate the arrival of this calorie-rich bounty.

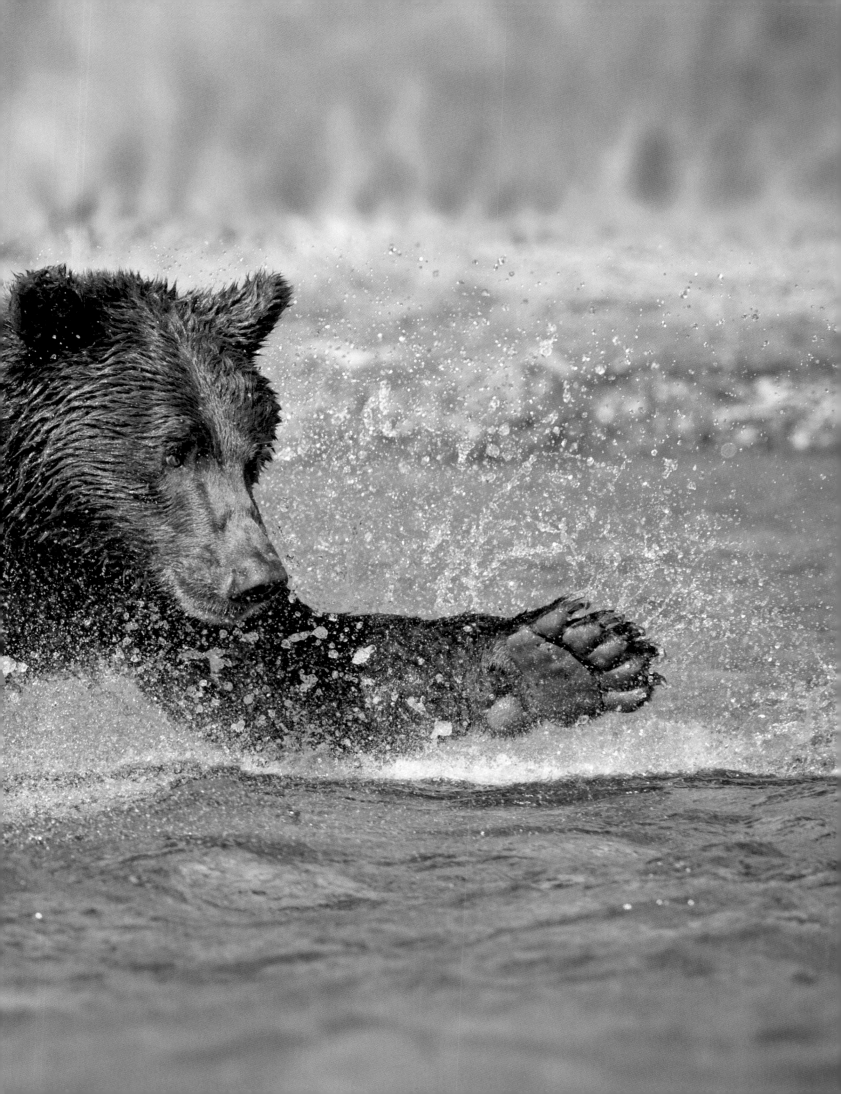

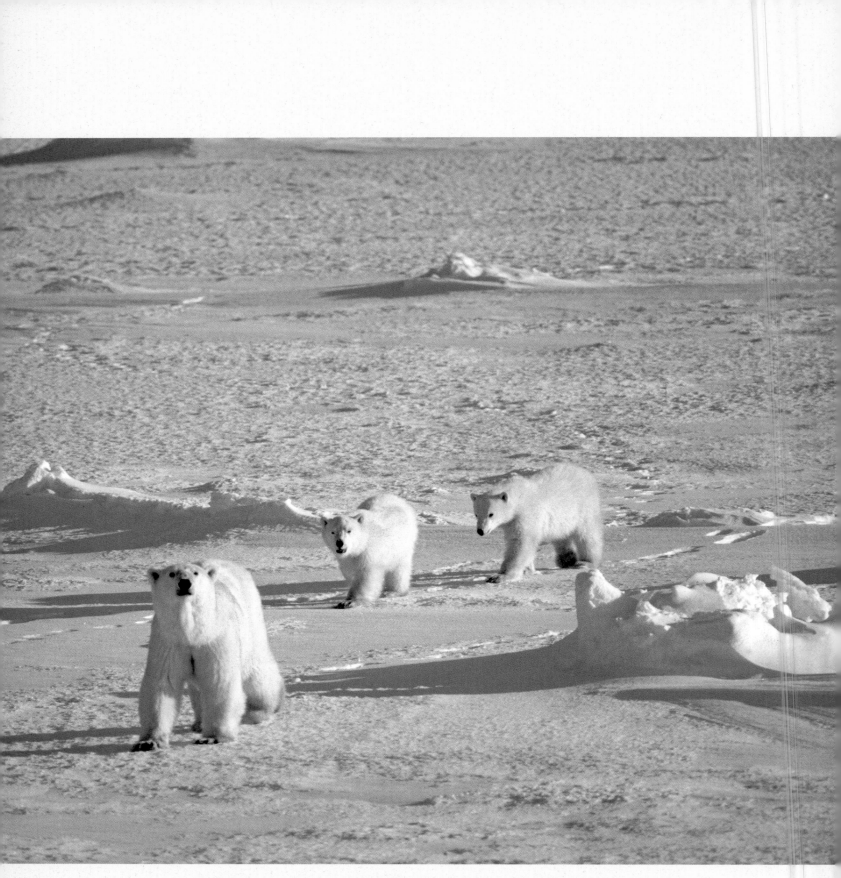

A polar bear family heads across the ice in search of a ringed or bearded seal meal.

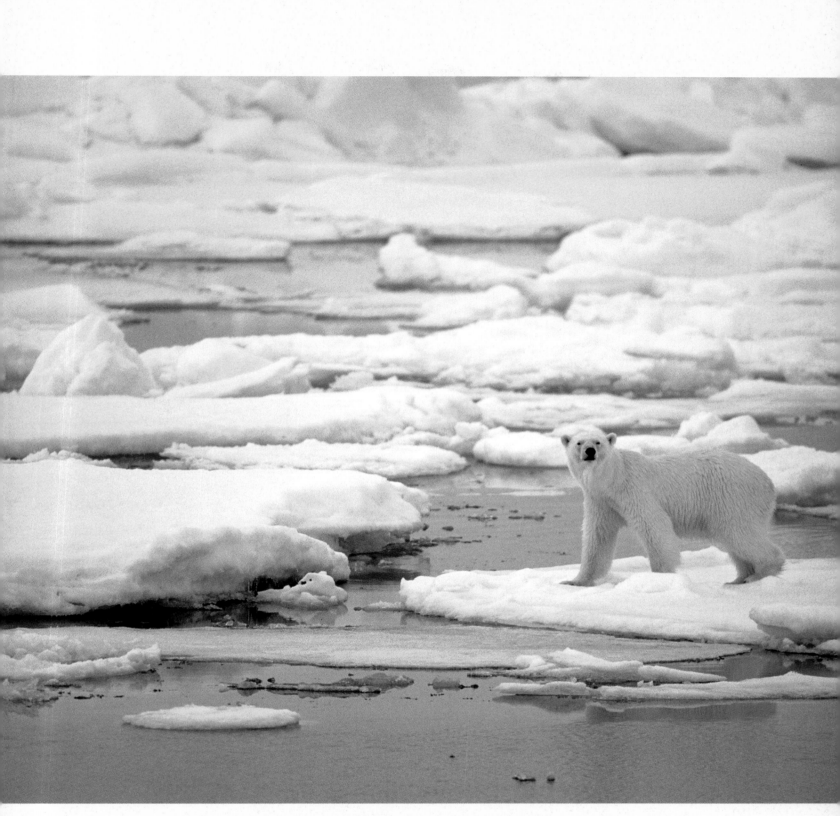

Polar bears are the youngest of the eight bear species, having split from the brown bear family around 150,000 years ago. They have become incredibly well adapted to their unimaginably harsh environment in this short time.

A coastal brown bear on the Alaska Peninsula walks the edge of a pool full of salmon. Ecosystems such as this one host many interdependent species.

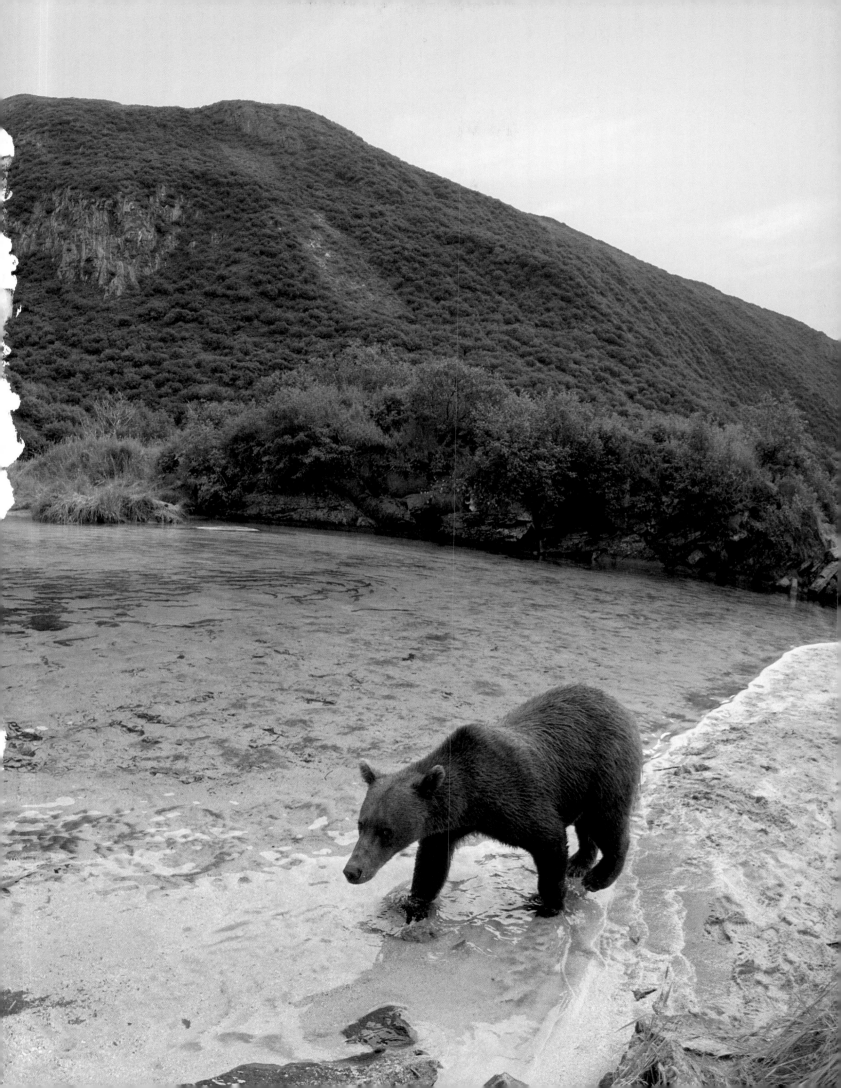

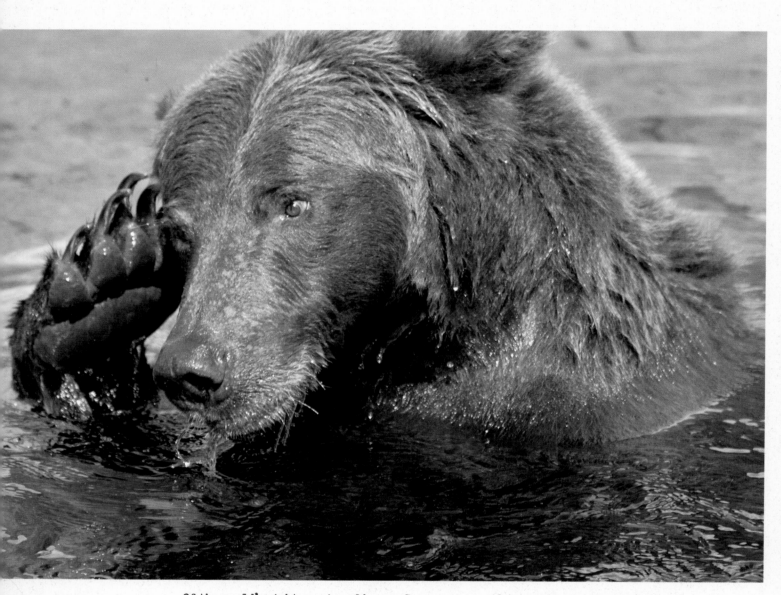

Of the world's eight species of bears, five are currently considered vulnerable to extinction and one is threatened. But there are success stories too, and fortunately bears are among the most loved and revered animals on earth. It is simply impossible to be in their presence and not feel a complete sense of awe and wonder. Their place in the wild is a rightful one, for no other animal more suitably represents it than they.

RESOURCES

I hope you enjoyed the book. There was so much more to say, but unfortunately I ran out of pages. If you are looking for organizations that do great work for wildlife, conservation, bears, and Alaska, here are a few suggestions to get you started, including some of the projects I am involved with.

www.adfg.state.ak.us

Alaska Department of Fish and Game

www.alaskawild.org

The Alaska Wilderness League, an organization dedicated to protecting Alaska's wildlands.

www.bearbiology.com

International Association for Bear Research and Management (IBA), a community of scientists and conservationists from more than fifty countries dedicated to bear research, environmental education, and conservation.

www.bearinfo.org

The Grizzly Bear Outreach Project (GBOP), our community-based bear, wolf, and cougar awareness project in Washington State.

www.chrismorganwildlife.com

My personal site, and a hub for interesting wildlife conservation and film projects.

www.iucn.org

International Union for Conservation of Nature, a global environmental network of government and NGO member organizations, and nearly 11,000 volunteer scientists.

www.iucnredlist.org

IUCN Red List of Threatened Species, the most comprehensive, objective global approach for evaluating the conservation status of plant and animal species.

www.nps.gov/state/ak

National Park Service, Alaska region.

www.pbs.org/wnet/nature

Channel Thirteen's *Nature* series, including information about our three-hour television special, *Bears of the Last Frontier*.

www.polarbearsinternational.org

Polar bears International, a non-profit organization dedicated to the conservation of polar bears and their arctic ecosystems through research and awareness.

www.vitalground.org

Vital Ground, a U.S.-based organization that helps preserve the threatened grizzly bear, other animals, plants, and natural communities through the conservation of habitat and wildlife linkage areas.

www.wildlifemedia.org

Wildlife Media, the non-profit wildlife film and awareness organization that I cofounded, including the global bear conservation film, *BEARTREK*.

ACKNOWLEDGMENTS

A life journey like this doesn't happen alone. From the moment I discovered my passion for wildlife and wild places, and then bears in 1987, many people have gone out of their way to put their faith in me. It is hard to find the words to describe how much that means to me, and for that reason, this has been the most difficult page to write. So many people have generously given their advice, support, love, and encouragement over the years that I don't know where to start. My heartfelt apologies go to those I may neglect to mention.

At the top of this impossible list are my parents, Philomena and Robert Morgan, who from the outset encouraged my love for all things wild, never questioning my desires to pursue unusual dreams. My brother Tony Morgan and my entire extended family also played a role in one way or another, but in particular, my uncles and aunties, Basil and Marie Tierney, and Veronica and Gordon Glover always encouraged me in the right direction.

Many, many friends and colleagues helped me to gain a foothold in the bear ecology and conservation world in my twenties including Doug Kane, Peter Clarkson, Nigel Dunstone, Anis Rahman, Vaqar Zakaria, Luis Suarez, Steven Herrero, the late Ian Ross, Hugh Robinson, Joe Van Os, Gary Koehler, Bill Gaines, and John Hechtel.

Many more people since then have provided friendship and support, without which none of this would have been possible. Thank you especially to my Wildlife Media family: John Taylor, who kick-started so much; Annie Mize, whose kindness has been there every step of the way; Joe Pontecorvo the creative genius; Matt Fikejs, my right-hand man; Nick Hartrich; Jordan Green; and Chris Palmer. My life would simply be impossible without Carmen Gilmore and the constant kindness, care, and attention she gives to every aspect of my work (thank you, Carmen!). My time away from the Grizzly Bear Outreach Project would not have been possible without Sharon Negri's incredible patience, hard work, and support.

Warm thanks to my friends and conservation allies Paul Lister, Bob Yellowlees, Lisa Brown, Erik Poulsen, Joe Scott, Chris Weston, Doug Zimmer, Wayne Lynch, and to John Rogers for his endless encouragement, generosity, and logistical support. Brad Josephs has provided friendship and insight among our favorite animals in Alaska for many years, and the entire crew on the M/V Waters and M/V Kittiwake always provide a welcoming home away from home.

From the bottom of my heart, thank you to the hundreds of Wildlife Media donors whose kind support for BEARTREK helped inspire our film with PBS Nature. Thank you to the many members of the International Association for Bear Research and Management (IBA) who have provided ideas and enthusiasm and feedback, especially Harry Reynolds and Frank van Manen.

Very special thanks to the PBS Nature team at WNET; they made the film and the book possible, and allowed Joe Pontecorvo and me to bring a dream to reality: Fred Kaufman, Bill Murphy, Janet Hess (so glad you found us at the International Wildlife Film Festival!), Janice Young, Laura Metzger, Jayne Jun, Richard Siegmeister, and the entire WNET team in New York.

The inspired creativity, hard work, and commitment of my conservation film partner, Joe Pontecorvo, constantly amazes me. Thank you, Joe—for everything. The dedication of our film crew and their many long days of hard work were so key to the film—and the book that followed. Hearty thanks to Dean Cannon (associate producer and second camera) for the smiles and logistical magic at home and on location, and to Nimmida Pontecorvo (sound person), Brenda Phillips (additional camera and location stills photographer), and Billy McMillin, whose magical work as film editor has helped the inspiration flow. Thank you to Lance Rosen for his insightful guidance throughout the process.

Huge, heartfelt thanks go to my editor, Dervla Kelly, who spent many long days and nights working very hard to make this book possible under a very tight deadline. Thank you to Kris Tobiassen, who designed the book in record time, to Kathleen Go for her huge help, and to the entire team at Abrams Books.

So many people helped us on location. I would like to thank everyone who encouraged and assisted us along the way. John Rogers;

John Whittier; Brad Josephs; Rick Sinnott; Jessy Coltrane; Jim Dau; Dale Brower; Daniel Zatz; John Spencer; Ron Chapple; Tom Smith; Josh Schein; Captain Ben Itta and his crew; the Nageak family; the residents of Kaktovik, Barrow, and Kotzebue; Fred "Papa" Tagarook, Sr.; Max Hanft; Mark Ryan; Tyler Klaes; Art and Jenn Smith; and Jack Reakoff.

Many thanks to John Hechtel, Jessy Coltrane, and Andrew Derocher for reviewing sections of the manuscript, and Steve Amstrup, Pat Owen, and Larry Van Daele for their helpful input during film scripting. Thank you to Tom Campion for his invaluable advice during film planning, and to the many organizations and companies that provided support, including everyone at Touratech (Germany and the United States), Ride West BMW, Alaska Riders, the guys at Lower Peninsula Power Sports, Andrew Airways, Ian Martin at Arc'teryx, Rick Menapace at Avai, and Peter Jones at Metzeler.

Thank you so much to the photographers whose beautiful work appears in this book, many of whom have helped support other bear conservation projects I am involved with: Cameron Baird, Dean Cannon, Matthew Felton, Kent Fredriksson, Jonathan Harris, Ryan Hawk, Brad Josephs, Steven Kazlowski, Wayne Lynch, Joanna Patterson, Patty Perone, Brenda Phillips, Joseph Pontecorvo, Nimmida Pontecorvo, John Prudente, John Rogers, Ian Ross, Rick Sinnott, John Taylor, Ellie Van Os, Chris Weston, and Brian Zeiler.

My heartfelt thanks to Sue and Jeff Bridges for kindly providing the foreword to my book—I am flattered more than you will ever know.

Love and hugs to my beautiful children, Sam and Sofia, and my warm thanks to their mom, Kelly Morgan, for her everlasting support and kindness.

And finally, thank you Bren Phillips, my best friend, my rock, and the love of my life, for everything you do, every moment.

Photography Credits

Brian Zeiler
Front cover, case and pages 44-45, pages 17, 18 (top left and bottom), 20 (both images), 22, 24, 30, 35

Steven Kazlowski
Endpapers and page 123 (bottom image), pages 70, 74, 75, 76, 81, 82, 83, 87, 92-93, 123 (top image), 124, 135 (both images), 136, 137, 138-139, 146-147, 148 and back cover, 149, 153, 155, 156, 177, 190, 196 and endpapers, 199

Matthew Felton
Pages iii and 31, 40, 46 (top)

Wayne Lynch
Pages iv, 9, 64 and back cover, 65, 68-69, 78 (both images), 79, 80, 108, 111, 114-115, 150, 151, 204, 205

Brenda Phillips
Pages x, 19, 48 (bottom), 50 (bottom), 51, 67, 72, 89 (both images), 90-91, 100, back cover

Chris Morgan
Pages 3, 4, 6, 13, 16, 18 (top right), 26, 34, 36, 46 (bottom), 47, 48 (top three images), 49 (both images), 58 (bottom), 59 (both images), 63, 73, 77, 84, 85, 86, 88 (both images), 94 (both images), 95, 96 (both images), 97, 98, 101, 104, 107, 109 (both images), 112 (both images), 113, 117, 118 (both images), 119, 122, 127, 129 (bottom), 130, 131, 132, 133, 134, 140, 141, 142 (top), 143, 152, 154 (both images), 159, 160, 161, 162, 165, 166, 167, 168, 170, 172, 173, 174, 178 (both images), 179, 180, 181 (both images), 186 (all images), 189 (both images), 208

Ian Ross
Page 8

Ellie Van Os
Page 10 (top)

Ryan Hawk
Page 10 (bottom)

Joanna Paterson
Page 11

John Prudente
Page 12

Chris Weston
Pages 14, 21, 28-29, 32-33, 41, 42 (both images), 43, 200-201, 202-203 and back cover, 206-207

Brad Josephs
Page 37

Kent Fredriksson
Pages 38-39

John Rogers
Page 50 (top)

Corbis
Page 52

Nimmida Pontecorvo
Pages 54 and back cover, 55, 58 (top), 60, 66, 102, 110, 142 (bottom), 188

Rick Sinnott
courtesy of Alaska Department of Fish and Game
Pages 56, 57

Joseph Pontecorvo
Pages 116, 187

Jonathan Harris
Pages 128, 129 (top), 144

John Taylor
Page 145

Dean Cannon
Page 175 (both images)

Cameron Baird
Pages 182-183, 184-185

Patty Perone
Pages 176, 193

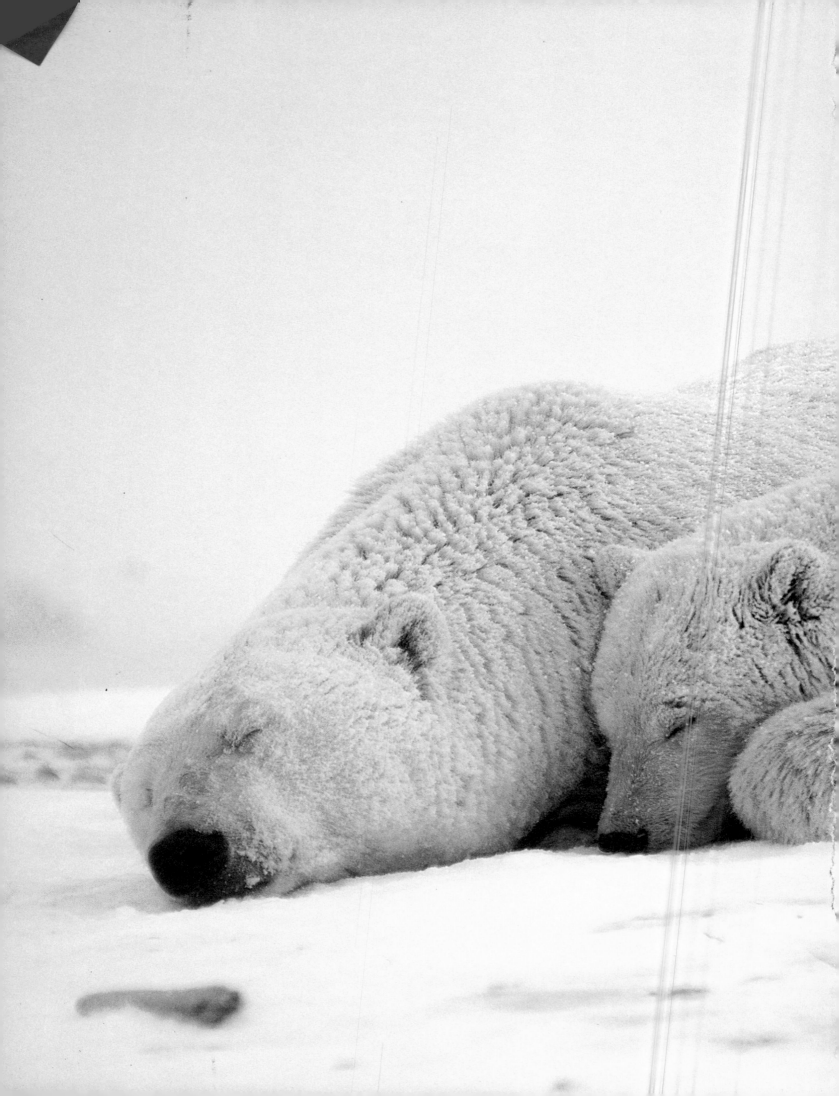